ALL ARE MY CHILDREN

All Are My Children

Voices of Ugandan Women Peacebuilders

Jennifer Ball

CONTENTS

ACKNOWLEDGEMENTS

AS MY ADVISOR, but also as a colleague and friend, Wayne Caldwell has been unwavering in his belief in me and my abilities and dreams. It was he who planted the first seeds of a PhD and he has in so many practical ways created the conditions necessary for those seeds to grow to fruition. For his extraordinary ability to see the positive in every situation and remain open to new ideas, I am grateful.

My committee members, Al Lauzon, Karen Landman, and Anna-Marie Ball, have been a dynamic complement. Al's gifts have been hours of listening deeply to my evolving ideas and process, challenging me yet offering guidance, and all the while giving me permission to follow my heart. Karen has brought an openness to my research ideas and, at key moments, posed challenging questions and offered refreshing insights. Anna-Marie, located in Kampala, was brought on later in the process and provided essential ongoing critique, analysis, and insight as the research process evolved. As well as accommodation, she provided invaluable companionship over my two years in Uganda—a circle now complete after my having done the same during the final year of her PhD. As my sister and friend, Anna-Marie not only forged the way for me by being the first in our family to earn a PhD but, in so many countless ways throughout my life, has mentored and applauded me.

The five women whose stories are the subject of this research have inspired and taught me important life lessons. Without them this study would not have been possible. Joyce Jermana Minderu Pol-Lokkia, Tina Zubedha Umar, Juliana Munderi Denise, Rita Nkemba, and Rose Miligan Lochiam are strong, innovative, and courageous women. Each in her own way welcomed me into her life and opened herself, her family, and her community to me. For such generosity and for the gifts of their stories, I am deeply grateful.

Marg Huber, of Global Peace Hut (GPH), with gentle graciousness and unflagging optimism, championed my research from its initial inception. With the affiliation of her organization, GPH, she helped open the way for

me to go to Uganda. While I was in Uganda, Dr. Deus Nkurunziza, of the Religious Studies Department at Makerere University, gave generously of his time, experience, reference resources, and personal connections. The Makerere Peace and Conflict Studies Resource Centre made it possible to complete my literature review in-country. Paulo Wangoola, of Mpambo Afrikan Multiversity, brought much insight and wisdom. Through his ongoing work with indigenous "mother-tongue scholars," I was privileged to participate in a series of dialogues toward further "decolonization of the mind." Adiga Eddie, research assistant and friend, saved me from hours of transcription, managed travel logistics, frequently translated language and culture, and continually reminded me to live in the present.

Throughout this entire journey, Ayiko Solomon's love and unfaltering belief in me and in my ability to complete this degree has sustained me. Irene Yebuga embraced me fully into her family and provided important introductions in Uganda. Jeanne Andersen, once high school art teacher and now resolute friend and fellow lover of Africa and of things woman, consistently calls me back to my soul and to inherent creativity. Heidi Hoernig, fellow traveler on the PhD path, led the way for me, providing academic insight and sharing the struggle of grappling with head/heart balance. Other strong women friends who surround me and, in their unique ways, nourish my life are Lyn McNiffe, Ildiko Denes, Doris Jakobsh, Heather Lokko, and Yvonne Kaethler.

My family, my source of constant support and ever-present advice, has traveled the whole of my life's journey with me, has ridden the highs and the lows, and their love is steadfast. From my parents, Harold and Patricia Ball, I have been given my great love for people, my affinity for Africa, and my sense of justice and integrity. In my family are both my roots and my wings. Finally, to my Creator, my ancestors, and "all my relations," I give great thanks.

This project was supported through funding from the IDRC Doctoral Research Award, the SSHRC Graduate Fellowship, and the University of Guelph.

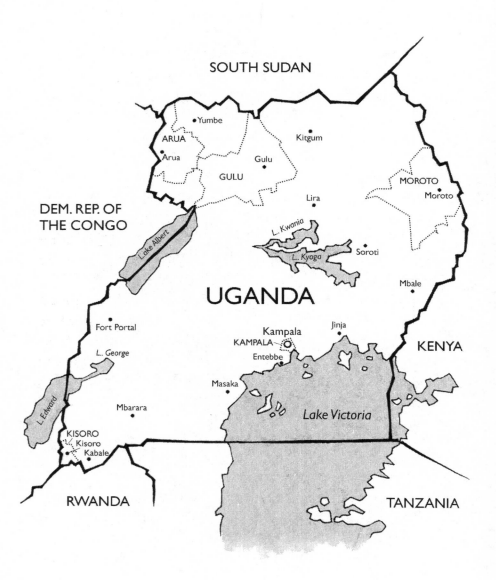

SOUTH SUDAN

Yumbe

ARUA

Kitgum

Arua

Gulu

GULU

MOROTO

Moroto

DEM. REP. OF
THE CONGO

Lira

L. Kwania

Lake Albert

L. Kyoga

Soroti

UGANDA

Mbale

Fort Portal

Kampala

Jinja

KAMPALA

KENYA

L. George

Entebbe

Masaka

L. Edward

Mbarara

Lake Victoria

KISORO

Kisoro

Kabale

RWANDA

TANZANIA

PROLOGUE

AMID THE HUSTLE and bustle of Owino Market, with people jostling around us through narrow alleyways, my friends and I mull over skeins of fabric.

"This one."

"What about this?"

"No, not that one—try that one over there."

We instruct the shopkeeper, who patiently hooks down bolts of material from the colourful stacks lining the walls, floor to ceiling. Spread before us are variegated patterns: a sheaf of earth tones, my shades of purple, and two heaps of multicoloured cloth. Our goal? Four handmade quilts.

The inspiration came to us when three Ugandan friends and I decided we should all learn to quilt. It would be a reason to get together weekly to sew and socialize. Living on the same street in Kampala, we had quickly become an integral part of each other's lives, with shared meals, much teasing and laughter, and many stories. Over the next months, as we cut, pieced, and stitched our patchworks, I reflected on the patterns of my own life that had brought me here.

Born to Canadian missionary parents in rural Zambia, I grew up immersed in both Zambian and Canadian cultures and yet not fully part of either. This identity, with its inherent tensions and versatility, is one I continued to develop as I sought to survive my traumatic transplanting to Canadian soil when I was eighteen. In the intervening years, through my education, my work in community development in various African countries, and my work in rural planning in Canada, I grappled with the dissonance between my skin colour and my African roots.

I learned of the power and privilege ascribed to being "white," the ongoing destructiveness of colonial and neo-colonial legacies reliant on the misuse

of such power, and my responsibility to use these privileges with integrity and for the good of the whole.

For many years I felt that, because I was white, my place was not in Africa; that there were African people who were better qualified to be making change and building that continent. While this is true, I have come to realize that it is also true that I, with my white skin and mixed African–Canadian culture, have something significant to contribute.

I wanted to spend time with women in Africa. I wanted to hear the stories of ordinary women who were doing extraordinary things to build their families and communities, and, in the process, building peace. I wanted to use my privileges and power (of education and articulation) to provide a platform for their voices.

Now, as I stitch my quilt, I think of all the threads that have come together over the last two years. I have traveled much of Uganda, stayed in numerous homes and villages, and built relationships with many extraordinary women. I am full of their stories. It is these that I want to share: stories they have shared with me and entrusted to me; stories that tell of the incredible work of their lives, and of their challenges and inspiration. They consider these stories to be very ordinary. However, it is in these stories—and the living of their lives—that they offer up a gift to the world.

CHAPTER I

Women and Peacebuilding in Uganda

Women and Peacebuilding

PEACEBUILDING, AS DEFINED by most mainstream literature and international policies, refers to processes and activities engaged in during periods of post-conflict reconstruction. Peacebuilding in this sense follows on the efforts of peacemaking and peacekeeping, those interventions designed to end the violence and negotiate an agreement or resolution, thereby enabling the rebuilding of societal infrastructure.[1] Peacebuilding, from this perspective, is limited in time and space, in scope, and in those deemed to be doing peacebuilding. These peacebuilders are generally outsiders, often Westerners, whose mandate and concern is to intervene and assist in situations of protracted violent conflict.[2]

An alternative and more holistic definition of peacebuilding understands this concept to encompass all aspects of life and all stages of conflict—pre-conflict, the actual conflict, and post-conflict—and so is inclusive of activities of prevention, resolution, and reconstruction. It recognizes the importance not only of the resolution of conflict and the rebuilding of physical infrastructure, but also the cultivation, nurturance, and transformation of the overall context in which conflict is embedded. The focus thus is not merely on ending violence (negative peace) but also on creating and ensuring the socioeconomic and political conditions in which people's rights and basic human needs can be protected and met (positive peace).[3] Such is the interconnection between peacebuilding and development.[4]

Women are actively engaged in peacebuilding at every level, from the grassroots to the international arena. However, their work is often not made visible, and thus their voices and perspectives are sometimes not heard or regarded as credible.[5] This is partly because the majority of women's involve-

13

ment is found at the grassroots or local community level, but also because women themselves often do not view their work as peacebuilding—it is more informal and is seen as part of their social roles and responsibilities. Because of this, "women's contributions tend to be undervalued and not readily incorporated or sought by many practitioners of peacebuilding."[6] They do not often influence higher level policy development and decision-making. This book hopes to redress some of that undervaluing by bringing the voices of women peacebuilders to the fore.

Women have long been associated with peace. This is in large part due to their role as mothers—those who give and protect life—and their perceived embodiment of "feminine" values of nurturance, compassion, communalism, and collaboration.[7] While holding some truth, these theories of biological predisposition and cultural socialization fail to recognize the diversity of identities within and among women along lines of age, race, class, ethnicity, language, religion, and ability. They also set up a polarization in which men are associated with war and violence as they live out more "masculine" values of dominance, aggression, and competition. Such dichotomies make peace the purview of women only, denying the reality that men are capable of taking on caregiver roles or may be socialized in more "feminine" values, and essentially abdicating men from their responsibility toward building peace.[8] As peace requires the transformation of whole societies, it necessitates the involvement of both men and women.

That being said, women are known to lead the way in peace initiatives.[9] While sorely underrepresented at higher levels of decision-making, women are disproportionately represented in peacebuilding efforts at the grassroots level.[10] Their roles and contributions have, however, only been recognized at international policy levels since 2000, in the passing of the *United Nations Resolution 1325 on "Women, Peace, and Security."* This disconnect between the on-the-ground reality and what is reflected in national and international policies, programs, and funding allocations is in large part due to the gender inequality and corresponding power imbalances inherent in global and societal structures and institutions.[11]

Women's perspectives, needs, and contributions in areas of conflict and peacebuilding have not historically been solicited, profiled, or incorporated into the policy and program decisions directly affecting them. Years of advocacy by women's groups have, in the last decade, resulted in a growing realization of the significance of a gendered perspective to peacebuilding. The field of peacebuilding, in this way, builds on a similar evolution of and discourse within the field of development.

International development originally operated from an assumption of "gender neutrality" as having no differentiated impacts on men or women but providing benefit to all. The effects of gender inequality, inevitably a part of every society, were not taken into consideration. As York reminds us, "women—who comprise the majority of the poor, who constitute more than half the world's population, and who do two-thirds of the labor—make only one-tenth of the money and own only one-hundredth of the property."[12]

Such realities became more apparent through the critique of feminist researchers, leading to a series of paradigm shifts in the field from women in development (WID) to women and development (WAD) to gender and development (GAD), and then to women, environment, and development (WED)[13]—all aimed at promoting greater awareness of and intentionality toward gender equity and women's participation in and empowerment through development. Pankhurst notes, however, that gender mainstreaming in development is fundamentally related to a realization of its impact on the overall "efficiency" and success achieved.[14] This she parallels with the shift in peacebuilding policies, with the caveat that such a shift has not necessarily "led back into reconceptions of the impact of gender relations on the conditions of conflict or peace. Nor has it led to a change in women's experience of conflict or peace building."[15]

The gendering of peacebuilding challenges underlying assumptions about the roles of men and women in conflict and peace. Conventional thought, with its roots in patriarchy, would argue that, as it is primarily men who fight in wars, men should negotiate the end to wars. From this perspective, women are simply victims of wars as they are confined to the home

15

front, looking after families and mourning the inevitable loss of their men-folk. Women are not seen as leaders, as being rational, or as having the experience to participate at other levels.[16] The consequence of this is that women are generally not present during peace talks. They are not invited to be part of negotiations, and thus their needs and perspectives do not help formulate plans for reconstruction or sustaining peace.

Women are indeed disproportionately victims of war, especially as the nature of conflict and war has changed. Instead of being fought mainly on battlegrounds far from home between opposing forces of professional soldiers, wars increasingly target civilians, of whom women and children make up between 70 and 80 percent.[17] Furthermore, in armed conflict and war, women are increasingly targeted in sexual violence—rape, trafficking, and sex slavery.

Feminist literature exposes the relationship between sexual violence and patriarchy. When women are seen to be without value except in their relation to men (as wives, daughters, and sisters); when they are without identity (personal, ethnic, national) except as they acquire such from their relationship with a man—as his wife, becoming part of his family and community, and producing offspring assumed to be solely of his people (not hers)—then women have no inherent individual worth. In war they then become the means to humiliate, degrade, and intimidate men of the opposing side. Their bodies become battlegrounds. Yet they are caught in a catch-22, for, having been raped and sexually tortured by men of the opposing side, women then face shame, derision, outright rejection, and sometimes death from their male relatives and community members for having "allowed" themselves to be so sexually defiled; for not better "protecting" their sexual purity from contamination by the "other."[18]

When so rejected, women also face a loss of social status and lose access to resources such as land and economic support derived from their relationship with male relatives or their spouse. This deprives them of the means to support and feed themselves and their children. It is exacerbated by the real-

ity that through rape many also contract HIV/AIDS and other sexually transmitted infections that further complicate and compromise their lives.[19]

Gender-based violence is not confined to times of war, however. Women are also victims of domestic violence outside of war. They report significant increases in such violence post-conflict when men, themselves traumatized, return home. In fact, such times of supposed peace and reconstruction may actually be worse for women than during the war: there is no aftermath for women; the continuum of violence is ever present in many women's lives.[20]

Other ways in which women are affected differently and disproportionately than men in conflict is in their roles as caretakers of children, the elderly, and the wounded and maimed. In the absence of men, women must assume the burden of producing or finding food within environments of extreme insecurity (often risking rape and violent assault as they do so). Women frequently face displacement from their land and homes, often forced for their survival into camps internal or external to their country. Their property and resources destroyed, they are left destitute and impoverished. Without means of income, many face difficult choices, selling their bodies for small amounts of money or food for the survival of their children. Their suffering is exacerbated by the lack of services and opportunities—health, policing, education, employment—due to the destruction of infrastructure and breakdown of institutions.[21] As Rehn and Johnson Sirleaf note, "war exponentially intensifies the inequities that women are living with."[22]

Some argue that women may also benefit from war, because when their men are absent they are freed from certain social norms, required by the necessity of survival to take on men's roles in protecting and providing for families. This experience can lead to frustration and resentment when the conflict is over and the men return, and with them expectations of life going "back to normal": back to the status quo. Women often do not want to return to their positions of marginalization and inequality. Their struggle against this results in internal tension and communal strife, usually with lit-

tle fundamental change in gender perceptions and underlying patriarchal ideologies.[23]

Depending on the duration of the war, some women, such as female combatants, may never have functioned in traditional roles and may find such adjustment difficult, if not impossible.[24] Those widowed face a loss of social status, the threat of forced remarriage, and the domination of male relatives. Thus, while war may create opportunities for women to experience their own capabilities beyond socially prescribed gender norms, and may even lead some to struggle for greater equality in the post-conflict context, war ultimately shatters women's lives, ripping the social fabric—for better or worse—in ways that render it irreparable.

In spite of calls for women's participation in all levels of decision-making related to peace and peacebuilding, women continue to be distinctly absent from peace talks and negotiations and are not represented or are underrepresented in local and international organizations.[25] The lack of understanding by international development agencies of women's needs as victims and their contributions as active peacebuilders in situations of conflict and in post-conflict reconstruction results in policies, personnel training, and peace and development program implementation that lack or have inadequate gender awareness and that in most instances perpetuate gender violence against women, be it direct or structural (or, usually, both). Handrahan makes the point that the inability of Western-influenced interventionist agencies (as peacekeepers, mediators, or development agencies) to recognize the negative influence of patriarchy, with its values of control, domination, and oppression, within their own cultures and structures results in them perpetuating the same in the contexts in which they work.[26]

Some of the most overt examples of this are in documented cases (in Angola, Bosnia and Herzegovina, Cambodia, Democratic Republic of Congo, East Timor, Liberia, Mozambique, Kosovo, Sierra Leone, and Somalia) of peacekeepers raping or sexually exploiting women and children under their protection by withholding food or basic necessities in return for sex,

and even being involved in human trafficking.[27] Other less glaring but well-known examples include the planning and design of refugee camps that make no consideration for the security and unique needs of women and children, though these are known to make up a majority of refugee populations the world over. Food distribution practices often favour men, and there is a lack of protection for women, who are preyed upon by men both inside camps and outside, where they must often go to collect water and firewood.[28]

Women at the grassroots level define peace more broadly than conventional international definitions. Peace is about more than the cessation of hostilities, disarmament, and infrastructure reconstruction negotiated in peace agreements. For such women, peace encompasses both an end to the particular violent conflict and an end to violence in their homes. Their struggle for peace represents their struggle for equity, for the protection of human rights, and for the transformation of structures and institutions that keep women and minority groups marginalized and oppressed, denying them access to resources, rights, and opportunities. It is about intercultural tolerance and nonviolence.[29] Most women live within the nuances of these concepts. Their perspectives emanate from their lived reality. And these, time and again, are seen to ground the more intellectual and theoretical debates, discussions, and negotiations of the men. Such is the role women often play in balancing "masculine" energies, values, and perspectives.[30]

Just as women experience the effects of violent conflict differently than men, so do they engage in peacebuilding differently, often employing unconventional and creative methods. Documented examples include women protesting naked—in New South Wales against war and in India against the provision of special military powers that resulted in the brutal rape and death of a young woman.[31] In Israel, the "Women in Black" movement has involved women protesting the Palestinian occupation by dressing in black—symbolic of mourning—and standing in intersections and public spaces.[32] Three women in the United Kingdom clandestinely entered a weapons factory and disarmed an aircraft bound for use in the East Timor genocide, plas-

tering it with photos of children and a woman killed in one of the massacres, and leaving a banner proclaiming "Women Disarming for Life and Justice."[33]

We are only just beginning to recognize the range and diversity of women's involvement and initiatives in peacebuilding. And, while many women join together and form organizations and NGOs for the purpose of doing peacebuilding, the majority so engaged do not define their efforts as peacebuilding; they see what they do as simply part of their lives, part of their struggle for the survival of their families, investment in the health and development of their communities, and ultimately for the future of their children.[34] For women at the community level, theirs is a deeply personal involvement and commitment. "Unlike political elites or international actors, women in communities never plan their work with an 'exit strategy' in mind."[35] They are in it for the long haul.

Grassroots women's peacebuilding concerns are more holistic and inclusive of meeting human needs—physical needs such as food, water, shelter, safety, and relational, psychosocial, and spiritual needs.[36] Women recognize the vital interconnections between all of these needs and peacebuilding; they emphasize that addressing some without the others cannot lead to people's empowerment and to sustainable peace and development.

In peacebuilding, women draw upon and develop networks of relationships within and beyond their own communities.[37] As some of women's primary resources, relationships provide essential support for women on all levels and afford them opportunities to assert much influence and therefore assert certain power. In this, many are highly skilled.

It is important to emphasize that peacebuilding is context specific.[38] Like conflict, peacebuilding arises out of specific socio-political, cultural, economic, and environmental settings and circumstances. It therefore takes many forms and is different in different places and situations, inspired by the varying conditions of people's lives. What is perceived or defined as peacebuilding in one area may not be the same in another. All views of peacebuilding are partial and would do well to be informed by others, especially by the experiences and approaches of the diverse women of the world who live out

peacebuilding in their homes and communities. The following sections look at the communities and larger environment within which the women in this book live and do their peacebuilding.

Uganda

Uganda should be viewed not as a single context but as made up of numerous diverse contexts—each with different geographic, historical, political, and cultural experiences and influences that significantly impact both the issues of conflict in these areas and the responses to conflict in terms of efforts toward peacebuilding. While each of the women in this study shares the experience of being Ugandan, each also has distinct experiences and perspectives based on her identity in being from a discrete part of the country.

Winston Churchill described Uganda as the "pearl of Africa." This is a country known for its many lakes, dramatic mountains, lush tropical vegetation, fertile soil, and pleasant equatorial climate. Its topography ranges from the semiarid plains in the east to the rainforests and snow-capped Rwenzori Mountains in the west. Uganda sits on the equator, on a plateau about a thousand meters above sea level.

Situated within East Africa, Uganda is bordered by the Democratic Republic of Congo (DRC), Sudan, Kenya, Tanzania, Rwanda, and the world's second-largest freshwater lake, Lake Victoria. As such it is surrounded by numerous ongoing regional conflicts (e.g., in southern and western Sudan, eastern DRC, between Ethiopia and Eritrea, the residual trauma of genocide in Rwanda and Burundi and, most recently, uprisings in Kenya) that at different times and to varying degrees threaten its national security.

Uganda is approximately the size of the United Kingdom, 241,038 square kilometers, and has a population of over 35 million.[39] It is a multiethnic and multicultural society with many diverse cultural groups and more than thirty-three languages spoken.[40] Although English is the official language, the majority of people are more comfortable speaking their own languages.

The ethnic groups in Uganda may generally be categorized as those of Bantu origins in the central and south, related to most of the rest of southern Africa; and those of Luo, Sudanic, and Atekerin or Nilo-Hamitic origins, related to peoples in Sudan and the Horn of Africa.[41] The Nile River is considered the general line of delineation between these two parts of the country. This distinction between north and south has been a source of national conflict and tension since colonial times, when the British intentionally exploited and exacerbated the differences between the regions. As well, the national borders, arbitrarily determined in Europe by colonial powers and so dividing families, clans, and ethnic groups, set the stage for internal conflict. Even today, those living along these borders feel a greater kinship with peoples across the border than with the rest of the country. Such are the ongoing challenges of creating a national identity.

Elements of the colonial legacy, together with the post-independence power struggles and current political and socioeconomic challenges, continue to create and contribute to conditions of local and national conflict. Uniquely, Uganda was never made a colony. It became a British protectorate in 1894. At the time there were five major kingdoms—Buganda, Busoga, Toro, Bunyoro, and Ankole—in the centre, south, and west. The most powerful of these was the Kingdom of Buganda, whose people the British favoured and strategically used in their mission to divide and conquer the rest of the region. Areas outside of Buganda, especially in the north and extreme southwest, were designated for labour supply for the large farms in Buganda.[42] Education and services were also provided disproportionately to those groups favoured by the colonialists. This resulted in regional imbalances of development and a marginalization of the north and southwest that continue today and are the source of much underlying tension. They are at the root of several of the rebel movements since independence.

Another significant source of conflict in Uganda seeded during colonial times is religion. As with most colonial enterprises, the subjugation of peoples went hand in hand with their conversion, willingly or otherwise, to religion. In Uganda, Roman Catholics and Anglicans fought each other, and

together they fought Muslims for territorial control. This intertwining of religion and politics would continue to haunt Uganda in future tyrannical regimes.[43] The majority of Ugandans are either Christian (Roman Catholic or Protestant), Muslim, or practice traditional African spirituality. Many, even as Christians or Muslims, practice some form of their traditional spirituality in rituals and ceremonies. However, the influence of religions that try to assert supremacy continues to be a threat in creating animosities not otherwise a part of traditional beliefs and culture.

Uganda gained independence in 1962 without a civil war. Its first president was Edward Mutesa, the Buganda *kabaka*, or king. However, in 1966, then Prime Minister Milton Obote unilaterally suspended the constitution and forced the president into exile after destroying the *kabaka*'s palace. So began a period of twenty years characterized by "tyranny and oppression; corruption; black marketeering, and economic collapse; tribalism, violation of human rights and civil war."[44] The period that became known as "Obote I" lasted from 1966 to 1971. In 1971, Idi Amin ousted Obote, and ruled until 1979. Among other atrocities, Amin is infamous for his expulsion of virtually the entire Asian population in Uganda. Obote then took power again for "Obote II" from 1980 to 1985. A detailing of Uganda's political history is not possible here. Suffice it to say that the religious wars during colonial times and the horrors of the twenty years following independence have left Uganda a society that has experienced generations of violence and trauma.

In 1986 the current president, Yoweri Kaguta Museveni, and his National Resistance Movement (NRM) took power by force after years of guerrilla warfare against previous regimes. In 1996 he was elected president, and again in 2000 for a second term. Subsequent elections in 2006 and 2011 were controversial, as Museveni had the constitution changed to enable himself to run for a third and then a fourth term; he was, however, re-elected in a relatively peaceful process. Many Ugandans, though increasingly dissatisfied with the government, fear the unknown alternative and so continue to toler-

ate the present regime. Others, especially those in the north who have known war for over twenty years, feel otherwise.

Under Museveni's leadership, the central, western, and southern parts of the country have rebuilt their economies and, in relative peace, have made impressive strides in providing government services, healthcare, and educational opportunities to their populations. This has been impossible in the north, where several civil wars have been waged—the most profiled being that of Joseph Kony's Lord's Resistance Army. The twenty years of this conflict and insecurity have left these areas disproportionately underdeveloped, further disadvantaging people already severely traumatized.

With 80 percent of Uganda's population reliant on subsistence agriculture, issues of land are paramount to people's survival.[45] Displacement, insecurity, and land shortage in some areas make cultivation virtually impossible and so create high levels of poverty. Currently, nearly 38 percent of the population lives below the national poverty level.[46] As of 2012, Uganda ranked 161 out of 187 on the *Human Development Index*; as such, it is a relatively poor country.[47]

Education is difficult in a subsistence economy and in a context where AIDS has left so many children orphaned, without parents to support them. Even for those young people who are successful in their education, high levels of unemployment mean few prospects for job opportunities and increased redundancy.

Healthcare demands in Uganda are high, with infrastructure and services inadequate and underfunded. Life expectancy in Uganda is about fifty-four years.[48] Many illnesses are poverty-related, and therefore preventable with improved sanitation and drinking water. However, over 60 percent of the population is currently without access to clean water.[49] Common diseases such as malaria, HIV/AIDS, cholera, meningitis, hepatitis, yellow fever, and periodic outbreaks of ebola take lives and put constant strains on healthcare resources and personnel. Both private and government facilities exist and both charge for treatments, thus making healthcare a feared unexpected cost for most Ugandans.

One of the most significant contributions of the present government has been the decentralized form of governance. There are five levels of local councils—village, parish, sub-county, county, and district—with the district as the administrative centre and each responsible for the planning and implementation of development. Government is in this way accessible to and active in the lives of local populations. As with other services, however, there is lower capacity in those regions dealing with civil war and insecurity.

Women in Uganda

Women in Uganda live in a society dominated by patriarchal values and culturally prescribed gender roles. Most women who live in rural areas are primarily responsible for the family—the production or acquisition of food, cooking meals, fetching water, bearing and caring for children, and often paying for school fees.

The roles and identity of men have, in many areas of the country, been so distorted and damaged by the violence and trauma of war that men often fail to carry out their traditional roles of also providing for the family. Some escape this crisis of identity through alcohol; others resign themselves to their redundancy and spend their days sitting idly, watching life around them and talking with other men. Most fall back on the privileges of their traditional male authority as heads of the household. All of this puts additional burdens on the women.

Most cultures in Uganda are traditionally polygamous; this is further encouraged among Muslims. While polygamy does serve many purposes, women often name it as the source of much domestic conflict, whether between co-wives or in the treatment of children by the various mothers. First wives hold a position of authority and respect in the home, while subsequent wives do not. Frequently, the last wife is the youngest and most favoured by the husband.

The position of women in traditional cultures in Uganda varies by ethnic group. Some give specific and direct powers to particular women in the family (e.g., the role of *ssenga* or "senior auntie" as a mentor for the youth

25

among the Baganda and Basoga); others do not. Where women do not tradi-
tionally have overt power in social arenas like the men, they have developed
avenues for acquiring and asserting power indirectly through their abilities
to strategize and influence. Relationships are the primary resource in using
such skills; thus, women often become astute at maintaining knowledge of
relational connections between families, clans, and larger ethnic groups.
They become masters of influence as they use these relationships to assert
power and acquire what they need for the survival of their family.

Urban women live with only slight variations on the roles of their rural
counterparts. Differences lie mainly in their socioeconomic prospects. Those
who are educated seek jobs, but compete for unequal opportunities with
men. Gender discrimination is rampant in getting or maintaining employ-
ment.[50] Professional women are faced with doing double duty in working
outside the home while being expected by their husbands and extended fami-
lies to maintain their traditional role within the home. In terms of gender
roles, the urban arena is a place of uncertain tension and transition between
traditional and modern expectations. Both women and men are trying to
find their way between traditional values and the issues raised by urban liv-
ing, such as shared responsibilities in the home, money management of dual
incomes, and expectations about monogamy and fidelity. Socioeconomic
status is a major factor in such negotiations.

Women as Peacebuilders in Uganda

Uganda has a rich history of women's organization and mobilization, pre-
and post-independence, as documented in detail by Aili Mari Tripp.[51] Na-
tional organizations such as the Uganda Council of Women and the Uganda
Association of Women's Organizations have been actively engaged in advo-
cating for women's rights and social, economic, cultural, and political con-
cerns since independence in 1962. After 1985, following the UN Decade of
Women conference in Nairobi, there was a noted increase in the number of
women's organizations and ad hoc mobilization around issues of concern to
the nation's women.[52] Significantly, these groups have managed to maintain

some autonomy from dominant political interests and have attracted a membership that cuts across lines of ethnicity, religion, and politics.[53] According to Tripp, "Ugandan women are highly organized even by world standards."[54] She goes on to say: "When viewed from a comparative African perspective, Uganda today is a leader in advancing women's rights, in spite of the continuing challenges."[55]

Such advancements have been attributed to the supportive political policy environment created by Yoweri Museveni's National Resistance Movement. The gender-sensitive 1995 constitution instituted affirmative action to ensure women's political involvement at all levels. This has resulted in increased opportunities for women in influential political positions. Uganda, for example, can boast the first female vice president in Africa, Dr. Speciosa Wandira Kazibwe. As well, it has achieved approximately a 40 percent representation of women in parliament[56]—a significant improvement from the lone woman in parliament in 1980.[57] Several notable women lead the way in courageously speaking out on and advocating for women's rights and gender equality at national levels. Among these are Miria Matembe, Rhoda Kalema, Betty Bigombe, Cecilia Ogwal, Naava Nabageser, and Sylvia Tamale.[58] Women are far more visible in leadership in Uganda today than they were in the past and there is a broader public awareness and acceptance, even at local levels, of the necessity of women's involvement in forums of decision-making.[59]

However, this environment is not without its challenges. Years of struggle by women activists have yet to result in the successful passing of a Domestic Relations Bill to protect women's rights in relation to "issues of inheritance and succession as well as the regulation of polygamy, payment of bride price, and the age of marriage."[60] Such a bill is deemed essential to women's empowerment and ability to engage more equitably and effectively in their own development as well as that of the country. This is of particular significance given that Uganda has ratified the Convention on the Elimination of All Forms of Discrimination Against Women (CEDAW), as well as other

related international conventions and protocols, yet appears to not have the political will to integrate such commitments into a national policy.[61]

Ugandan women activists observe a diminishing level of commitment and support by government for women's issues. This is paralleled with increasing constraints on democracy in the country as Museveni employs more desperate measures to remain in power. It is also evident in the dramatic downsizing of the Ministry of Women in Development that has, since 1999, been subsumed within the Ministry of Gender, Labour and Social Development.[62]

Against this backdrop, and in response to the violence of the numerous conflicts and civil wars that characterize Uganda's history, the Ugandan women's peace movement has emerged to protest and advocate for an end to the insecurity in various regions of the country, to educate and raise awareness of the effects of violent conflict on women, and to demand a voice and place for women in the male-dominated public forums and peace negotiations. This they have done through demonstrations, conferences, workshops, and many individual acts of courage.

The first mass organizing by women for peace in Uganda was in 1985, by the National Council of Women, after the coup that put Tito Okello in power. Two thousand women demonstrated in Kampala against the heightened insecurity and violence particularly perpetrated against women by the military.[63] In 1989, "when few others dared to speak out about the conflict,"[64] the Gulu Women's Development Committee organized a protest in which 1,500 women, in mourning attire, marched through the town for five hours chanting funeral songs and blowing funeral horns, causing the entire town to weep over the atrocities of the war.[65]

The 1990s saw women's organizations start to work more concertedly on issues of conflict and the impacts of war on women.[66] Isis-WICCE has played a central role in this through training and capacity building among women, assisting with the setting up of local women's peace clubs and facilitating cross-cultural exchanges within the region. Its work in documenting the physical and psychosocial impacts of violent conflict on women and men

in regions such as Luweero, Teso, Gulu, and Kitgum has been invaluable in bringing attention to the on-the-ground realities of people's lives and invaluable in advocacy for services, for the protection of human rights, and ultimately for conditions of peace.[67] Uganda's women's peace movement has certainly benefited from this international organization being headquartered in Kampala.

Uganda Women's Network (UWONET) is a prominent national organization focused on networking and action toward "the transformation of unequal gender relations in society."[68] In 1997, together with the Agency for Cooperation and Research in Development (ACORD), it organized a peace conference in Kampala, bringing together stakeholders in the conflict in Northern Uganda. UWONET now coordinates the Uganda Women's Coalition for Peace, formed in August 2006 as a "coalition of women and human rights NGOs making contributions through lobbying and advocating for the inclusion of women and women concerns in the ongoing peace talks."[69]

Prominent Ugandan women have taken personal responsibility in championing causes of peace. Betty Bigombe, a former government minister, is perhaps the most renowned for her efforts in initiating peace talks between the LRA rebels and the government and in working tirelessly since 1988 in official and unofficial capacities within these negotiations.[70] In November 2006, a coalition of Ugandan women carried the Women's Peace Torch in a five-day journey from the parliament in Kampala to the site of the peace talks in southern Sudan, symbolic of the need to include women's experiences and perspectives.[71]

In addition to the many national organizations and initiatives, there are numerous women's peace groups and initiatives at local levels. To name just a few, there are the Lira Women's Peace Initiative (LIWEPI) in Lira District in the north, Participatory Rural Action for Development (PRAFORD) in the northwest or West Nile, Teso Women Peace Activists (TEWPA) in the east, Luwero Women Development Association (LUWODA) in Luwero District in central Uganda, Kitgum Women's Peace Initiative (KIWEPI) in the northeast, and Kasese Women's Peace Initiative in the west. These or-

ganizations work in communities to mediate interpersonal disputes, assist in reconciliation rituals, provide civil education on government policies such as the Amnesty Act, offer safe havens and counseling to those who have escaped from the rebels, provide vocational skills training for ex-combatants, document women's stories, and build coalitions with women across districts and regions that are in conflict.[72] Local women's groups are frequently at the forefront of grassroots peacebuilding initiatives. These initiatives often create an enabling environment for more formal, publicly recognized interventions or negotiations.

Local women's groups are known to use singing and drama to convey their peace messages. Acholi women, for example, have sung songs intended to be heard by the rebels in the surrounding bush, many of whom are their children. These were songs asking them to come home, and reassuring them of the community's acceptance and forgiveness if they do. Such messages contributed significantly to shifts in the relationship between the rebels and local communities.

As well as women's organizations, there are a multitude of individual women engaged in informal peacebuilding activities—"mobilizing communities, creating opportunities for dialogue and non-violent means of conflict resolution, as well as mending the ripped fabric of society."[73] It is these women's stories that still need to be heard. As a report on women's peacebuilding notes, many of the peacebuilding efforts of women in Uganda are undertaken in conditions of great danger and difficulty but remain almost entirely invisible to male leaders in the region and do not appear to be recognized at government levels at all.[74]

Gathering the Stories

As I set off to gather women's stories in Uganda, I was aware of various issues that would have a significant impact on the process and outcomes of my research. These were issues of *positionality*—both mine and the women I would interview; *power*—reflected both in post-colonial race relations as well as in the researcher–researched relationship; and *voice*—in terms of how I

would choose to present both the women's voices and my own. All of these I explored through ongoing reflective journaling over the course of the research. These were not issues to be definitively resolved; rather, they were to be grappled with daily in lived reality, sometimes leaving me straddling uncomfortable tensions.

Like any other individual, I have multiple identities influenced by historical, social, cultural, political, economic, and environmental contexts. Some of my identities define me as a single woman, in my late thirties, without children; as an English-speaking, white Canadian; as a child of missionaries, raised in rural areas of Zambia, Kenya, and Canada; as being from a Christian background; as an academic; and as a rural planner. Several of my identities gave me much cause for self-reflection throughout the research, as they were the basis on which I was given access to and invited into relationships with the various women I interviewed. Their complexity was ever present as I grappled with being of Africa (having been born and raised there) but also of Canada; with being a woman but not an African woman; and with being a researcher but also a close family friend of some of the women. The interplay of these identities with those of the various women is manifested in the process and content of the interviews as well as in our ongoing relationships.

The selection of research participants was an emergent process that took place over some time. It drew on personal friendships as well as new acquaintances, and it involved prearranged introductions as well as cold calling. It was in some circumstances a natural connection and in others a forced fit. In some instances I had heard stories about a woman from a close friend or relative prior to meeting her. In others I had heard a woman tell some of her stories to me as a family friend. In still others I had hope based on little more than an inference and a phone number. I began with a general desire to seek out women engaged at the community level (the level least often profiled) who would represent a diversity of peacebuilding approaches and experiences. I also had a basic conviction about working with women who speak English, so as to avoid the distortion of meaning inevitable in transla-

tion. Other criteria that came to influence my selections were: whether I had a reference for the woman by someone I knew, thereby facilitating an introduction for me; her level of interest and willingness to talk with me; our rapport; the respect for the woman in her community; the type of work she was involved in and my interest in her work; regional representation of the Ugandan context; and the security and accessibility of her region and home.

The five women selected ranged in age from thirty-five to seventy at the times of the interviews. They have all been formally educated, most beyond secondary school. As such, they all speak English, though with varying levels of competency. Four make their homes in rural areas, and one in the capital city. Two are retired; one has a disability and so works from home; another was between formal jobs and so busied herself in development within her village; and the last is actively engaged in running her own NGO.

Relationships were central to the success of the research, both in terms of gaining access to the women's lives and the depths to which the interviews would be able to go. Significant time was spent in cultivating relationships with each woman. This often began with a series of interactions, either in person or by phone, over the course of about a month. During this time, I was introduced, explanations were made about the research, an initial agreement was established, and dates and logistics were discussed for when I would visit the woman. In one case this process did not happen and all of these elements were condensed into our initial meeting. This particular approach was decided by the person making the introduction and led to challenges in establishing agreement and rapport over the course of the interview. In most cases, I then spent about a week living in the woman's home or village—eating local food, sleeping in local homes, participating in daily life, interacting with family and friends, and getting a sense both of the woman and her environs.

Elements that were important in establishing rapport in this context included the fact that during the research I lived with my sister who works in Uganda and so I was seen as part of a family context; that I have very personal relationships with two of the women's family and friends who live in

Canada and who therefore provided invaluable introductions;* and that, due to my upbringing in rural Zambia, I have a knowledge and experience of traditional African culture that makes me comfortable in such settings. The comfort of a white person is a great concern, and often a significant inconvenience, in most rural African villages.† Expressions of surprise and veiled relief were common when my willingness to eat local food and live in local conditions became evident. In other far more subtle ways, my ability to navigate Ugandan cultural norms and English idiom facilitated my interactions and made people more comfortable with me as a white person. Such skills are acquired not through school but through life, yet they were essential in the overall process of my research. As I reflected in my journal (in the following pages, journal entries are italicized):

So much is dependent on my way of being with people, my way of communicating, even just my presence. So much is drawn from this, so much observed and assessed and yet this often without me knowing. Perhaps it is done unconsciously yet it so consciously affects the ensuing process and, for me, the ultimate outcome in terms of my research.

Another level of conscious and unconscious rapport-building that I was keenly aware of was the role of proper introductions. Introductions are critical within the African context—an element drawn from traditional culture, for *"who I am is not just about me but about who I am in relation to others in my life."* Introductions by a respected third party have the power to open doors and make walls crumble or, conversely, bring out reinforcements. As a

* I spent two years as a primary caregiver of the nephew of one of the women prior to his untimely death in 2002. I am also considered part of the family of close friends of another woman. With this family, in 2005, I played a significant role during the illness, death, and burial of the father/husband, a man highly respected in his region in Uganda.

† Such concerns hearken back to colonial times when African people became only too aware of the lifestyle expectations of whites, but they also reflect an awareness of the privileged lives many whites currently live in Uganda. With African culture placing high value on welcoming a visitor, people often go to extraordinary efforts to provide conveniences for a white person, such as heated bath water, soap, a towel, a bed with sheets and a blanket, a mosquito net, milk for tea, and even meat to eat, which may mean slaughtering a chicken or goat. All of these are at a cost to a local family, a cost often not easily recognized by most white people for whom such "luxuries" are a norm.

white person and one unknown in this context, with limited time to spend in the country and with no long-term relationships on the ground, I knew how critical introductions were to my work. As a starting point, those provided by my Ugandan and Canadian friends provided unimagined access to some of the women's lives. Another, by a university professor to one of his female relatives, created an openness from her that was a response less to me than to her respect and relational obligation to him. Where possible I went through others, but where none were available I took the risk of introducing myself and, surprisingly, due largely to the personalities of the women, I was well received.

Such observations and reflections on my experiences were recorded in a journal. Journaling gave me insights into my own process of changing perceptions and understandings. I grappled not only with the research, but also with ongoing issues and tensions around identity, race, privilege, cultural norms, decolonization, women's lives, and voice. Such musings would inevitably inform my involvement with the women in their interviews.

I was ever attentive and aware, constantly assessing my words and the necessary actions (or inaction) to move us together toward the interview. Perhaps in a sense it is like a dance—and each woman dances differently (and differently with me). My challenge is learning quickly how to adapt to and follow her dance moves, to subtly insert some of my own so as to gently guide her, but mostly it is to trust and follow her in her own direction. Perhaps in this way we are engaged in co-creating the dance—our dance. And so far, in spite of my anxiety, what has resulted has been beautiful—actually quite magical, I must say—much to my own surprise (and relief!) each time.

The way stories get told, questions are asked and answered, and the direction that responses take is an ongoing negotiation between the researcher and respondent.

I had to spend a lot of time just sitting and listening before even broaching the topic of the interview. It was also important for me to know their stories so I

could ask appropriate questions or prompt them in the interview if certain
points or stories that I'd already heard didn't come out on the recording. I knew
where I could take them because they'd already taken me there in previous story-
telling sessions. And also, often the stories they told before the interview were
longer and in more detail while in the interview they seemed to consciously edit
them down as part of their whole life story. Thus the interview became a con-
densed version of several stories all linked together. This they could do because
they had already told me the detailed version. It would not have worked any
other way, for I expect it would have inhibited their willingness to talk and to
get to know me or introduce themselves to me in a relaxed manner.

While researchers will often probe more deeply into the storyteller's
feelings and emotions, I found myself needing to proceed with caution for,
in contexts of war and violence, life stories inevitably contain experiences too
painful to put into words. After one interview I wrote:

She would talk of these things and then fall short of finishing all the de-
tails because the memories were visibly painful. It was this pain I wanted to
respect. I did not want to be, as it were, probing at a bleeding wound simply for
the sake of my own curiosity and lack of exposure or experience ... so I tried to be
general and gentle in my asking.

It was important to trust that the storyteller would tell me what she felt
comfortable telling about her life at that time and in that way. I learned that
sometimes silences must be respected.

Once each interview was written up or transcribed, depending on the
original method of recording, it was given back to the woman to read
through and edit or add to. I then followed up with a visit during which each
woman inevitably wanted to read through it with me page by page to affirm
or explain her edits. Minor details such as place names, dates, and spellings of
names were verified at this time. All the women were excited to see their
words in print and often exclaimed at what had been produced from them
simply talking. One proudly called it her "novel," showing it off to relatives

and friends. Though offered the option of using a pseudonym, all the women preferred to use their own names. Their stories have been lightly edited for clarity and concision.

CHAPTER II
Joyce Jermana Minderu Pol-Lokkia

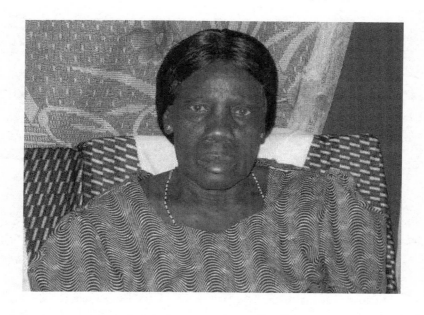

MAMA JOYCE'S STORY emerges out of her life in the north of Uganda, initially in Lodonga, in the West Nile Region, and then in Gulu District. Gulu District is in the Acholi region of northern Uganda, a naturally fertile and productive region inhabited primarily by the Acholi people. This, however, is also the region most affected by the twenty-year civil war that came into focus internationally because of the plight of thousands of children commuting nightly into the town of Gulu to avoid abduction, death, or mutilation by the LRA rebels. Ninety to ninety-five percent of the population was displaced, with 1.9 million forced by government forces into camps for internally displaced peoples (IDP), where movements were restricted and dependency created on humanitarian aid after people's cattle and livelihoods

were destroyed. Over 20,000 children were abducted by the LRA and used as child soldiers and sex slaves.[75] Many members of the population underwent horrific mutilation: LRA soldiers cut off lips, ears, noses, buttocks, arms, and legs. This was in addition to the destruction of infrastructure such as schools and clinics, the inevitable socioeconomic decline of the area, and the devastation of social structures and cultural values and ways of life.[76] Given the national and international disinterest in this war, it was described by Jan Egeland, then UN Undersecretary-General for Humanitarian Affairs, as the "worst forgotten humanitarian crisis in the world."[77]

The LRA war was between the rebel forces of Joseph Kony and the Uganda Peoples Defense Forces (UPDF) of the Ugandan government, with support from the United States, northern Sudan, and the southern Sudan People's Liberation Movement/Army (SPLM/A). Its roots lay in colonial policies that created systemic inequalities between peoples of the north and south of the country—designating the south for cash crops and industrial development and the north as a labour reserve, favouring southerners (mostly Bagandas) for the civil service and northerners (predominantly Acholis) for the military.[78] Subsequent regimes perpetuated these disparities and further fuelled the ethnically influenced political rivalries, leading to atrocities on all sides.

Rebel opposition to the current government began soon after its installation in 1986. The current rebel movement claims to have taken over where the "Holy Spirit Movement" of Alice Auma "Lakwena," a spirit medium, left off when she was defeated by the army and went into exile in 1987, where she died in 2007.[79] Kony, himself a medium, used distorted spiritual principles to justify the actions of the LRA and their motivation for fighting. In contrast to most conflicts, the LRA targeted not only the government military but also fellow Acholis. This made the involvement of the larger Acholi community essential to any attempts at negotiation or peace talks.

The Juba peace talks were halting and tenuous but offered the most hope for an end to this civil war. Since late August, 2006, this region has experienced relative peace, with the rebels withdrawn to neighbouring coun-

tries as a condition for the talks. People have begun to try to pick up their lives, to go back to their villages from the camps they were forcibly confined to for years, and to cultivate food crops.

It is in this context that Joyce Jermana Minderu Pol-Lokkia lives and where she has survived with her family for the duration of the war.

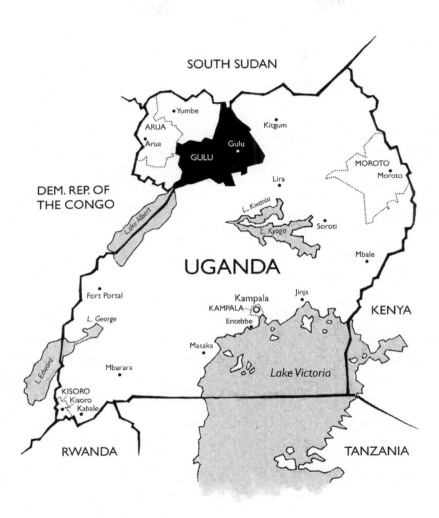

Introduction

Sunday I went over to Kisaasi and, while there, Ayiko's aunt from Gulu arrived. This is an aunt I have heard so much about because she has had no children of her own and yet has raised so many other people's children who have been in need, taken in children affected by the war, got them to safe places and looked after them. She arrived from Arua, where she is apparently helping supervise the building of a house on a plot that her brother Peter is developing for the family in their home village of Lodonga.*

Mama Joyce, as she tells me to call her, is a very tall and well-built woman in her early sixties. She has a commanding presence. She's obviously a strong woman. At first she was a bit distant but gradually, to my surprise, she started talking quite openly—little bits of stories thrown out here and there ... stories of life during this war ... stories of the children she's raised ... stories of her own life.

Over the next few months, I met with Mama Joyce in three very different locations and contexts, each of which influenced her stories and how she told them. Our first meeting was at the family home in Kampala where she had come to visit some of her nephews. The first section of this chapter is my summary of and reflections on the stories she shared then. Next I met Mama Joyce in her home village at Lodonga, in the West Nile Region. We met in a mud-walled, thatch-roofed hut. Here she told me her stories more formally, in the company of her younger sister, Mary. Some months later, I visited Mama Joyce at her home of displacement in Gulu, also a traditional village, where we edited the transcript and she elaborated on certain of the stories.

Mama Joyce begins talking. She tells me how her parents did not have money to pay for her education. Yet she managed to go to school and told herself that, if she managed to finish school, she would educate her younger brother, Peter, so that he would be a "pillar" in the family—"and indeed he is." Peter has now worked for the UN in Somalia for many years and is the only significant

* Ayiko is a long-time Ugandan Canadian friend of mine. I first knew his older brother, Mo Waiga, who Ayiko and I nursed for two years during his hospitalization before his death in 2002. Because of my involvement, the extended family has known of me for several years and I am warmly welcomed in their homes.

wage earner in his extended family. He pays for the education of numerous chil-dren, as well as their upkeep, and periodically helps out his two sisters, Joyce and Mary, and alcoholic brother, Natali. Mama Joyce says that all that he has was built on her back. And it's true. Because of this woman's efforts to educate her younger brother, an entire extended family survives and progresses and is held together. He appears in the forefront because he's the breadwinner, but actually it is she who was behind him, supporting his education that is the foundation on which this whole family stands today.

Mama Joyce was then educated as a social worker. But when she went to work in her home area, she was poisoned. I assume this was because of the usual jealousies—of her being successful. Such jealousies are such a disincentive and certainly do not encourage the development and advancement of areas or re-gions. She then decided to leave that area. She married an Acholi man she had met in Arua and moved to his area in Gulu District. At the time she didn't speak Acholi, so had to learn. But she says it wasn't difficult because, as a social worker, she is talkative. People came to know her and love her, and she learned quickly.

She told me that before she married she told her husband that "you are marrying me and not my paycheque," and she made him sign something like a prenuptial before they were married. I exclaimed and we both laughed at how incredibly strong she was. She was way ahead of her time. She laughed so hard—she knew exactly what she was doing.

When she moved to Gulu, she "didn't have a chicken or goat," but then she and her husband decided to "cooperate on some things," which I assume means pooling resources, and managed to eventually have a lot of cattle, thereby ac-quiring significant wealth. This was until the government soldiers came and took all the cattle, throwing her and her husband into instant poverty. I imag-ine it'd be like someone coming and emptying your bank account all at once. Bankruptcy! What this woman has seen in her life is incredible. As she herself

said, she has "not enjoyed at all in this life yet." And what can I say? Nothing. I am quiet (out of respect for her pain and suffering).

She tells me how she was not able to have children ... of how God has punished her ... and in the next phrase of how God loves her and how she is to love God. She talks of there being a curse by their uncles but of how her father raised them as devout Catholics so they had no knowledge "of those things" (curses) and so didn't know what needed to be done. I wanted to ask more about this, but felt it was a sensitive subject since I know that in Africa not having a child is a disgrace and can lead to a life of being talked about maliciously by other women. It can also lead to a husband abandoning a wife, or at the very least taking another wife who is able to give him children. So I can only try to imagine the hardships of her life because of being childless. She said her husband was, fortunately, a kind man. He did not leave her and she told him he could "get another woman if he wanted," meaning traditionally marry another wife in addition to her, to try to have children.

She said when her brother Peter's wife died the children were too young for him to look after by himself and so she felt she had to look after them. Her husband's family initially resisted, but she defied them and told them she was leaving to go to her home area to look after the children. Her husband's people wrote a letter telling Peter that, since they had helped to raise and educate him (through her and her husband's combined resources and effort), his children were also their children so they should come there so they could look after them. This is when the children came to live with Mama Joyce.

As a social worker, she worked with the Ministry of Culture and Community Development* and had worked a lot with women's groups. She said the women really liked her. Her husband, too, had been a social worker. He had died in 1995 due to kidney problems. She told me he had been a good man to her but also that since he'd died she'd been "a bit freer," probably no longer hav-

* Now the Ministry of Gender, Labour and Social Development.

ing to fulfill the "wifely" expectations. Though she retired last year, the govern-ment has not yet given them their retirement packages, so she has no income and that is why she is now helping her brother to build in Lodonga.

She told me how she was also a politician. She had been an LC5 for ten years (an LC5 is a local councillor at the highest local political level) until fi-nally she told them: "People, I am tired, let me rest." But I could tell she was proud of the fact she had been re-elected so often. She told me openly how people loved her, and how she worked for women's issues and how those women loved her. It is significant that a woman of her age and from the north would be so highly educated and would be elected to such a political post, especially as she was not Acholi.

It's important to mention that she is Lugbara by language and tribe and is from the West Nile Region in the north, thus the significance of her marrying an Acholi and having to learn their language. However, her own mother was brutally murdered by the Acholis during Obote's time. They killed her with a bayonet inside the church where she had sought refuge. When this happened, Mama Joyce wanted to leave Acholiland and go back to her home area, but her husband said to her that it wasn't him who killed her mother, that he is not all the Acholis. And this she told me as she was saying that many people don't like the Acholis because of this war and they fear them, but that not all Acholis are like that; that they are like all other people in that there are good ones and bad ones and it just depends on their heart and that you have to come to know them. This is so hard to fathom—your mother killed by the people of your in-laws, the people you live amongst, the people in whose home area you are an outsider and perhaps thus have reasons to fear, the people you still continue to help as a social worker.

Joyce has lived in Gulu District, one of the hardest hit in terms of the rebel attacks, for the whole of this twenty-year war. As we sit together now in silence, each reading one of the daily newspapers, she petitions (to no one in particu-lar—or maybe to God), "Let this war end. People have suffered too much al-

ready. We have suffered enough." Such phrases come from her often ... they come from deep within her ... they come from one who has seen and experienced things she will never be able to describe. Even now, she begins to tell of an incident and her voice trails off, the words lost in memories too painful to be spoken.

JOYCE POL-LOKKIA FAMILY TREE
Names in bold are mentioned in the book.

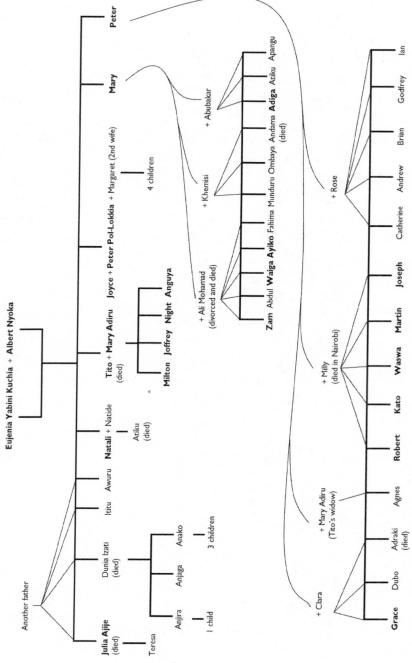

Joyce's Life as She Tells It

Family History

My father's name is Alberto Nyoka. We were born in Lodonga, Parish Iyiba, Division Kuru. By that time they were calling this area Kuru Division but now it is created Drajini—when they divided these districts. So my father comes from Renda; the clan is called Renda. His uncles are Kakwa. He is from Koboko. And my father was only brought up by his uncles because my grandmother was killed when he was young. He has no sister, he has no brother. He was only one. He grew through difficulties at Koboko.

When he grew up he joined his people. He said, "I cannot get married in my uncles' place." Because here, if you marry at your uncles' place, then in future the blame will come to you.* That means his clan, they are not interested in him. So, he came here when he was mature and he came and joined these missionaries. He came and settled here and he got my mother. My mother's name is called Eujenia Yabini Kuchia. Three names, but the home people call her "Kuchia."

First, my mother had two children with a certain man who married her. Then that man left. He just took off; he went to Kampala for these sugar works [sugarcane factories]. Always they used to collect the porters here. He stopped there; he didn't come back. So when my mother came to the mission, she wanted to become a Christian. And then she got my father. My father had no wife. Then the priest advised them ... because he knows that these people are humble. My father said, "Maybe the husband will come to disturb me." Then my mother said, "There's nobody who can come to disturb." Then they got married in the church. Then they started to give birth. They got nine children ... with my father we were seven ... but then, plus those two [earlier children] ... all of them, they were brought up by my fa-

* "Uncles" in this context refers to the brothers of one's mother. Culturally, a person belongs to the clan and tribe of their father. In any significant life issues requiring the involvement of cultural elders—such as marriage—a person may be held responsible for not involving the appropriate people from their clan. This is a serious issue for any children who may be raised by their mother's people due to the death or absence of their father; connection to their father's people is imperative.

ther. They started to stay together. They were humble. They would never fight in front of us. Except, what we have experienced in our family was poverty ... because there was nobody who could assist him. But God gave us intelligence; we were intelligent. But otherwise, I wouldn't even reach up to this stage.

Struggle for Education

I didn't study further. Because during those days we just stopped at P6 [Primary 6], then you go for training. I was supposed to go and join Junior* so that I go for teacher's training or my aim was to go further. It was one of my uncles who said that since I am bright then he can pay school fees for me. Then we went to him and he said, "Oh, I've got some brothers of mine, I will just bring them up. I cannot continue. What I said was just a suggestion. But now, since I have too much to do in supporting other relatives, I cannot help you." He was a headmaster. He was even having these grinding machines.†

When I heard that message, I said, "Father, let's go back home." The man said, "Let these people kill for you this cock so that you eat."‡ I said, "My father, let's go. Let them eat their cock. For me, I am now disappointed. Let me go, 'cause I know God will lead me." So we left that place. We took off from there. I said, "Let's go back. Whether we will be eating grass, let us go and suffer together."

So, I stopped there [at P6]. Then from there, the Catholic Sisters asked me my interest. "If we ask you to go and join this course of nuns, to become a reverend sister—what do you think?" I said, "No, I cannot leave my mother." Because I really love my mother too much. I said I cannot leave my mother since she's poor, she's suffering, she lost all. I was born after all those four girls passed away ... then Natali was our elder [child] now.

* In those days, the school system was organized such that students started in Primary 1–6, then went to Junior 1–3, then Senior 1–4. It was possible though to leave after completing the Junior levels to enter Teacher Training and other technical training institutes. Nowadays, the primary school system goes from P1 to P7, then continues from S1 to S6 for high school.
† By saying this, she infers that he had a certain amount of wealth—with the salary of a headmaster and income from a small grain-milling business.
‡Traditionally, a chicken is killed and served to a special visitor.

My father really loves me much, and also my mother. So they said, "Can you go and join teacher's training?" I said, "I can go, but my problem is I don't know who can assist me with my school fees. So let me just go." Because we were just brewing these local beers. We'd sell, but during those days money was just too little so I couldn't get much money. And my brother [Tito] who was trying to assist me—he was the father of the late doctor [Dr. Milton*] and was also following me; he was in P5 at that time. So I went to Moyo for teacher's training. From there, I finished ... I think it was first term.

By that time our elder sister was married somewhere. She's called Julia. So Julia was sick at her place [at Moyo]. Then I came for the holiday. Moyo is just near. When I came, I had only a sheet. Then the message came that my sister died. And the husband was fond of saying that it was my sister who killed herself—that she was a wizard, what.† I said, "How can Julia become a wizard?" I told my father, "Even if I have nothing, I'm going to suffer but God will help me. You take this bedsheet of mine, you go and bury my sister if they don't buy her any clothes." Those people went. "But you tell them, since I'm young but this is going to be a blessing to me. If my sister killed herself alone, she will stay in the grave alone but if she did not kill herself, the one who poisoned her, they will all follow her. God is going to be there." They should not judge anything before. So these people went and buried my sister with my own bedsheet. So from there, I went back to school. There was nothing I could cover myself with. So what my prayer is, "God, just you give me ... let me suffer ..." I had no mattress. Just I would sleep on the mat. So I just had one uniform and one dress. Then that ordinary dress, I would just put it here and lie in it. So I suffered for one year. I passed. I said, "Who is going to really lift me up with the school fees?"

* Dr. Milton was the son of Mama Joyce's brother, Tito, who died. Mama Joyce helped raise Milton. When Milton completed medical school, he was the pride and hope of the family. Unfortunately, he had contracted HIV/AIDS and died soon after his graduation. This was a huge loss to the whole family.
† In Uganda, the word "what" is commonly used at the end of sentences either to imply "whatever" or in place of "etc."

Then Sister said, "Since there are no school fees, if you were to pass, you can go for this supplementary course for a teacher. You become a teacher. You teach for at least five years. Then, when you get a chance, with the little money you have saved, you can go for another training." So I accepted. So we were sent to Gulu. I went to join that college. Then the Sisters also assisted me with some sheets, because when we reached there, they also knew my problem.

I went and got my brother [Natali] there in Gulu. He disappointed me. He said, "Oh, so your parents have sent you here so that I can assist you. My little money that I am getting from my work is for me. So to hell with you." [*She laughs.*] He just disappeared and went and transferred himself to Lira. I told him, "My aim was just to come and see you because we lost you in our family for a long time. If this is the life, I'm not coming here."

So I was in the school in Gulu. During the holidays I could not come home. I was made to work with the Sisters. At least the life became easier. Then I was made a head prefect. Then I became a bit happier. So what little I could get, I could keep it for when I go back home, for transport. I finished a year. That was a one-year's course. Then I passed the exams. The inspectors came. We finished our finals. I was the best. So I said, "God, you know what you can do for me." This was my way of thanking God, for appreciating what he has done for my life.

Then, when I came back, by that time Peter was in primary. Mary was also about to finish. She was so bright. I said, "No, with my little money, we'd better send her to the Junior." Then, since they were two, the problem comes. She went and joined the Junior Secondary and she did at least, I think, two years. Money was becoming difficult. Then Peter was also going. Then my brother Tito also said, "I'm not going for school since there's no money." Tito stopped in P6 and then he joined the army. Before he left for the army, I went and I kept on teaching. Since the salary of supplementary teachers was so little, I couldn't make much development ... since at home here I had to see that my parents, at least they get something. My mother could not work at the fields because they put a certain poison on her grind-

ing stone. My mother caught the poison and one side, her left arm, was completely paralyzed. So I could see the suffering of my mother.

Through further struggles and without the support of her elder brother Natali (who culturally is expected to help if he can), Mama Joyce successfully graduates as a teacher and returns home to begin supporting her younger siblings in their education. Eventually, however, with her limited income, she is faced with a difficult choice. Who is a better long-term investment, her sister Mary or her brother Peter? She chooses Peter and hopes one day he will help her carry the burden of developing their family.

Community Development Worker

So then, after I taught for five years, before I came for holidays, there was a workshop, training for these volunteers or community workers. These were part-time workers assisting community development workers. I wanted to go and see what these people are doing. So, I was good at doing handcrafts [*pointing to a woven mat*] and then teaching adult education for women. When you teach a skill to someone, you're also sharing education. So I went there for the whole day. I joined those people. My things were best. Then they asked my interest: "Suppose we asked you to go and join the real community work, would you accept?" I said, "Why not?" So I said, "I can do it." Then they called us for interviews. We were taken up to Gulu. From there we did the interview. I passed. Then the inspector here gave me the recommendation ... because, as a teacher, if you are not released from the Ministry of Education, you cannot join. When they gave me the recommendation, I went.

So I started to join the Ministry of Culture and Community Development, as by that time it was called, and I went for training as a Community Development Assistant. The course was done at Entebbe and I did it for a year. I got a certificate and then I started to work. I was brought here to Lodonga. There is a skeleton of a community centre—I don't know whether they have retiled it—it was destroyed during the war time. They employed

me. They brought me to my own county. Then I was in my county at Yumbe in Aringa County. They used to call it Aringa County. So I was here.

From there, I kept my money. Because, when you did the interview, the best thing in community development was that you start your salary when you're in training. You train in service. So I was getting my salary. I came back with a bicycle. I bought a radio. People were saying, "You are really funny. You don't want to buy so many clothes." I said, "These are not my aim. [*She laughs.*] So long as I have got a few clothes, if I keep them very clean, they are enough, because I am not from a rich family." Some people, their girls were proud. Some of them, they were running after men. I said, "No, this is not my aim." I said, "God should really give me money so that I can raise this standard of our family." See, it was my plan. "So what I'll do, I'll make sure that I have achieved but at least now things are coming up."

Community Jealousy and Poisoning

So I came to Lodonga. After I had worked I think three months, people became jealous. They said, "Eh, this is the home of Alberto? I thought that those children of Alberto did not eat on a table. Now they are starting to eat on tables. This girl does not like to go and get married. She's here." So they poisoned me. [*She laughs.*] The reason why I "ran" to Gulu was because they poisoned me.

My father had these local medicines. That local medicine, he came and rubbed it so that thing [the effects of the poison] was not itching me. He said that, "This is poison. Don't take her off to the hospital." They started applying those "drugs." When you start feeling cold, you start feeling a terrible, severe headache that you think is malaria. Then when they apply that medicine, it does not itch you. That indicates that is the poison ... so it is dangerous to take treatment. If it does not itch you, when you are taken for medical treatment, they are going to inject you, that is the end of you. So I was feeling something like when you are feeling too cold. So they started to rush with these local medicines. They give me, some I take, some I vomit. Three

months I was down. My mother was almost going to die because of too much thinking. I said, "God is great. I will get up."

Then, after curing, I went to the office. I said, "Sir, if you have sent me to work there as a punishment, I cannot go. Because in our tribe, you can't work at your own place. People are jealous of me. But they pretend to be happy with me. I will not stay here." And then they transferred me to Vura County. From Arua town to where I'd been teaching is seven miles away. So I was transferred there.

Marriage: "Prenuptial Agreement"

So when I went there, that husband of mine was also brought to work at Vura County ... because in counties, people used to work one female and one male. We got used to there and then we were staying together. There were so many men who were running after me. I said, "No." Some were just near here. I said, "No, I don't want. I will be poisoned again. It is better if I go far away. I can assist my parents. So long as that man will accept my ideas, my promise. If he does not, I will just say that, 'You go and look for another one—not me.'"

Then after, when the man paid the dowry, I just told him, "Before we go for 'introduction' at my home,* I need for you to answer me my question. You know I am from a poor family—you have seen. I want that young brother of mine to be educated. If you accept me, my salary I will use it for paying the school fees of my brother—that will be okay. So if you accept, that's fine. The notebook, just get and sign. If you refuse, you go and marry your own tribe. You know how men are disturbing me. It is me who refused to get married because there are so many whom I could get married to here." Some were government workers, one was a bank manager. I said, "No I will not do that. I know some of our tribes; some of them are after money. Even

* "Introduction" refers to the traditional marriage ceremony during which the young man is introduced to the family of the young woman, negotiations are discussed between the families for the bride price, and, upon agreement, a big celebration is held before the woman goes to join the man in his home.

though he's rich, I don't want. So I accept this one who is poor. Let me just go."

So the man said, "I will not disappoint you … because I am part of your family. I will not disappoint you. I know because I have studied you. You are good. You are going even to assist my family. Why should I refuse?" So he signed my agreement of paying for my brother's school fees with my salary. Because my salary is not his money! After he accepted, then he called his people. So they came after paying some things [for dowry], and then I said, "I don't want to remain here; let's go to your home in Gulu."

Barrenness

But I found that man was kind. I had no child with him, but he accepted to assist me with these orphans from my home—those children of my brothers, Tito and Peter. They were about seven, I think. He could look at them as his own children. So I said, "You are free. You can get another wife … because, according to your custom, when your woman is like this, the people disturb you. So I set you free. Let them talk but don't get annoyed. I'm a social worker. It is not me who refused to have a child. It was a curse from my uncles' side." (I've just learned it when I called for the funeral rites.) So that disappointment, my husband didn't show me. If he were to show his bad moods, he could just do anything that can disappoint me so that I just feel, "Uh-uh, this one, I cannot stay with him. Let me leave him for this woman." But there was no word of insult. We were happy.

Raising Orphans

During those times, we were not keeping all these orphans at home. So after, when my brother [Peter] lost his wife, the mother of those of Waswa, I really felt that loss. I said, "No, if that is the case, Paul, I think it is better I leave you, then I go to care for those children of Peter. I leave your family; I move to our home. If you feel that your dowry, you want to get it back, you just write any message and then I will send it to Peter … so that he can refund back what you feel you need. We call Peter as our firstborn because you were

the one who assisted me to educate him. Now I feel that really Peter is alone. Since my mother is now killed, I cannot ..." Then he said, "No." We went there to the funeral.

Peter brought his wife who died up to Uganda.* It was just a sudden death—only one day. So I said, "I better go and keep these children." There are five—'cause the first one is Robert, then the followers are twins—Waswa and Kato, then also Joseph and Martin. Martin and Joseph, they were young. So he said, since in Kenya there is much milk, he could keep Martin and Joseph with him because they were too young by the time their mother passed away. These two he cannot send them. He'd better send the three to me. And it was my husband's family. They sat down, they wrote a letter—without showing me. They said, "You, Peter, you bring all of those orphans to us." During those days we had a lot of cows, because, when I got married, with our part of salary we could buy cows. So we had eighty-two heads of cattle. So from there, then my husband accepted. They wrote, then Peter replied, and they brought these three.

And then here also were the orphans of Tito—Milton, Joffrey, and Night—then Peter's firstborn, a girl who is called Grace. Then I took them all. Peter got that girl, Grace, when he was in Senior 4.† So, I took them. They all grew with me. And the firstborn of Mary—Zam—she was with me. She went back when she was in P3. Then there's Anako, the third child of my sister Julia. Julia died when that girl was young. Then Angu, then also Regina. They were with me now altogether seven, plus those who were there before ... they are even more than eleven. So those children, I raised them up.

Living Through the War

And then war. When the war broke out, that was in 1986, those of Kato and Waswa, they were just young. And then those children, Night, Milton, and Joffrey, were the ones who assisted in cooking and looking after the small children. So they grew through difficulties.

* Peter and his family were living in Kenya at the time of his wife's death. Traditionally, Ugandans would want to be buried in their home area, thus Peter brought her back to Uganda.
† Senior 4 equates to grade 11. The Ugandan secondary school system is from Senior 1 to 6, equating to grades 8–13, although Senior 5 and 6 are similar to the British system of O-level and A-level.

So from there, when the war became worse, that was the time when they had at least reached senior level, secondary level. Kato was in Senior 2. Then Waswa was in Senior 1. Robert was in Senior 3. The rebels were collecting, abducting children in the schools, taking them to the bush. I said, "God, what can I do? These children, if I keep them there, they will just get spoiled." And once you are abducted to the bush, you cannot come back. You are spoiled. So I said, "No, I'd better take these children to Kampala." Then, from Kampala there, I called my brother [Peter]. So from there, in 1988, we took these children to Kampala. I advised my bother to build that house in Kisaasi. I taught these children; they know how to cook.

Certainly the work became difficult when this war became very serious. So we were driven away from the village. People were grouped in camps. The camps came later. At first, people came all to Gulu town. We were driven by government. They said that, if you stayed in the bush, in the village, that means you're supporting those rebels. It was really very difficult for anyone who was there ... especially me. I had no interest because, in the town you cannot dig [cultivate crops], you cannot do what. Then it became serious, but I had already transferred these children to Gulu. They were in Gulu.

Sometimes during holiday, I could just keep these boys with my friends who are in Gulu. They could just remain there. I tried my best. I'd come and see them. There are days for visiting them. By that time these children were in P2 and P3, P4. Then the problem became worse. Then sometimes if you come, they arrest you on the way. You are tortured. But God protected them.

The rebels have arrested me twice. I have experienced that one. We were made to be washed by rain, on the grass. Then at six they left us. Then we go. They warned us not to go to Gulu—"You go and sit there." If the government army gets you there, they will say you are rebels and then also you are killed. When, if each one gets you, ach ... It was terrible. That one was really terrible.

So, there were so many problems we were facing. The reason why we came to Gulu ... There was a day these government soldiers came. It was

around five p.m. These people came; they started to kill all the cows. They just collected some, they went with them. Then they started to fire ... all the villages, they were firing them. Eh, our area there it is a bit bushy. They were just firing bullets. So they set a granary full of g-nuts [groundnuts; peanuts], they just burned it. Then they started another one. There was a lady also who knows Luganda, my brother-in-law's wife. She was also digging there. She could stay with me. Oh, I just ran into the bush. I was just hearing those ... That woman was trying to defend my home because she knows Luganda.* She was a nurse. She got her education at Mulago.† That was when things became worse. After that, burning all these things ... I said, "Paul, I'm going to Gulu." I just packed. I just went. I was having first-aids for injecting my children. All these things were destroyed. They collected them. You know these army ... army are the best thieves. So, we left everything. We came with nothing. It was only this bishop who assisted me. So, things were terrible.

So we came to Gulu. The problem of money became bad. Then when Grace passed to go for Senior, there was nothing. What she took when she went to school, huh! ... she was also following me like my history problems ... my history. I gave her these pillows of this sofa ... because we had transferred those ones ... because we carried them. There was a chance. We went and found them and we brought them. I just gave her the pillows, the long ones, as a mattress. She said the girls were laughing. I said, "If they laugh, don't cry, don't wail, but let's see how time shall pass. Then, with my little salary, we shall get you another mattress." Sometimes, during war time there was no money. Ach, things were bad.

Then I started with the little money which the bishop gave me, I started to raise it. I'd buy these small-small fish. We started to sell it in the market. Nobody could know that I'm a worker—social worker. There people didn't know. They came to know that at the time when they called me to stand. I

* Luganda is the language of the Baganda, the people of the central part of Uganda, around Kampala. It is not spoken in the north, where Luo is the language of the Acholi people. The soldiers were evidently not from the north and must have spoken Luganda, thus the woman's attempt to reason with them in a language they understood.

† Mulago Hospital is the main government hospital in Kampala. It is also the main teaching hospital attached to Makerere University and thus graduates the majority of nurses and doctors in Uganda.

said, "I don't want to become a candidate, a politician. I don't want." Those are my own people at our division in Ongako—our division people. They came, they said, "Joyce is fit because she's a social worker. She will tolerate. She will know how to talk with this war problem. Because she can assess, 'If I say this, this can save my life; if I say this, this can help.'" So I was elected and, I thought I was only going to stay at Division level.

Election as a Local Politician

Then the woman who was supposed to represent us in the county level, to be a councillor, the one who stood LC5,* then they chose her to be a Member of Parliament. So that vacancy in my county was left. Then all the LCs in that county—(Because, since they know me I'm a government worker, I was a social worker, I was staying with them. Then most of them they come for workshops; I was the one teaching them with handicrafts ... they know me.) —they went and discussed this when I was not among them. They told me, "Now we have given that chance to you. You hide yourself. You didn't go for that election. You are now our Women's Representative for LC5." Then I said, "Now you people, you want to kill me or what? My mother was killed during the war, now you want me to die? Uh-uh, let me remain in Division." They said, "Whether you like it or not, you have to stand." So, they gave us the day of swearing. I went and did it. And so, I worked for five years. That is the first period.

Then, after that period, before the second election, I went to the bishop. I said, "You bless me. They gave me this one, this post. I don't know what I'm going to talk. God should give me the words, because my own words may be offending them." So what I've been doing in their county, it was assisting. Because I had experienced, being a social worker, when you are going to the community you have to assess what type of group you are going to talk with. Because usually all categories are there. Rebels are there where you are going to address the rallies—all those bad ones, the good ones are all there. But, what you are going to say, you should know. Because, some peo-

* LC5 refers to a Local Councillor at the District Level, the highest level of local government. The local system of governance in Uganda has five levels: the Village (LC1), Parish (LC2), Sub-county (LC3), County (LC4), and District (LC5) levels.

ple, teachers, they talk just careless: "Oh, these rebels are useless, what, what, what ..." When you talk against the rebels, you will find danger. That was when so many people have died.

Political Speech: Opposing the Policy of "Making Alarm"

During this time, the government was promoting a policy which would have local community members "make alarm"—make a loud noise—if they saw a rebel in their midst. This would alert nearby government soldiers, who would come and arrest the person. This was seen as a method of engaging the local communities in trying to flush out the rebels. It is important to keep in mind that the majority of these rebels were their own abducted children, family members, and members of their ethnic group. Joyce opposed this policy and spoke out strongly against it—at risk to her own life.

So, as a mother, for me, I know there was an easier road. I've been talking to people, humble. I said, "I am a mother. For a mother, a good mother will not divide her family into two parts. Being a mother, you may bear a thief, you may bear a drunkard, you may bear a good one. So, for me, all the people in my area, in my county, are all my children. The rebels are my sons. I'm the one who bore them. And all these government troops are mine. I'm a mother. So, nobody should mistake me that I'm a politician. I'm a social worker ... but I'm misplaced." [*She laughs heartily.*] People ... whenever I talk, they laugh. I said, "For me, I will not divide. I will not refuse those who are in the bush. Everybody knows why they are there."

There was a time when we were addressed ... that we, the community people, should accept that we should make alarm when the rebels come. Is this really a good advice from the government politicians? They said, "When the rebels come, you make alarm, you get *panga*s [machetes], you cut them." I said, "For me, I will say that, those children, they have been staying in the bush. They are wild because the rain washes them in the bush, they feel hungry, they don't feel happy. So, for me, in my county, I will reject that idea." This one we have refused it in the council. When the suggestion was

brought, we refused. We said, "No. The moment we shall accept with these councillors, the blame will go to us. For me, being a mother, I will not accept."

"Do you know why, if I tell you, do you know the reason why we are dying? Rebels, when the moment we make alarm, they will see that 'Oh our people have refused us.' You have got so many soldiers, why don't you fight with your troops? Why do you invite us, we civilians? You want us to fear? To be finished by our sons? They are mine! [*She chuckles.*] They are mine! I will not!

"When we refused, saying that this alarm should not be made in our district, they started to arrest us LC5s. We have been hiding. Now our chairman was taken and our MPs who supported us are arrested. Today I want to be a mother who could go and represent for that ... experience that prison. They are there and I want to go and suffer with them. Because in anything, when you are straightforward people mistake you to be a bad one. If somebody thinks that I'm going to follow their advice, it's not me, Joyce Pol-Lokkia.

"I know. I'm a social worker. I need at least peace. Those people [rebels] have been staying in coldness. They have been washed in the rain. They are very unhappy. And when they come to seek for advice to their parents at night, your LC who is in charge of security, he could just go straight to accuse the soldiers: 'So-and-so is around.' They go and ambush their home. Maybe he [the rebel] has come to seek for advice so that he comes out of the bush. And, going there, you just rush and then start bulleting that home. Such a person, if he escapes, he goes back, what is the revenge he is going to do? He will just come direct where those security people are. He will just start burning houses, killing, what. Is that not a revenge? And you are crying, 'Ooh, people are dying, people are dying!' You don't know the cause. The cause we are inviting, us with our tongue. I don't want to see disability in my area. You go and make alarm. You experience. Your hand which you are going to make alarm with and your mouth, they will cut it.

"I'm here to guide my people. I'm not Acholi. Let you know that I got married to an Acholi. But if I die here, they will bury me in the culture of Acholi. So I will never accept this alarm. For my county, I will never accept this alarm. You better kill me today." And so I stopped. People just clapped. When I talked, people clapped.

I said, "People are seeing me thin. You should not see me to be a 'slim'* lady. But I am not affected by AIDS. No, it is the sorrows ... because my people are dying. My sons ... I am losing many, and also ladies who are among them. Abduction is really a dangerous thing." So, I sat down.

So, those who accepted [the alarm], who were forced, saw in their area people died. You can see some lips are cut, some hands are cut. Ach, I tell you things were terrible. But, what I had said there, the rebels have got their radios. They have said, "If all the LCs were to talk like that Madi† woman. If we get that woman, if we were to know her, our rebels would never touch her, 'cause she's really for us." So, that was the reason why, after I'd said this, no cut was done in my area, nothing was bad in my area. After that period, people said, "You better come back and stand again." I was fearful. I said, "No."

After that period, I was called back to stand and I became LC5 again, with the advice of the bishop, because I said, "People are interested in me. I'm now fearing. How can I go back?" He said, "You go. We were born leaders. If you're a leader, you just go. I want to see whether you have been doing well in the system of LC." That was the reason why I went. And also when I finished that period, that was my end.

Mama Joyce completed two terms in office; she was a politician for ten years before she finally stepped down. This was during some of the worst years of the war. From her years of tenure, she is still known and respected for how she protected her people during this dangerous time. While not Acholi, she is ac-

* "Slim" is a colloquial term used in reference to a person with AIDS—as in someone having slim—because of the weight loss characteristic of the illness.
† Madi is a tribe in the West Nile region where Joyce is from. She is not Madi but Lugbara. The rebels may have assumed her to be Madi since she was from that region. They evidently knew she was not Acholi.

cepted as an Acholi, for she has suffered as they have and has led them coura-
geously as she has lived and raised her family among them during this war.

Gift to Husband on His Deathbed

So, what I've done on my side for thanking my husband—because he has done a lot for our family, I wouldn't forget—I said, "Paul, you have done for me a lot of things. You break and get prepared. I know this sickness may cure you or it may kill you." He was having kidney problems. "So what I've experienced, you are a Christian ... so, at least I need you to die in a good way. What do you say?" He said, "What are you saying?" I said, "I want you to get married with that young lady."

Because, after I had discussed with him,* he married a young lady.† God gave them children. I said, "I give you these cows; you just get married." When your husband works, with the money you get in the family, you buy a cow on his salary but they respect it as mine, because it was me who did everything for him, who cooked for him, washed the clothes, what. Those are your benefits as a wife.

So I said, "You get married with that one. Since God gave those children to us, in future they may assist me also. I need you to leave us in a good family, in a Christian way. What do you think?" The man burst with tears. He cried and since we were taught, when you are a social worker, when you hurt your friend, when he's weeping, you just keep quiet, let him ask you ... let him start questioning, then you'll answer. I left him freely. He shed tears. What he was thinking was not in my aim. That was one day. He refused food. We were just there ... I was in hospital looking for every food for him to eat but he refused to eat. [*She laughs.*] He thought this was a way for me to run away and abandon him in hospital but it was not like that.

Then in the morning, we were just discussing and then he said, "Why did you hurt me yesterday?" I said, "What have I done?" He said, "Yesterday, you decided to refuse me when I am sick like this. That means you are run-

* In "discussing with him," she was essentially giving him permission to marry a second wife so he would have the opportunity to have children.
† This refers to a traditional marriage and not one in the church.

ning away. If you leave me here, who is going to keep me?" I said, "Have you seen a sister who refuses her brother? Have you seen a mother who refuses her son? I'm going to keep you until the God will call you. What I meant, yesterday I told you I need you to offer the sacrament of matrimony, which you were supposed to do with me, now I turn it to Margaret, my co[-wife]. So I need that we should be one. I'm not running away from the family. But even if God cures you, when you have gotten married in the church, I'm going to be there as a mother of our family. I want to step down as a wife—not to run away from you. You've assisted me so much. Should you be such another man who used to really abuse, who used to say what, I wouldn't even keep on keeping these children here.

"According to some relatives of yours, what people have been telling me, sometimes you could just quarrel with them and I could just come and tell you that, 'Are you really a social worker?' But what people are telling you is the truth. God has given me that problem [of barrenness]. I'm not against it. I will not hate anybody's child. So, I am looking for my way to go to the heaven. I want to at least do something better on the earth. I'm not after these things for life. So, I'm not running away from you." So he said, "Oh, if that is the way, did you talk to the bishop?" I said, "Yah."

This bishop of Gulu was a man from our area [in Lodonga]. He's related to us. Their home is just near here. Bishop Martin Luluga. He assisted me with these children. From there [in Gulu], people think we are from the same mother. So even Peter knows, all of our family knows that he assisted me.

The significance of the bishop being from her home area and being related to her is that, quite apart from his clerical capacity, culturally he could be expected to advise her and, in lieu of a closer relative, represent her family in such a serious decision. Mama Joyce had anticipated all this and had already spoken not only with the bishop but with her brother Peter, the actual family representative.

So, I said I have discussed it with the bishop. He said, "Did you discuss with your brother?" I said, "Why not? He has accepted." I said, "I went to

him. I said, 'I want to do this, this—what do you think?'" He said, "My sister, if you did that one, so be an example. Even if he's cured, don't attempt to go back to him ... as a man, as a husband." I said, "I will not do such a thing, because I have been staying in darkness.* I was brought up in a Christian way. But when I found that things changed, because maybe he was not happy and the parents were advising him 'don't get married to this one in the church,' so I could not force him. Now at least I want to give that offer to that lady." So I said, "I want that if they get married, I will just change my heart and then I confess.† I will be okay." So, I advised him. He accepted.

Margaret said, in fact, that sacrament [of marriage] was not hers. She grew up as an orphan. When she came, I welcomed her and I offered the dowry, cows, to her family, to her father, and everything was done by me. And when she came she was young. She could sometimes disappoint me due to some jealousy. But she tried me in many different ways. Being a social worker ... She would never find a co-woman like me. In fact, I'm her mother. So, if that is the offer, she wanted to know why. I said, "The reason why is, I don't want to leave these children aside. So I'm sure he is going to leave us. So this one, I want you to become a woman for sacrament of matrimony. That one is on condition. We have to see him going happily. So he has assisted me, and these children, I will not leave them aside."

The priest asked her, "If this is the case, then are you a Christian?" She said, "I am a Protestant but I wanted to become a Catholic. When I was a girl I went for the catechism training. My father came and stopped me. So now I'm on my own and I can be baptized." I said, "If that is the case, then I can leave you with the catechist man. Let him teach you how you can confess." The prayers ... but she was okay because she was staying with us. We prayed as a family, so she was okay.

So he said, "If that is the case, you give us the name of who is going to be your mother of baptism [godmother]. And then who is going to be your wit-

* She told me later that "staying in darkness" is how it feels when you are not married in the church and so "cannot receive anything which is supposed to be done by Christians. Like Holy Communion, you cannot receive; you cannot go for confession."

† The concept of "confessing" is about "making a promise to God that I won't go back to him as a wife. I will be there in the family as a mother but not as a wife to him."

ness of matrimony." The girl said, "Father, before I answer this, I want to ask you, is it a sin if I said, since I was brought to her [Joyce] when I was young, and she kept me up to now, can she stand as my mother of God? Can the church allow?" Then Father said, "Why not? That would be even a special case now. It is good. You want our mummy to become your mummy also?" [*She laughs.*] She said, "Why not?" "Then who can be the witness?" She said, "I want that one [Joyce] to be. She can do all those things ... because there is nobody who is trusted." So Father said, "That is a good thing. I will take the message to the bishop. But, since I have seen the advice of doctor, we have to hurry for this sacrament while he [Paul] can talk, to confess on everything. He has to answer by himself." So we hurried, because it was doctor who told us that he thought he's going to be alive for three weeks only, because all the kidneys, the organs are really sick ... and he was weak.

Father said, "If that will be a good thing, God will reward her in eternity because of what she has been doing. She struggles. What she has been struggling for Paul is really special. I couldn't even believe she could think up to that level." He took the message to the bishop. The bishop called me. He said, "My sister, I thank you but you be encouraged not to go in reverse." I said, "I will never. With my Lord, I will never."

So then I came back after. They were just nursing him now. When they discharged him from hospital, he came and we kept him in my house. We made a bed in the sitting room. Mine is just a round hut, because in a war place, you can't build. It was in my sitting room. We made him a bed. We put the mattress down because we could not put him up. So he accepted. We were happy and we waited for that day, and then the catechist came. Then we said the catechist will be the witness of Paul. That one was on condition. Then the priest came at home. It was done there. All the people became surprised. They said, "What is happening?" Then I confessed, then Margaret confessed. She was baptized. Then they married in my house and I became a witness of their marriage. I also became a "mother" of her. [*She laughs.*] After this, people are fearing me in the church. They are respecting me for what I'd done. You can't find this one anywhere. They wanted me to go and teach

around the diocese. I said, "No. That is not my time. I'm still working." Because I can't come from government and work in the church.

So, after they got married, then he was returned back to the hospital and the priest could bring us the Holy Communion. We were just the three of us—we were taking communion. Then people were wondering, "What is happening? This man has got two wives and all of them, they are receiving Holy Communion. Why?" Then the catechist, they asked him, "Ah! What are you doing? Are they deceiving you? Why are they receiving the Holy Communion?" And then the catechist said to them, "Let me explain to you. This one is the first wife of this one. Then she offered the sacrament of matrimony to this young one. Now this one has become a 'mother' to this woman, and also the witness of their marriage." [*She laughs.*] It is really strange. In all the world, you will never find what I've done.

When I commented on how difficult it must have been to do this, Mama Joyce admitted, "It was very difficult, but I did it." Perhaps to try to explain why, she reiterated how unhappy she had been over the years when unable to take Holy Communion, being helpless to make her husband wed her in the church, and then in having to adjust and cope with sharing her husband with a second wife. As she says from experience, "This too is not good also for a family."

Due to all these circumstances, she said they "were all staying in the darkness," but that she wanted "to pull out from that one" and that is why she did this. But she was also clear that she "didn't want to be selfish … just to save [her] life alone," but that she wanted to save all three of them.

Husband's Final Speech

Then when he was passing, after two days, he prayed, he said, "Joyce, now I am going to die peacefully. The reason why I said I'm going to die peaceful, our patron St. Jude has offered me a bed. Are you seeing my bed?" I said I don't know. I didn't see. He said, "My bed is full of flowers. Eh, it is full of flowers." He had confessed before he got married. "I have been disappointing you, indirectly, sometimes in the open, but you have tolerated me. And all

the punishment which I gave you, God should forgive me and forgive you. I thought what you were going to do to me was you were just going to run away from me. But what I'm asking you kindly, I'm going to go, my bed is there." He pointed, like: my bed is there waiting for me.

The elder brother was around. The wives of the brothers were there. "But people have been"—he was open—"people have been really advising me to get many wives so that I produce children. Now I have produced. There's nobody who is going to assist this woman with these young children. I ask you, don't get annoyed, don't go to your home.* The moment you leave me, this home, these children are not going to grow. But I will ask. For you, I am not worried, but for this young one. This young one, she is going to spoil this sacrament. She should not think that I've died forever, but my soul will see and will guide you. All my prayers are going to guide you. Don't get disappointed. Now they thought that anything on earth is happiness. No. Now I'm going to leave these children. Are they going to help me? They are not going to help me. But if my relatives are going to help them, let them assist. But they should not leave you to suffer alone. I know that I should give you my benefits. I should leave [instructions] that you should follow up on all my 'debt gratuities' [pension] ... But if I leave them to you, I know our clan people are rude; they will just disturb you. So I am going to give my will to my brother. But if he messes, it is going to be a curse to him."

Joyce's husband is expressing concern for Joyce's wellbeing in his absence. He wants her to be well taken care of and would like to leave his pension benefits to her in his will. However, he knows that his relatives may feel that they deserved his pension money and might harass Joyce to give it to them. Also, in this context, since she had officially stepped down as his first wife and has no child with him, they actually would have more rights than her in this regard. In order to prevent such hassles for Joyce, he entrusts the pension and her care to his brother, drawing on the only power he has to ensure compliance—the threat of a dying man's curse.

* Because she was in essence no longer his wife, she would traditionally be expected to go back to her parents' home village; she was no longer officially married.

He stayed a few days and then he passed in the hospital. So, he passed peacefully. That was in 1995, March 13—he died at one p.m. That was the day.

After his burial, we stayed for a few years. And then also this son of my brother passed away—Milton—in 1998. So, when I lost Milton, I started to feel that there is no one who can think about me now. Then also the late Waiga [Mary's eldest son], he sent me a message. He said, "Auntie, you should not feel much. If Milton passed away, I am still around. I shall assist you." So God has made also ... he [Waiga] has passed away and we cannot say much.*

Foster Parent

So, after that death of Milton I was crying all the time. My friends would always come and visit me ... those women ... those who are Christians. There is a lady from Alur, she's there, she knows him. She's my best friend. So, from there, she started to advise me. She said, "You should not be worried. Now what you can do, just you join our Foster Parents' Association."

It was started by Archbishop John Baptist Odama. He's also from West Nile here, a Lugbara. John Baptist Odama, the one who is now trying for peace talks. He started an Association for Foster Parents in 1993, when he was a rector at the Major Seminary of Alokolum. He started to introduce an Association of Foster Parents for the boys who have finished Senior 6, those who want to become a priest at the seminary, because some of these boys were fearing because they don't know that area. When these rebels come, they want to run away from the school. So the bishop created it, saying, "Let them get foster parents around so that when they think about their parents at home—that 'I'm in such a condition'—they fear. To take that fear away, let them go and visit their foster parents. Then they come back happy."

As Mama Joyce explains, the Association of Foster Parents in Gulu was created specifically for the young men in the seminary, many of whom were from different regions in Uganda, but who found themselves in the middle of this war

* It was Waiga for whom I was a primary caregiver during his two-year-long hospitalization in Canada.

67

zone. Attaching them to local families gave them the chance to integrate and also to experience that not all Acholis are dangerous like the rebels. As well, the foster parents gained the opportunity to get to know people from other tribes and regions, to become connected to their families, and so have linkages in other parts of the country—something rarely possible on such personal levels and therefore not to be taken for granted.

So these women came—especially the "parents." They called a chairperson of Foster Parents. They came to visit me. So they said they had been advising me that I should not keep on crying. "There are children of God who God is giving to anyone. You had better join us. Then God will give you at least somebody whom you can take care of, who you can pray for, and he can pray for you. You just come and join us. Then we shall advise you when we attend the meetings. You will see how the "mothers" are behaving when they go to visit the boys." And I said, "Okay, when the meeting day shall arrive, you call me." Then I went and joined them. Then I started to pick interest. I said, "Let me just get a foster son, for forgetting those people [Milton and Waiga], but you can't forget them totally. But to release me from that pain, I'd better get one [a foster son]."

Then I started. I got Paul. Then I got Alfred. Then I got Vincent Kasire—he's a Muganda—the one who has just become a priest. You pray, God gives you according to what you ask. You may see that the picture of that one is the same ... it takes the place of one picture in your family here. God is doing miracles. So God gave me four. But there are also their friends—when they leave, they also just come and visit me. So I've got at least these.

Current Development in Home Village

Coming back to talk about her home village in Lodonga, Joyce expresses a certain disappointment in the fact that no one, apart from her sister Mary, has continued to develop their home. Mary at least had built a house. She complains

that Peter, who had the resources, "could not turn his face to home," but had given priority to building in his wife's home. She finally confronted him.

Like I forced him to build at home. I told my brother, "Before I die, I want you to see that you have put a small structure at home. If I die before I have seen any development at our home, I don't know what you will do. I will not feel happy, because this is not what I have educated you for. Home should be the first, because even if you die when abroad, they will still look for your real home. So let me go and suffer there and see, since this one [Natali], you cannot give money to because you know he can just finish it on drinking." So Peter accepted. He has started to give me a little money. He delays sometimes. He diverts the money that's supposed to be brought here. I said, "No, God is great." So that is why I am here. After this building, I will go back to my home in Gulu.

Mama Joyce has been spending long periods of time in her home village in Lodonga, supervising the building of a couple cement-block houses financed by Peter. This brings her some income while she continues to follow up the government bureaucracies holding up her retirement pension.

Life Summary

This is my life history. I like my people. The reason why I left here [Lodonga], it was the problem when they poisoned me. I couldn't have the interest to stay here because all the people who want to kill me, they are around here. They were against our family. What they are thinking is this home should not be developed. It should die forever. But now, when I come, when they see this building, when ... It was only that hut of mine and my brother Natali. But this drinking has destroyed him. I wanted him to be stronger but since he started to drink when he was young ... we can't help it. But it is good that he has stayed, kept us our land. Otherwise, the land of my father would be snatched by people around. Now when we came, we had a terrible court case. My sister Mary started it. Then when we came we joined. We have ended it this last May; it was in May it was finished in court. And

then those people were made ashamed, because my father has witnesses of all these trees which he has planted, and where he had started. He started to move there and then came up to this side.

She indicates the boundary lines marked by a line of trees. These, together with local oral testimonies, were the evidence provided in the court case that won them back their father's land and thus preserved the family home.

So, for us, I cannot be proud. In fact, it is God who kept us. Otherwise, the experiences, the standards which we have started with—it was terrible. We were not thinking about eating the best food—where could we get it? My mother suffered. My mother was also an orphan. My grandfather was also alone. And the father of my father, when they separated with my grandmother, he just … they told them he disappeared. He went to Gulu. Whether he has got married there—maybe we have got uncles that side—we don't know. So my father was left young, with his uncles. He was a clan leader. Also my mother was alone. They never quarrelled. Those people, they were really showing a good love. But God has taken them in a different way, so it is okay. This is me, Joyce. I'm called Joyce. I didn't introduce myself. My name is Joyce Jermana Minderu. But most people, they like calling me these two names. But they're used to Joyce. Some are used to Jermana. Minderu, my home name, means "tears"—because of my mother's grief losing the children before me.

CHAPTER III
Tina Zubedha Umar

TINA'S STORY IS SET in Arua District, in the West Nile Region, on the border with Sudan and the Democratic Republic of Congo (DRC). On both sides of the borders, due to the arbitrary colonial demarcations, there are peoples of the Alur, Lugbara, Kakwa, and Madi groups. The flow of people between these borders is fluid for trade and visitation, and especially for refuge in times of political conflict.

Considered part of the north, this region was subjected to the same colonial policies as the Acholi Region. West Nile is therefore less developed than the southern part of the country and has a disproportionate number of men in the military.[80] There is also a large Muslim population in West Nile, resulting in further alienation of the region by the Christian-influenced colonial administration. Christian conversion was a prerequisite for admission to

schools. Consequently, a lower percentage of people from this largely Muslim region reached levels of education that would enable them to be leaders in the development of their region or nation.

Many West Nilers have, however, been leaders within the military. Idi Amin is the best known of these. In order to secure his power, he massacred many of the Acholi and Langi soldiers in the national army and recruited more from his own region. This, together with his other atrocities, resulted in a bloody retaliation against the people of West Nile by the Acholi and Langi soldiers who had escaped into exile and who, together with other rebel forces and the Tanzanian army, succeeded in overthrowing Amin's regime.[81] All West Nilers were held suspect and targeted as having supported Amin. In 1979–'80, in the wake of brutal West Nile massacres, there was a major depopulation of the region as people fled en masse to become refugees in Sudan and the DRC.[82] Some then emigrated to North America and Europe as political refugees. Most would, however, remain in camps for most of the next ten years as civil wars were waged at home.

During this time, two separate rebel movements in West Nile engaged the government in civil war. The first, the Uganda National Rescue Front (UNRF), was formed in defense of the people forced into exile by Obote's Uganda People's Congress (UPC) forces. It disbanded in 1986 after negotiations with Museveni, the current president, as he assumed power. Subsequent imprisonment of and threats to some of the UNRF leaders led to the formation of the UNRF II, a renewed rebel movement. This war only ended in 2002 with the signing of a peace agreement between the rebels and the government.[83]

Since 2002, peace has prevailed and the region is in a state of postwar reconstruction. With increased stability and security, more NGOs are present to support this process. Gradual progress in infrastructure and institutional development is occurring although, due to history and war, this region's socioeconomic development lags behind that of other areas. Men who fought as rebels need vocational skills training to create alternate livelihoods, but such facilities are few and often inaccessible. The more invisible effects of

war in terms of trauma still deeply impact this population. Still evident also is an underlying sense of disenfranchisement and dissatisfaction with the current government for the lack of development in this region; this percolates just below the surface.

In spite of its own relative peace, West Nile has been affected by the LRA war in areas along its eastern border with Gulu District and along its main transportation routes to the rest of the country. The LRA insecurity made the movement of people and goods on these main roads extremely dangerous, and at times even impossible. Since the Juba peace talks, this flow has opened again between the rest of Uganda and West Nile, as well as into southern Sudan.

Within Arua District, Arua town is the major urban centre. It is here that Tina Zubedha Umar lives with her family.

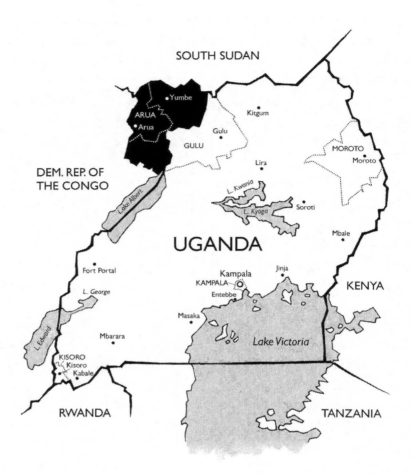

Introduction

My introduction to Tina Zubedha Umar came through a mutual friend, Irene Ayikoru Yebuga, a Ugandan Canadian now living in Toronto, where she and her family immigrated during the war after Amin's fall. Both these women were in exile with their families in Sudan. They have known each other for many years. They know each other's stories and struggles. Irene believed I should hear Tina's stories; she believed they had something to say about peacebuilding. So, following her advice, I called Tina and arranged to meet.

Tina lives in Arua town, the main urban centre in the West Nile Region, a six-hour journey from Kampala. When I arrived, Mary Khadija, Mama Joyce's sister, met me and took me to meet Tina. Through family connections, I was already well known to Mary and her family and had stayed several days in their village. She would now further pave the way for me with Tina by telling her own introductory stories of me.

At that point I knew little about Tina Zubedha. I was aware that she was married to Dr. Umar, who is known throughout the West Nile Region. As a medical doctor, he is one of the few educated and accomplished Aringa.* He has for years worked for an international NGO based in Nairobi, doing work in southern Sudan and surrounding countries. Dr. Umar's name is spoken of with great respect, and almost anyone in Arua town can direct you to "the house of Dr. Umar"—this in spite of the fact that he is rarely there and that, as I would come to learn, it is his wife who is ever present, who built the house, and who runs the household on a daily basis.

This chapter is Tina Zubedha's story, the story of a woman who, without any public position or formal recognition, and in the face of extraordinary obstacles, is the "chief planner" and manager for an extensive household, producing food, paying school fees, and developing not only individuals and families but through them impacting an entire region. The first section describes how I met Tina and provides highlights of her life story. The second section is her stories as she told them to me. Most of these she told in chronological order except for those segments that appear almost as a series of mini lectures she gives on issues in her community and society.

Getting to Know Tina and Her Stories

Arriving at Tina's place, I realized I was finally seeing this house I had heard so much about—Dr. Umar's house. It was as impressive as described. It is a large two-storey house within a walled compound on Arua Hill, looking

* Aringa is a tribe in West Nile. The majority are Muslim. As such, they and their area were neglected by the British colonial administration and so have remained less developed than the central and western regions of the country. The Aringa are known to be strong, proud, warrior types, and so were intentionally recruited for the army. This became the main avenue of opportunity for many. Relatively few have reached higher levels education due to these historical factors.

75

down into a valley green with banana groves and gardens, dotted with smaller houses and structures. Just inside the gate to the left is a small cottage with two main rooms for accommodating overflow guests. A cemented driveway slopes up to the main house, which is large and imposing. Both houses are of brick, with burgundy and cream trim. Behind the main house, and parallel to it, is the "boys' quarters,"* a long, narrow building of four or five rooms with separate entrances, and an outside kitchen with wood-fed clay stoves and charcoal burners.

The property is lush with mango, avocado, papaya, and orange trees. To one side of the house, near the boys' quarters, is the big mango tree that is the centre of household activity, under which Tina often sits in a plastic lawn chair, preparing the day's food and cooking, giving instructions to her workers going to and from the fields, hearing reports from children returning from school, and generally supervising the household. This is where she works, in the compound to which she is mostly confined due to her disabilities. All this I would observe in succeeding days as I stayed and became part of the life of this home.

That first evening I was seated in her well-furnished living room where, following our initial welcome and greetings, I had been left while Tina and Mary went to prepare tea in the privacy of the outside kitchen, where I guessed they were also exchanging stories about me. Those stories, I knew, would influence Tina's perceptions and likely her willingness to open up to me. When they returned it was time for more formal introductions. I'd been wondering how to address her, since I had been calling her Christine on the phone—the name Irene gave me—but this felt rather informal for a woman who was much older and therefore due respect from me. She introduced herself formally: "I am Mrs. Tina Umar." In the course of the week, however, I would come to call her "Mum" like others around the house and even people from outside, for this is a term of endearment from the many people she mothers and a term that holds both the respect and familiarity that would come to characterize our relationship. In time, I would also call her Tina, the

* A "boys' quarters" is usually a smaller building behind a house which, in colonial times, was used to house domestic workers but today may be used either for this or, more commonly, to accommodate family members or as rental units.

name she most commonly uses, and then later, during the editing process, she would specifically request I use her full name, Tina Zubedha, when writing her story.

Tina Zubedha is a short, heavyset woman. Although only in her early fifties, she walks slowly, with a subtle but discernible limp. She drags her right foot forward with effort, often reaching for the support of a nearby wall or chair to steady her balance. However, her face is bright, her eyes full of light, and her infectious laughter is ready to bubble forth as she speaks. Tina laughs often, even when speaking of things that have been painful and difficult. She is effervescent, though not without the depth of lived experience. Later, I saw this lightness vanish when she vented on issues of real concern. Tina is strongly opinionated; she knows what she thinks and speaks it out clearly. She seems unafraid.

Before long, I learned that, like Irene, Tina loves to talk. In fact, she can talk incessantly. That first night, we were up until two a.m. I had evidently passed her test and she talked nonstop, telling me story after story of her life and experiences. This happened almost every evening for the next week of my visit. Stories would flow endlessly. Some would later be retold and recorded; others would remain between us.

Tina began with what was foremost in her life—her multiple health problems and present disability. She told me candidly of all her surgeries on her back, her fractured legs, and the years she has spent bedridden and in rehab and recovery. She showed me her scars. This woman has a powerful will and determination to live and to be well. She has survived death many times. Today she lives with varying levels of constant pain and is unable to walk any long distance. As such, she is confined to her compound unless being driven by others. In spite of all this, she is extremely active, engaged in the lives of the many people around her.

Tina grew up in a well-to-do family. Her father, though orphaned, was well educated for his time, and had a salaried job and several businesses. He consistently supported her education so that she became a nurse without much struggle. Her parents worked hard on their land in spite of their re-

sources and wealth. As such, they became her inspiration in how she now farms to produce food and support her own family and dependants. Both parents died unexpectedly just before her marriage and (strangely) left her and not her brothers with the responsibility of caring for the younger siblings.

Only a few years after her marriage, the war came to West Nile after Idi Amin's fall. Tina fled to Sudan on foot, carrying only her newborn baby. With bombs falling, she and her husband and children were separated. Once reunited, they then struggled for survival and lived for the next ten years as refugees before their eventual repatriation. During this time, though, her husband went to the UK on a scholarship for studies, leaving her alone, without support, to find a job and the means to raise the family for a year and a half in a foreign land. Following his return, because the best job opportunities were in neighbouring countries, he would continue to live apart from the family, earning income to send back and help support them. At the same time, Tina would manage the home life, singlehandedly dealing with daily challenges, not the least of which was raising her four children. At great personal sacrifice, this arrangement has continued, becoming a kind of partnership that has allowed them to together not only raise their own family but also to contribute to the development of their West Nile Region.

With their combined efforts and resources, Tina and her husband have sponsored and continue to support numerous children and young people, most of whom are disadvantaged and many of whom are orphans. To do this requires resources and, especially, food. In this matter, Tina is particularly hardworking and determined. She once went to the fields herself, but due to her disability she now hires labourers to do the cultivation and harvesting. But she has had to fight for her land. When her brothers, as men with cultural rights and power, failed to reclaim their father's land, Tina in desperation took the matter to court and won.

Tina is a landowner in a place where women culturally have less access to land. Even when they have resources to buy land, they face obstacles to getting the title to it—often due to their gender. Such was the case for her in

buying the property for the house in Arua. Certain men opposed her because they thought such a prime plot should not be owned by a woman who could not properly develop it. Through sheer perseverance and determination she succeeded and supervised the construction of her house. Since then Tina has built another house in Kampala and owns several more plots. Some she has built on and others she keeps as an investment for her children. She is outstanding in her ability to plan for the future, to work incrementally as resources become available, and to manage the competing demands for what limited resources she has.

Interspersed with her stories, Tina would periodically wax eloquent on issues of concern in her community and society, topics such as her in-laws and her intolerance for dependency, the importance of planning for the future, the plight of women in polygamous marriages, her concerns for the youth, and the effects of privileging children.

On some issues, Tina is quite a radical woman—a feminist even, though I am not sure she would define herself that way. She gets angry and indignant about the treatment of women and the role of women relative to men, particularly those women who are one of several wives. She believes no polygamist home is a happy one: "the women fight and the children suffer." And she would know: her father had three wives. Furthermore, she lives as a Muslim, in a community where multiple marriages are common.

Tina converted from Catholicism to Islam when she married. She is well versed in the faith, capable of defending her rights as a Muslim woman. God is important to her, particularly given her struggles. The faith and values she shares with her husband are a source of deep respect and appreciation for him and the basis of their generosity to others. Islam is the centre of their home, as I experienced, since my visit coincided with the final week of Ramadan, the Muslim holy month of fasting, and then with the celebration of Eid at the month's end. So while the whole household fasted that week, extra effort was made to prepare food for me, the only non-Muslim. Then, during our interview process, interruptions were made as Tina gave instructions and supervised the bustling food preparations for Eid. What a day of celebration!

As she told me, "Eid is a celebration that you don't have to invite somebody; it is your legs to carry you wherever you want to go ... wherever you want to go. And you are welcome everywhere." Indeed, this hospitality is what Tina's house is known for.

Tina's Life as She Tells It

Family Background

I was born here in Arua. My father was a medical assistant by profession. He went to the training because he was an orphan himself. He lost both his parents when he was still a tender age. His mother died when he was six and his father died when he was reaching seven or eight. And there were no close relatives, on the mother's side especially. So he was picked up by a priest and brought up in a mission in Nebbi District. And that's the district I come from, actually.

So, after marrying my mother—that was after he had already graduated in his profession—his first place to work in was in Lira. Then after Lira, he was posted to Pakwach, the home district. And that is the year that I was also born, when we were living in Pakwach. I was born in '53: December 25. I'm the fourth-born in the family. And it was in 1960 when he was transferred to Arua Hospital. Then he got a plot, behind the mission at Ediofe. He had a stepfather actually, like an uncle, who was a carpenter in the mission. He got the land there and he built a permanent house and we transferred to Arua.

And it was 1960 when I joined in nursery at Ediofe and I had my primary education in Ediofe Girls. It used to be called Ediofe Primary School. And from Ediofe was when I joined the senior secondary school. And we lived in our house actually throughout our life. My mother never worked except as a housewife. My father had a part-time business in Arua and down at Rhino Camp. He had a grinding mill and a shop there. And in Arua was another shop.

Back home in the village, they call us "Pakwinyo Pabego." "Pakwinyo" means "the people of Kwinyo," who was the father of my grandfather. "Pabego" is our clan's name. We are just at the bank of the Nile, where Emin Pasha* was buried. That's my clan, where I come from. And there, he built us a permanent house but the house is now completely too, too old—the one in the village. And that's actually where they got buried. Although we have lived all our lives in Arua, when it comes to a funeral, when it's one of the family members, we usually take them back to the village and bury.

Marriage and My Parents' Unexpected Deaths

It was, I think, after my S6 [in about 1973] when I joined the nursing profession. I went for a three-year course in Mulago.† I did general nursing and became a registered nurse by profession, although my intention was to be a teacher. I finished my course in 1977. That's when I graduated as a registered nurse and where I met my husband, at Mulago. He was also graduating from medical school. We were not very serious actually at the beginning, but after graduating was when everybody knew that things are going to go astray because everybody's going to be posted in one direction or another. That was when we became a bit more serious. He got his posting order first. He was posted at Kuru Hospital, in Yumbe District.‡ I remained in my administrative course for two months. Then after that, I got also my posting order. Fortunate or unfortunate, I was posted to the same hospital where he was. So it was a big joy to him actually, because he was not very sure whether he was going to lose me.

When I came to Kuru Hospital—that was in 1978—each person got a house for himself or herself. I had my own house; he also had his own house.

* Emin Pasha was a German Muslim convert who lived in this area during the 19th Century. He was known for his army of slave soldiers who settled in the area and formed a new 'tribe' called the "Nubi" or "Nubians." His troops were known to be the best trained and were used by the British to conquer kingdoms in the southern parts of the country. In 1888, he was "rescued" from the area by Henry Morton Stanley.

† Mulago Hospital is the main government-run hospital and medical training institution in Kampala.

‡ Kuru, in Yumbe District, is near Mama Joyce's home village of Lodonga.

81

We just kept on visiting one another. And it was in 1978, September, when we actually did the "introduction." After that, unfortunately, both my parents died. Just the week when we had the "introduction" was when my father died of heart attack. Then my mother died of a shock 'cause it was so sudden. It took everybody by surprise. I became very, very depressed ... very, very depressed. It was so bad—a matter of four days. My father died and after four days my mother died. I broke down completely. From the funeral, I never recovered. I couldn't go back to work. Because, coming just to tell you so and so is dead, not even just sick ...

Father's "Will"

My father died in Rhino Camp where he had his other business. He died writing a letter saying I should take over his family, especially the young ones. He wrote it down. He died actually with the pen in his hand. He didn't finish the letter. The message was given to me. It was at the burial. After the burial was when we sat with the letter—and his relatives also, because this was a message from him. I had to take it seriously. I didn't know what to do. My father loved me so, so much, and was a really good, caring father—especially taking my education very seriously. But now I didn't know where I was going to begin from. My plan was to get married first and then, maybe, think of other things ... but here death has come. There's no alternative.

Other people were so much against the marriage now. It was a bad omen. My husband just said, "Everything comes from God. Death comes from God. We don't know the time. It may be that God planned that these people are going to die at that moment. It just happened." For him he doesn't regret anything. So long as I settled down, maybe after recovering from the shock, things should go on smoothly. It took us another six months before the marriage took place. And, immediately we came together, we stayed at Kuru Hospital. The war broke out in October 1979.

Culturally, upon the death of a father, responsibility for younger children would be assumed by the eldest son but, strangely, Tina was being asked to take this on. Her future husband would also have realized the implications of this

extra burden to them as a couple. Despite this additional responsibility, and without regard for the opposition due to local superstitions, he still married her.

War: Fleeing to Sudan

War in the West Nile Region began in 1979, after Idi Amin's regime fell. This was the region that Idi Amin was from and so, in retaliation, people from this whole area were targeted. Many were killed, and most others became refugees. Subsequent rebel movements were formed in opposition to the central government and continued to destabilize the region until peace agreements were finally signed in 2002.

I delivered my first-born in ... actually, I got this other boy, the one I showed to you, much earlier ... in '72, after my S4.* I came, I stood for the training. That boy was there but I left that boy with my parents. His name is Arubaku Kenneth. And then it was in September 1980 when I delivered the second-born ... the one I told you about, Achema Siraj. And a week after delivery was when I had to flee the country. My only luggage I carried to Sudan was my baby. Nothing—I left everything—I carried nothing. Unfortunately, at the time we were running, my husband was in the theatre operating. The kids actually took off before me. I was in the bathroom when they started shelling the hospital. By the time I came out of the bathroom, the kids had already gone. I had four children who were staying with me. They all ran.

Now, I didn't know which direction even to run. I came out of the bathroom, just put on a skirt and a blouse, no slippers, no what. I carried my baby and just started running. To where are you running? is the question. But they were shelling. There was nothing one could do; we had to continue running. You just follow other people running. So we ran. About eight miles away was a big river—the River Kochi. Most people had stopped there, by the bank of the river. We settled there for some hours, till evening. There

* Tina is explaining that she got pregnant and gave birth to her first child while still in secondary school, in grade 11. For her to be able to continue her education, her parents looked after her son and then, once she had finished her nurse's training and had her own home, she was able to take him back.

was no sign of my husband, no niece, no anybody. No one knew of the direction they had run. So we crossed the river and continued walking with other people. And we camped up in a school for the night. And that's where I met my children—those boys that were staying with me and the girls. That's where I met them, in the school. And we continued together, walking. My feet became so swollen. And the umbilical cord had not yet healed, so I couldn't even tie the baby on my back. My arms became too swollen, so paralyzed—no food, no water. We had to continue, up to the Sudan border. You don't have anybody to go to or what. So just anytime, when we got some kind Samaritans, they gave us some shelter. That was all we had.

Those of my husband were in another direction because for them, they took the other road running towards Moyo side. Then from there they headed from the other side, from Kajo Keji side. But it was a far distance from us where we were. And for him, now that he had lost even the pride of his family, he didn't know what to do next. So we kept on sending messages, messages, until the message got to him. That was after two weeks. Then he came and joined us.

Life as a Refugee

Life was hard. By then UNHCR* had not yet even come in, so most of the refugees were just self-settled. You have to hunt for your own food. No shelter. If you get a kind person and they do have a big premises, they can just give you a small place to squeeze yourself. I remember the first week. We were forty in a room. My husband said, "You people think you've come to escape death but here you have come to die." And the fear. You couldn't move a distance from the place you stayed.

Life as a refugee is hard. You have no choice. Life is hard. And the duration between deliveries of food from the agencies is long. And the amount of food is never enough. The youngest and the oldest die. There is nothing like diet; it is just survival. That's why I refused to go to the camps.

* The United Nations High Commission for Refugees, an agency providing humanitarian aid and relief to refugees.

The most depressing time in the camp was when there was famine. People died. You might stay with the body for three or four days because there was no one to help you dig the grave. That was the time we really confronted the UNHCR people. They said it wasn't their responsibility. We really confronted them and finally they helped us. They used to hate me. I will speak what I see. I will not keep quiet.

If the camp you're in is where water dries up, you are in worse trouble. Trucks with water tanks would come to deliver water but people had no containers to store the water in. And the pipe was so big, bigger than the opening of the containers, so most of the water would pour on the ground and it became a big puddle where the kids would play. It was such a waste of water. And people didn't have enough water. And it took long before the next delivery.

If you're not a strong person, you get so depressed as a refugee. That's why mental health problems are so common among refugees.

Surviving: Picking Up the Pieces

After my husband joined us was when he talked of thinking of what to do. But he really didn't know whether it would be possible because he didn't even know where his papers [medical qualifications] were. But this boy of mine, that time he was six years old, he had carried the documents in the briefcase. Because we used to make fun in the evening like that: "If the worse comes to the worst, these are the things we should carry." So one of the girls carried a radio, but this boy carried the briefcase with our documents. But we didn't know about it. He didn't even tell me.

One evening my husband was telling me, "How are we going to live? How are we going to begin? Nobody's going to recognize our qualifications because we don't have any of our documents." That was the time when this boy answered that, "I have them." "How do you have them?" we asked. He said, "I picked that briefcase because Mum used to tell me every evening, if the war breaks, the only thing I should carry should be the briefcase because it is having important documents." Then he walks inside and brings the

briefcase. But there was no key to it. [*She laughs.*] So we had to break it. And when he got his documents, there was really good excitement; there was great joy because at least now there was a future for my husband.

Where was the money going to come from for his transport even to Juba? There was nothing. I said, "Why don't we sell off this radio?" He said doubtfully, "If they can buy it." So we sold off that radio, and used the money for his transport. But he was so depressed. He said, "How am I going to leave my family?" I said, "God is there, we are going to survive."

When we ran, it was dry season, November–December—very dry, no rain, no what. You can't even plant any greens. But we were living near a very small stream that didn't dry up. So I started planting something that could give us at least the sauce to eat. With some little money, I bought some seeds of these peas ... because, you know, for us here, we eat the leaves and then the seeds as well. We used to fetch water to water it, with my sister who was staying with me—every evening and every morning. That was her work so we could get our greens. Maybe the little food we had, we just ate once a day ... a meal once, at least once. There was nothing like breakfast, no lunch, but at least we can have something little in the evening. It was how life was moving.

He went to Juba, he got a job, worked for six months, was not paid—nothing!—no coin, no what. He had to come back home and join us. By the time he was coming back, at least it had started raining. I had got some plots from people. I started digging. That was the time when we could now at least have food from the gardens. Because there was a month when the UNHCR came and now started taking people to the camps. But the camps are very, very far. I was not in the mood of moving to the camp. I remained at the border. Because where we entered was Kaya—this is at the Uganda–Sudan border, about five to six miles away from the border there. We settled there. After some time, he got another job.

Paralysis of One Leg

When he got the second job in Juba, that's even a bit hard. They'd just pay him a bit of allowance, like that. Then he and some other men decided,

maybe if they could go to Khartoum, maybe that's better. So he went to Khartoum. From Khartoum, he got another job. He got a job, but alas, that was when I started getting a bit of a big, big problem. That was when I started getting this problem with my back and paralysis. It started then that year, when my son was a year and some months—this boy whom I carried as the baby.

It happened, I was sweeping that morning, and when I reached the door, I was getting the rubbish away from the house, I heard some noise: *tick*! Then a sharp pain ran down my right leg; there was a pain that was going like this, down, up, down, up, just like a needle moving. After some few hours, I was totally paralyzed on one side. He was not there; there was no way to get help. Actually there was not even a good hospital where they could do an x-ray or what. So, they started treating me natively. They would cut, cut ... it bleeds ... put some herbs. It didn't work. For six, seven months, I was just on my bed. And communication was very difficult to Khartoum. I couldn't send him a letter ... till we met one of the Arabs who was traveling to Khartoum. I used to visit my neighbour, so my neighbour told me about his going to Khartoum. Then I wrote a letter. And he really, really took the letter and even gave it to him.

And when he got the news, he immediately had to travel back to Kaya. And he got the news very differently. When he reached Juba, he was told they had amputated my leg. So he became very, very depressed. On reaching home, he found me seated by the verandah—it was about three in the evening*—and the sick leg, I'd put it straight like that. Then this one, I had folded it because I was sitting on a mat. So he just took it for sure that one leg had been amputated. He broke down and started crying. I said, "What? What are you doing on earth?" He said, "It has just been because of this war and the fleeing that has brought me to Sudan, otherwise I wouldn't have had all these problems." I said, "You're not God. Problems are *everywhere*. There

* "Three in the evening" is actually 9 p.m. The East African system of telling time is a twelve-hour clock of day hours and twelve hours of night. It begins at 1 a.m., which is the conventional 7 a.m., and runs until 12 a.m., which is the conventional 6 p.m. The night clock then begins again at 1 p.m., which is the conventional 7 p.m. and runs until 12 p.m., which is the conventional 6 a.m.

is nothing you should even lament on. This is God's plan. If it's death, I'll die, but if not, I'm even feeling much better. I can even walk with a stick. In the beginning it was so, so bad I couldn't even make a move." He said, "When did they amputate your leg and what did they do?" I said, "No, it's not amputated." That's when I pulled the other leg and stretched it. He said, "My God, that was the news I got in Juba." I said, "Who told you? That person might have not seen me."

There was nothing much he could do. He couldn't even take me for treatment in Juba; there were no facilities in Juba. Now, I just remained in that condition. And he had to lose that job—he couldn't now go back. So he remained with us till he joined with GTZ*—with the refugee programs. And that was the time we had now to move to Yei, sixty-eight miles from where we were. That was where life started being a bit better because now he was able to get some money. We were able to rent a big house. And there were water facilities. We had electricity. And it was good. It was in '85 when he got his scholarship to go out. When he left, Hamid, our third-born, was seven months old.

Husband Abroad: Alone in Sudan with the Children

Now the decision was so abrupt. He didn't have *any* money which was going to be looking after his family in his absence. I told him, "Yah, I think it's the right time I can begin working," because he was providing for the family all this time. Me, I would only do the garden work and other things. He left in September to go for that course in Britain. Actually, he went for his Master's and he was there for one and a half years. He left in September, then in January I started working in Yei Hospital, actually in charge of the paediatric ward.

I worked there up till '88, when we decided to repatriate, because the SPLA war had already started. They were mostly attacking camps, which was not very good for us. And that time he had already come back from Britain and was working in Somalia. When I asked for my resignation to come back

* Deutsche Gesellschaft für Technische Zusammenarbeit, the German government's international development organization.

to Uganda, the Ministry refused because they needed me so, so much. They wanted at least somebody to come and replace me before I could leave. But because of the instability, I couldn't wait. I had to repatriate and I came back to Arua.

Starting Over in Uganda

In Arua, we had nowhere to begin from because we didn't have a house. Actually we had to rent while we tried to build our own house. We didn't have any plot. We were living in a government house. He went back to Somalia, left us here. He got us a place, at least, in Oli Division. We were renting a three-room house. So, we lived there for a year.

The second year was when I decided now to get my own clinic because I couldn't go back to work; conditions were very bad in the hospital. I started my own clinic and ran a clinic in the front part of the building while we were living in the behind part. The clinic was doing very well. I don't know whether it was envy or if it was through theft, but they kept on breaking into my premises taking all my drugs. They did it three times. I said, "No, let me change in another direction maybe. It's too much. I'm losing so much money." They would break into the premises when I have just stocked the drugs. And I used to stock at least enough for two to three months. So I lost everything. I didn't have any capital. That is when it came back to my mind: why don't I go back to my late father's land where we used to live?

Land Issues

Going there, I found somebody had already claimed the land and had destroyed the whole place. They wanted actually to change it to different things. My late father had a very huge coffee plantation. They destroyed all the coffee plantation. He had a very nice big orchard of oranges. It was destroyed completely. And the building, they were actually harvesting honey and they set it on fire. The whole thing got burnt. I became furious. These were people who came when we were in exile. For me, I lived in exile for ten

89

years and came back very late. So there was nothing I could do. So I started a court case against them.

Going to the local councillors couldn't settle the disputes, so I sent a message to my elder brother because my brothers are all in Kampala. And when they attempted and failed, they just gave up easily like that, but me, I was so, so desperate. I needed a land. That was the time I came to the police and reported the case. This man was Simon.* I had to write a statement and then I hired a lawyer. We went to court. He did not have any document about the land but they claimed we don't belong to the tribe here, that the land belonged to their ancestors. But the court said, "No, this is the land where the parents of these people had owned it for forty-five years before he died. And these kids were all born here and they were brought up here. Now, if there was no war, how were you going to reclaim it? And if you wanted to reclaim it, it shouldn't have been in that manner, in their absence." So, when they did the ruling, it was in our favour. We got back the land. That was the time when I stopped working in the clinic and turned to farming. [*She laughs.*] That's what I did.

Owning Land: The Arua Plot

And it was in 1990 when I got this present plot where we are, where my house is. That was when my husband was working in Somalia. I got this plot with a lot of difficulties. I applied to the municipality for plots four times. I never got any reply from them. Then I sensed there was some danger. How long am I going to continue applying without getting a plot? So I walked physically to see the town clerk by then, talked to him, and wondered how I couldn't get a plot even though I was somebody who was so, so much determined at least to get a plot and develop it. When he checked through his files there was no record of any of my applications and yet I had the duplicates of the forms which I had. Then he just told me, "I think there must be something fishy. Somebody must be blocking you and the person should be in my office here."

* The name of this person has been changed to protect his identity.

So, the present plot where I am on—that is Plot 26, Arua Hill Road—I got it in 1990. It was his own plot, the town clerk's own plot. But, because he knew he was not going to be able to build on a plot, he gave it to me.* I started the fencing; I put this barbed wire around the place. That second week, I made a plan for my boys' quarters and started digging the foundation. But here comes somebody above [in a high position], comes and blocks me from developing the plot—just because of looking down upon me, thinking I was so poor that I wouldn't put up a good structure on the site. And to him that site was the best site, whereby a nice house should be put on and could be seen from a distance. God willing, the only poor person who could not build up a plot has managed. I've built my house now twenty years. I'm living in my house.

By 1991, I'd finished the boy's quarter. I dug the foundation for this big house.† In 1992, May second. That is when I dug the foundation and that was the day when I delivered my last-born. That very day is the day I delivered my last-born, the girl, who's now in Senior 2. The workload was so, so much. When there was money, we do something, but when there was no money, we stop there, especially when the kids are going back to school—no work on the site. Yah, that's what I was doing. School fees take all the money, so gradually it got done.

I didn't mind of the blockage between, because I was determined and I knew nothing on earth was going to stop me ... because I had my papers [title deed] and the plot had been allocated to me. We went ahead with him to face the authorities, and truly he was told the plot was mine. And I went ahead and built. And I feel happy that I own the plot, which actually has a good structure—a house which is admired by many in Arua. So poverty can be there but, once you're determined to do something, you can always do it. You can't gather money. That's one thing: you cannot just put a granary of money and start saying, "I'm going to build." But, with determination, with my husband, we have put up a plot and we are happy. We are happy living on it.

* He didn't actually give the plot to her but rather gave her the opportunity to buy it from him.
† She herself was not physically digging the foundation, but was supervising the laborers.

Emergency Hysterectomy

It was 1995 when I had the second problem. I started bleeding profusely. Each time I got my period, it took so long, it didn't stop. I'd bleed and become so, so anaemic. I couldn't understand what was happening to me. At first I kept it a secret from my husband for some time but then, when things were going worse, I had to inform him. Then he came back and said, "Let us go for a check-up in Nairobi." I went and found I had a very huge fibroid, a very bad one. So he decided that I should be operated. But I said, "Nooo, maybe I'll come later for the operation. Give me two weeks." But I was so anaemic; my haemoglobin was so, so low. I collapsed in Nairobi. Then I was operated as an emergency. They did the hysterectomy as an emergency. I remained in hospital for about two weeks and then got discharged and they sent us home.

Major Back Surgery

I recovered from that, came back, continued my work with the house. It was a struggle. My aim was actually the house. I continued the work.

Then, it was in 1996 when I started getting this problem of my leg. When I went to the field, coming back I felt a lot of pain, my legs were paralyzed, I had to sit by the roadside. Just like that. I couldn't understand, till gradually I started getting worse problems. Movement became a problem, my legs got swollen, my arms got swollen. And it was the time when I decided also to go for another check-up.

First, I went to this hospital nearby here, a private hospital, Kuluva Hospital. They couldn't get anything. And then they gave me a referral to Rubaga Hospital in Kampala. I couldn't decide whether to go to Rubaga or Mulago.* By then Mulago was not yet functioning very well. So I decided to go to Rubaga. They did the x-rays. They saw some damages, especially in the lumbar region but they did not have the tomography machine and said maybe if I could go for tomography it would give a better result. So, I was

* Rubaga Hospital is a private Catholic hospital in Kampala, whereas Mulago Hospital is government-run and conditions are often questionable.

referred to Nairobi Hospital. I came back to Arua. My aim was to finish up the upper wall. So I did it and, after two weeks, finished it. Then, I went to Nairobi, did the tomography. It was showing some bad signs. The nerve supplies were not very good. They gave me another appointment to come back for review. It was to be on July seventeenth. But, before I could go back for the review, it was when things went astray, on July thirteenth.

July thirteenth—that is when I lost everything, like that. I was walking to go to the toilet at lunchtime and, reaching the corner of the building, I heard that noise: *tttsshhh*. I was totally paralyzed—the hands, the legs, nothing could move. Two days after that, I was flown to Nairobi, admitted. They did another tomography. They found that the bones had already been separated. Two were completely pushed inside. The whole of the lumbar region was not coordinating with any part of the body. As to the operation, there was no surgeon that could take care of me immediately. I remained in hospital for about two weeks. The only good surgeon who could have operated me was in Aga Khan Hospital. He was so sick by that time. He was on his dying bed and that week he died. I didn't have now any alternative. So the hospital told us maybe we should try outside Kenya. We applied to Madras Hospital in India. They said they're full up; they couldn't take any patients; I should wait for three months. But I was in so, so much pain. I couldn't wait any longer.

Then, there was a doctor, Dr. Steve. He was a Nigerian, working together with my husband in AAH (Aktion Afrika Hilfe) organization—a Nigerian doctor but he graduated from Nairobi University. He happened to come and see me in the hospital. Now, when finding out why they couldn't operate, he decided to meet a family where he knew the professor who was a lecturer in the university and became a very good surgeon in orthopaedics. But he was out of the country; he was in London for a conference. And the wife said he will be back maybe after two weeks but she gave him the communication. He communicated with him and he said, "No, I will be back in next week. I'll communicate to you on arrival." And indeed he came back that week and communicated to us.

I was taken to his clinic to see him. An examination said I needed an immediate operation. I went to the clinic, not knowing that I was now going to remain there. Of course my husband couldn't believe it. For him, he was thinking that maybe I was going to be given an appointment and the operation would be done later but the professor decided that I should be admitted immediately and the next day I was operated on. And when he saw the mood of my husband, he decided to give his own vehicle to take me. He went in his car and drove me to the hospital.

I was admitted in Nairobi Hospital at 7:30 p.m. There were no beds. Every part of the hospital was full up. I remained on those forms or benches at the reception up to 11:30 p.m. I was lying down and they were there, the professor, even my husband. They were mad. They were both seated there. They were waiting, and the professor was still coordinating with the hospital. And the only bed which was there was in maternity ward. So I was admitted for that night in maternity. They took me to the ward at a quarter to midnight. Immediately upon reaching the room, they sent the lab people to come and take blood for hb, blood grouping, and what.

So, the next morning I was taken to theatre at around eight in the morning. But, reaching the theatre, there were more emergencies. There had been an accident. They got bleeding patients and theirs was more emergency than mine. So I was brought back to the ward. They worked on them first. Then, at 1:15 p.m., that's when I was taken back to theatre, operated on. I remained in the theatre from 1:15 p.m. up to 10:30 p.m. The operation was successful. I remained in the hospital for three months, paralyzed. The only part of my body which I could turn was my neck. Turning has to be done by the nurses. Feeding has to be done by the nurses. And the only thing they could give me was very little fluids because I was taking mostly IV. It was quite a long time for recovery.

Finally, I came out of the hospital in October. From July, I came out of hospital in October. I do not remember the date exactly but I remained attending physiotherapy in Nairobi Hospital for another month. There was good recovery except the big toe on the left. It became stiff, couldn't make

any movement. At least I could now drag myself with my crutches, I could move. I finally came back to Uganda in early November. Life was completely difficult for me because there was nothing I could do for myself, nothing. Bathing, somebody has to do it for me. Feeding, I can hold the spoon but then my hands begin shaking like that till it drops down. So, most of the times, somebody has to put something in my mouth. And I only take light, light things—porridge, milk were all what I could take. It's the only things I agreed to eat because my digestive system was not there. It was completely shut down. I would really spend some time, a week without opening my bowels. And if I have to open my bowels, it takes me so, so long a time. But slowly by slowly, I recovered.

Fall Down the Stairs

Four years later, in 2000, Tina suddenly received news that her cousin had had a stroke and been found unconscious by his young children. This was a cousin who had been raised by her parents and was like a twin brother to her; they were extremely close. So this news put her into shock. Because the drugs he needed were not available at the hospital, Tina had to try to find them in Arua and then sent them with a young man by bus to Nebbi, an hour away. She then planned to prepare herself to travel there that evening.

As soon as this boy left, I came from my room after bath. I started to get down the stairs because other relatives have heard that news and they are coming to get more enquiries from me. Reaching the step, my other cousin rings me from Kampala that he has been ringing my brother but he is not picking up his phone. Has my cousin died? I said, "No, my brother rang me five minutes ago and told me we should not get worried, he has just switched off his phone for a meeting, a board meeting, where he was working." As I was getting down the steps, I just missed one of the steps. I fell from there. Both my legs got caught in the rail and got a very, very bad fracture—both sides. Both legs were in the rail. I don't know how then I missed getting frac-

tures in both of my arms because the whole arm was behind my back like this. So, after being taken off from the rail, I was taken to Kuluva Hospital.

Not much attention was paid to the right leg because it didn't swell that morning. I was not feeling any pain and the only thing was this leg which had the tibia and the fibula all cut, and the joints from the middle just went off. There was a big, deep hole here at my ankle. This one was completely shattered, this was shattered—both anklebones. I had multiple fractures, both spiral and compound. On the left leg, there were two fractures across the calf and then two on either side. And on the right leg, there was a fracture across the top of the foot and across the lower calf. Then, I couldn't believe, the next day my cousin dies.

I remained in hospital for another week. Then I was brought back home, after they applied the plaster of paris. Then I remained in the house for one whole year without coming out. After removing the plaster of paris—the POP—there was no good union of the bones. Only this one on this side at least took up. But this one and here, there was no union. My ankle didn't heal. The foot was a dropped foot and the foot couldn't even reach the ground. So I thought twice, should I put the POP again? People were saying, "You are making your leg worse by putting another POP. Why don't you try the traditional means, manually?" I got a lady who would come every morning, spend the whole day with me. She would massage it with hot water and then just start pulling it using oil. Slowly by slowly, it started picking up [getting better].

Brief Reprieve in Kampala

It was in 2000, December, when I came out for the first time from my bedroom. And in January 2001, I decided to take a break away from this home. By that time we had not even finished that building of ours in Kisaasi, in Kampala. Roofing was done, plastering was done, but painting was not done, window plates were not fitted, doors were not fitted. I made up my mind that I'm going to stay in that house of mine. My husband couldn't believe it: "What is happening? How are you going to live in a house without doors

and windows? And there's even no water in the house. How are you going to sleep?" I just wanted to be out of Arua and out of this compound especially. He thought I might go with one person or two people but I told him I'm going with the whole family. He got very depressed. He couldn't understand what was happening to me. And I made that arrangement. I had the money for the transport fare. I had my food. And I was going to begin a new home where there was nothing in the house, so I planned *everything*.

Tina then tells in some detail all the planning she did to get her family— her own four children, four others, her stepmother, and herself—to Kampala, much to the shock and consternation of her husband, who evidently did not realize how far along she'd got with the construction of the family's Kampala house. Tina had bought this plot in 1994, after the one in Arua (in 1990), and had been working on them simultaneously, though this one had been delayed due to her illnesses. Moving the household to Kampala was for her an initiative of self-care but may also have been part of a strategic plan, a way of getting the finishing touches done on the house and maybe also of getting her husband to help finance this. Soon after their arrival in Kampala, when her husband joined them, this is exactly what happened. The family then stayed there for two months, after which she brought the children back for school. It was during this break that, as she told me, "life started."

Life Resumes in Arua: Producing Food Again

When I came back, I felt very relieved. I had been out after being in the home where I was so depressed. When I came back, I started planning my things afresh. Because the three years when I was completely down, I couldn't do any work in the field, I had nobody to supervise, I stopped digging. But that was the time when I started picking up my work again.

Actually, I started to produce all my food from the field. I hardly spend on food, except the basic things which I cannot plant in the field. I used even to rear my own goats and sheep, except some thieves came and stole all of them from the field here. We had tied them on the hill. Yah, I had twelve

goats and six sheep. They took all of them. From that time, I decided to transfer them, the little I had bought after that, and I removed them away from here to the village. And that small house you are seeing there, that's where I used to rear my chickens. But, because now I cannot do much of the work—bending is a problem, walking is a problem—I decided now that, let me rear the local chickens, which I'm still doing. And I don't sell them. I just rear them for eating, for the family.

These fields I have, the nearest is just in the valley, right opposite to my gate here. I bought that place when I was still living in a rented place, before even I got this plot. That man was moving away from here; he was going to Nebbi District. So I happened to know him. Then he came and told me that he had some land to sell but it's in the valley. I came and saw it and knew it was a good place. After buying it, I planted bananas, sugarcane, and yams.

[*She laughs heartily.*] I have so many things going on ... people coming and going. I have at least my brother-in-law, Mawa, who assists me so, so much in running out of the house and checking the people in the field, checking on our premises. I have fifteen people working right now. He goes and makes the contacts with them in the fields and checks on their work. And the payment, actually I have a book. I have records of everything we are doing and I do it on a yearly basis. When we begin a new year, I open a new book. I record everything, and how much we spend—what we have finished, we give it a tick; what we are still doing, the work still in plan. You just plan them. They're all in the records.

Lecture on In-laws and Other Potential Dependants

Tina describes her late mother-in-law as being a hardworking woman who never bought food; she always cultivated even when her son gave her money to pay others to do the work. Upon her death, none of her children have followed her example. Instead, many of Tina's in-laws have tried to live off the efforts of Tina and her husband.

From the time my mother-in-law died, I told my husband, "The chapter is closed. The chapter from there is closed. The land is there. Let them

98

learn how to take care of themselves. They think the way peo
ever we have got comes freely. It's a lot of effort and strugg
and struggle. You have to plan and work hard and I always
think it's an easy way, come in a bus, follow your brother where ...
robi], let him give you money from there. But mine is a hard sweat. I eat
from my sweat. I plan my things. I don't depend on your brother. I don't.
Because, just see the distance where we are. If I tell him, 'Today I slept hun-
gry', it's a gone case. If he has the money, he will send it maybe after two,
three days. And what am I going to do for the next two, three days? Am I
also going to continue sleeping hungry? It will be the same story."

I know why he's struggling and he also knows why I'm also struggling.
That is why we've decided to let one person remain outside the country and
the other one stays in the country. Otherwise, if both of us were out, we
wouldn't even develop. And these types of people who are just negative, you
can't entrust your money to them to do for you any different thing. You just
can't. If you do, it means you are just throwing your money in the ditch.
Nothing will come from it. And when I started this building, so many of the
brothers came so close to him: "Let me do for you the work, let me do the
work for you!" And he said, "No, I'll talk to her first." And that word alone,
"I will talk to her," is an insult to them because they know I will just tell
them "no." You give your money to them, you will never see anything done.
Nothing. Not even a foundation will be dug. And where is the money? It's
gone.

So, I would rather help a person who is sick or a person who's underage,
an orphan. Let me bring them up to a certain extent where he'll also be de-
pendent on himself, rather than helping a big or grownup person who is do-
ing nothing for himself. That is my motto. How much you hate me, how
much you talk bad about me, I remain what I am, and I have my own agenda
of life. That is my aim. If you're struggling, I'll help you. But, if you are there
sitting and waiting to be a beggar, intentionally, you can't get anything out of
me—never. That's my motto. Help an old person—it's understandable be-
cause the age has now worn out; he needs assistance. A sick person, yes, but a

very healthy person who is there eating his *marungi*,* playing cards from morning to sunset? No way, I can't help that. I just cannot help it. And to make it worse, there are those you would want to assist to go to school, but they won't.

Lecture on Planning

It is good to understand and aim high in life. If you have a plan and an ambition in life, you'll always achieve it. But if you're living, not planning, not thinking of tomorrow, then you have no future. There is nothing like saying "I was born unfortunate." Who was born fortunate? Nobody! Nobody's born fortunate. God has created us all the same. Nobody has been created by God without giving you the brain. Very few ... maybe the disabled. But what God has given you, you have to add one plus one on top of it to make a living. The rain rains. Whether you're poor or rich, it will always rain in your compound. And if you do not utilize it, who is going to do it for you? God has given you the land. Actually, in Africa, we are so gifted. There is plenty of free land. Except, very few people would want to use the land the right way and very few people make the effort. They call it a waste of energy, which is not the case. Today you're sweating, tomorrow you are going to eat the sweat of yours.

If you have a plan, you use how small your plot is, you can at least earn a living out of it. But if you get up in the morning, walk to town, play cards the whole day, come at night, and you expect to be fed ... *huh*? You expect somebody to think about you, to feed you, and you make that routine. Every day you do the same thing, what is that? And when you are told, "Why are you doing all this? I'm also making an effort to feed you," you get annoyed. Am I a wrong person? Call me bad, I don't care. But I have told you the right thing. Because there's a saying in our language that "one hand cannot do what two hands can do." So join two hands together: the effort combined is double and production is actually more.

* Qat: a leaf that is chewed, producing an addictive high. It is stereotypically used by young men, those unemployed and idling about town, as well as taxi and bus boys.

Lecture on Women in Polygamous Marriages

Like these husbands who have many wives and you want to depend on your wives. Yours is only there, a man in the home by name. Those types of husbands ... I wish I could be the wife of those types of husbands—they would know what it means. I can't help this. You live your life only, bathe in the morning, take breakfast, you go out. You come back with your empty hand—empty hand! You sit in the middle of the compound to wait for where the food is going to come from, from which wife. And they call it love: "Let me show my husband the love by feeding him." I can't do that, I just can't.

Let's work together and then make the family. The family doesn't belong to one person. It belongs to all of us—you as the man, me as the wife, and the children, all other relatives who are living with us, and then we call it a home. But if you're going to be a grownup, you are the head of the family and you want to be dependant—on who? On who? They stress women so, so much, I can tell you. And many women just go under that stress, without even mentioning it, but deep down in their hearts, there's a lot of depression ... a lot of depression. You die a silent death.

You see a person, talk to a person, so happy. But you call yourself a married woman and he is stressing you so, so much. He is your own husband and you even fear to mention it to him. Are you not a human being? The day when he was bringing you, did he tell you the ABC's you're coming to do in his home? He never told you. Why can't you have your right and tell him, "Why can't we do things this way?" It mostly happens with the illiterate women. They feel, if you complain, your man is going to chase you away. Is he the only man on earth? Can't you do without a husband?

Concerns for Youth

I always talk to girls who come near me, and my advice is: Look for your own, own husband. Be the only wife of your husband. How poor he is, make that effort of bringing up that family of yours to a grade which you want and you will always achieve it. But marrying a rich man because of his riches,

there's no happiness in it. Because you didn't make an effort to get what he has got. That's why he doesn't even consider you as part of anything to him. He does his thing the way he wants it. But you marry a poor man, you start from zero, you start getting, you buy a radio, the radio will be yours—both of you. You buy a bicycle, it will be yours. You put your small house there, it is yours. But if you come because of riches, there's no happiness. I don't know whether my reason is different, but that's the way I take it. It's very difficult. And these young girls, most of them dropped out of school because of their own stupidity, dropping out of school because a *boda boda**—these motorcycle riders—gives you some money. Is there any future in this type of a person? The motorcycle is not his—he's hiring it. You have become now two, the next day you're going to become three, four, five, six. What's the future there?

And most of these boys you find around town, they don't want to dig [cultivate]. They don't want to go to the villages. They don't assist anybody in their own families. They can rent one small hut, five or six of them in one room. What type of life is that?

But the war has ended long time ago. Many of those boys even who went to the bush after the war,† they were given packages and some of them have even gone to school and graduated. Yes, it's your own ambition. School has no age limit. Once you're determined to do something, you'll always do it. But there are people who take it for granted, saying, "I'm now too old to go to school." Who has chased you from a class? There is nothing like that in Uganda, that "you are too old, get out from this class." It does not happen. There are people who have no ambition in life. They just think "If I can ride my *boda boda*, maybe I get 20,000 shillings in a month."‡ So, they just take it that it's life, which is not the case. You aim at something at least. It would be better, get your education, do some course, have a formal job to do. You do this one [*boda boda* driving] as a substitute to your daily living. But as soon as maybe you keep on applying, you get a good job—it's much better. But if you have no qualification completely, that is your own problem. How are you

* *Boda boda*s are motorcycle taxis. Tina is referring to the men who drive these for a living.
† With the Uganda National Rescue Front II, a local rebel group that signed a peace agreement with the government of Uganda in 2002.
‡Ush20,000 equates to about US$12. 102

going to survive? That's impossible. You'll find it difficult ... very, very difficult.

They think digging is meant for those who are uneducated, which is not the case. If you go to the agricultural institute, you will find a whole professor* teaching you. Why? Ask yourself that question, if a professor has just graduated in agriculture? And what does that agriculture mean? Is agriculture done on a paper? It's on the land. So things are not pleasing. Agriculture is the backbone of the economy, because all the income which comes in is generated from the land. The tobacco we dig, the coffee we dig—is it in an office? It is on the land. So if you are going to look at farming or cultivating as a poor man's job, then you are lost. You are completely lost. The poor man, for him at least he has his food. What about you who are on the street looking for the white-collar job? Where are you going to get your food from? You've not got the job, you don't have the money, you don't have the food? Who is better off? Don't you think the one in the village?

For the generation to change and to believe, a lot has to be done, a lot has to be done. And of late, actually, there've been a lot of seminars for the youths. The churches have been organizing it. The mosque also organizes it. Then schools also do the same thing to make these negative attitudes of the new generations to change at least.

Concern About Privileging Children

I am not soft with my children. I am not. And they know me the hardest way possible. I don't give them that soft life they want out of nothingness. That's why I was telling you, those boys of mine, they cook for themselves. They maintain the home. It is a home in their hands. Right now, because you know they're not working, they're all in school, that money they need we give it in their own hands. "Don't eat it in a day. But I've told you, this money I've given you is supposed to take you for this duration. Spend it the way you want. It's not my problem. I'll never complain. You want to eat? It is you to get the food and it is you to cook it." They don't eat from restaurants;

* She means a full professor: someone who has achieved professorship.

they don't eat in any restaurant. They do their own cooking, starting from breakfast, lunch, and supper. They have to make it because that is the way I brought them up at home here. I don't want my kids going to eat from neighbours' places. I don't want my kids going to eat from restaurants, unless on occasions when we take them out. I've never given them a part of the soft cake, because we also never got that soft cake on a plate. We never inherited it. We sweated and got it. So, that is what I am trying to pump into them. Don't think that "My father has a car. My father has a nice house. This house is going to be mine." "It is not yours. Anyway, you will inherit them when I die, but when I'm alive? Ahh, no, nooo ... no way. [*She laughs.*] I have given you the education. Aim higher."

I have these undeveloped plots and they think that I was buying these plots because of nothing. There are three plots that I've not even done any development, and they don't know what I'm aiming at now. "As soon as you get a good job, why are you living with your mummy? Why can't you start building on this plot and you take it over?" That's my aim. Because this habit of bringing up children on soft plates will never be good for their future. They will remain dependants on you ... completely. They will become a nuisance.

Supporting Orphans

Of late, I have decided to help mostly orphans. But the ones who are just able-bodied don't get anything out of me. Right now, I have the three children of my late brother. He passed away in 1998. Immediately after my operation, that's when he died. I've taken up the family and I'm the one helping them. The education part of it, there's a priest who is in St. Cypriano, in Kampala. He pays for a lot of the orphans, especially from the displaced, northern region. And these kids, their mother comes from Kitgum so, during the war, they were in Kitgum. When they came from Kitgum to join their mother in Kampala, when my brother passed away, the mother took them to their grandmother. So, when they were brought to Kampala, this Father John took them. He started with their education. He pays their school fees. But

the other requirements, it's me and my sister to give them. I'm renting for them a house, a two-roomed house. I pay 45,000 shillings per month.* The foodstuffs I produce from here. Even the potatoes, at times I give. I put it on the bus, it goes. I just ring them to go and pick. I buy beans or get the beans from the fields, send for them the groundnuts, the *simsim*.† So, half of the food I produce I use for myself; a quarter I sell; the other quarter I use for helping my people.

Of the other orphans from her family that she is helping, Tina explains ...

Those ones are the younger ones. There was a set who are now grown up. Like this one, I brought him up, the small Mawa. My father died when that boy was three and a half years old. He has lived with me all through, from that age when my father passed away. My father died in 1978. Up till today he is with me. And they are two—the brother who follows is in the university. He's finishing this coming academic year. He will be out of Makerere University with a Bachelor of Education. There were two sisters and two brothers whom I brought up from childhood. I took over them immediately after my father's death. They are my father's children but from a different mother. They lived with me all their life. The two girls are now married; they have children. But the boys are still with me.

All of Tina's own children are grown or soon finishing high school and so live in Kampala during the school term. However, there are several young children I see staying in her home. She tells me ...

They're my relatives' children. The boys, actually the three ... There's Mohammad and Jafari, they have the same mother. After my last-born grew up, she was in P6, I felt the next year when she goes to boarding school, I'm going to be completely alone in this house of mine. And then this stepmother of mine comes around and tells me, "There is this brother's daughter, your brother's daughter, she has children but her husband is not assisting her in any way. Suppose you talk to her." I said, "Please, you go and tell the

* Ush45,000 equates to US$27.

† Groundnuts are peanuts. *Simsim* is the local name for sesame seeds, which are often ground into a paste similar to tahini.

girl." The next week, I had to first get that boy. He had kwashiorkor when they brought him up to me. There was no hope. Everyone thought Mohammad was going to die. I never took him to the hospital. I never took him to the feeding center. I started feeding Mohammad. Within two weeks Mohammad was fully recovered. So he grew with me. And each time I tell him, "I want to send you to your mother," he says, "Me? I'll never go back there. I want to remain with you." And when I tell him, he gets very depressed. When I tell him I'm going to take him to his mother, he gets so depressed because of what he underwent in the village.

And Mohammad's brother, Jafari, is his second follower. They gave me Mohammad's immediate follower. I said, "No, let that one be for her [the mother]." Now, after delivering this one, Jafari ... He started walking at the age of one and a half years. I told my stepmother, "Bring that little boy to me." He didn't even know how to talk when he was brought here. He had just opened his eyes slowly: "Who is my mother? Mum is my mother, Dad is my father"; he doesn't know the parents. The good thing is, though they go to school, when they come back they give you a lot of time. And when they're not at home I'm completely so, so lonely. With them around the compound with their friends, even when I go to Kampala, the home keeps on being lively. They play around with other children. They keep me at least busy. So I have decided to bring them up.

And the other boy, the one in P7, is Jamal. I had brought Jamal's mother up. When my mother died, they gave this girl to me. I'd asked my sister to give me somebody to stay with me. She was a little girl of two years. I went with her to Kuru Hospital. We went together in exile. She got this boy when she was in S3. I didn't want her to drop out of school, so she breastfed the baby for seven months. I sent her back to school. She went and joined S3, completed S4, did very well, went to HSC,* did well. I wanted her to go to the university. She said her points were very weak. The course she was going to do was not of her interest. Then she went to UCC [Uganda Commercial College] Pakwach. She graduated. Now she has registered in the university [Kampala International University] for a diploma course, this academic year.

* HSC refers to Senior 5 and 6, which are the equivalent to O-level and A-level in the British system.

Now she's married to a different man. She has two children with the man. And this one [Jamal], nobody knows whether I'm ever going to give this child to her again. So, that's another boy of mine.

I have a set of new ones whom I'm bringing up and now people are even asking me, "Suppose now these ones also grow up?" I said, "Uh-uh, don't call me 'night dancer'.* I always have at least a set to bring up." I don't like bringing up girls. They're a big nuisance. Girls can mean to disappoint you. I got actually so, so disappointed when this girl, my sister's daughter, got pregnant. I was not happy. I wanted this girl to go up to university. But fortunately, she has really given me the happiness I wanted. Because, when I took her back to school, she knew that "my mum, at least my auntie, really wants me to go to school," and she has at least achieved what she wanted. So, girls are more disappointing than boys. Yah, I always like bringing up boys because, with the boys, it's very hard, if you're hard with them, for them to drop out of school—unless you are a soft parent.

So now Jamal is in P7, Mohammad is in P6, and it's Jafari who is in P2. The moment these ones go to a boarding school, I'll have to bring a new set of boys. I don't want to pick a kid when it's big—I don't want. I want to raise them from childhood so that they know my own teaching exactly. And at times people ask me, "What do you do with these tiny children? Why are you picking a small kid like that?" I know why I'm doing it. Because, you bring a kid like Rashid—Rashid came here when he was already a big boy. He acts quite different from the others. He doesn't want to work. He's so rude. But, if I'd brought him up from childhood, from the age of one or two, it would be a different story. I prefer bringing a kid from childhood so that he grows up knowing the right thing which I want out of him.

There's a set that I wanted to take up but I didn't like it. A cousin who died has young children but the children, the way their mother brought them up, they don't like school. What am I going to do with them? A group

* A "night dancer" is a person who comes at night and dances naked outside another person's home. There is much superstition around them, as they are believed to do this out of jealousy of the other person and to be involved in witchcraft. In referring to this, Tina is likely making an inference between such suspicion and people's questioning of her.

of people who are going to give me only headaches. "Why don't you want to go to school?" The answer's not there. They just don't like school. That's the attitude. And my husband doesn't want a kid who is staying at home here who doesn't want to go to school. He doesn't want it completely. So he would always tell me, "Mum, any kid you bring home here should go to school." So I failed to bring up those kids. I just give them assistance, from their uncle's place where they're staying. It would be good for a child to have a future. That's my motto.

As is evident, Tina and her husband support many more children than just their own. Over time I heard of several others whose higher education they paid for, many of whom were not even relatives. These young people are an investment in the West Nile Region, as some are now doctors, lawyers, teachers, and local leaders.

For now, to keep her company and her life busy, Tina has with her at her house in Arua ...

Four small kids, three big boys, my worker Bada, "Uncle" who keeps on coming on and off, and then the three big boys. Yah, we are around eleven. We are eleven at home here, although visitors are always in and out.

Reasons to Keep Going

After listening to so many of her stories, hearing of her disabilities and challenges, of how many times she has survived death, I wanted to know how Tina has kept going. What gives her the will to live, the strength and resilience to go on?

So many times, actually it is true, I came back from death. But God has always looked after me. And there's one thing me I believe so, so much— with God there's nothing impossible. Without God's blessing, I would have died a long time ago. But I'm still pushing on. And, each time I fall sick, people get so, so moved.* Me, I don't. It has been an experience. If it was time for dying, death comes. You can't avoid it once it comes. I'm not the type who is so much concerned about my health. I don't get so moved when other peo-

* "Moved" here implies scared.

108

ple are sympathizing with my disability because I know there are people who have worse disabilities than me. I'm able to do all things, except the disability of not being able to walk long distances. Within my own compound, I can walk. I'm able to sit and cook. I'm able to plan my things. I didn't get any disability mentally. I'm very, very sound mentally. That's something I'm so proud of. I can still keep on moving. I plan my things. I do them actually even much, much better than those people who don't have any disability.

Many people get so, so surprised when they see the work I do, because nobody would even expect me to do such type of things. And there are those who have that attitude that, "Why should I keep on struggling? My husband can provide for me. Why should I give my husband the burden? There're a lot of other responsibilities to take care of. Let him take care of the responsibilities where I know I cannot do anything. But the ones I can still help myself, why can't I do it? Why can't I?" Actually God has created people, saying: "I have given you the legs, the eyes, the hands to help yourself." I'm still alive, breathing. Why should I be giving people burden? So I did not want my disability to take me to an inability—I don't want it. The stage I am in, I'm still able to do a lot ... able to do a lot. That's why I continued. Except when I'm in much pain, that's when I cannot get all my own responsibilities done for two, three months or a month or a week, like that. But, so as long as I feel okay, I have those workers who help me. But I'm the chief planner. Why don't I plan it and keep the work going? That's my aim. That's how I lived.

I don't want to become totally dependent on somebody—I don't want it. Because, if I were to do that, my husband wouldn't be able to go back to his workplace. He works outside the country, and here is somebody who needs totally your attention. How would he be able to go out? And that's actually what happened the first year when I came out of the hospital. He felt that he should actually take three months' leave without pay. My relatives told him, "Is this the end of the sickness? For us, we think it is still the beginning. And it has been very expensive—my treatment. Now, suppose she will need to go back to hospital, what would you do? And if you take leave without pay, where will you get the money to look after her? So the best

thing is, you leave her to us. We are near her. We shall always take care of her. Go back to work."

He was so depressed. My husband was more traumatized than me during the time I was in hospital. He broke down. He was speaking so many things. And for him he had no hope. He thought I was going to die. And here is the husband who has never been in the family all the time. He doesn't know how to take care of the family physically, although he can provide finance. Planning, he has not been doing it. He was not close to his children; the children were more attached to the mother. So he was thinking a lot of things. And actually he went up to the point of telling me, "Mummy, do you know what is in my head? In case you pass away, as you have also requested that I shouldn't bury you in Kenya but take your body to be buried home, I will do that. But after your funeral, I'm going to get out of the country. I will take my children, sell our properties, and go away." I said, "Why?" He said, "I will not cope, living in the same house where we have been together. Because it has been all your efforts and now you will not be there. Where am I going to begin from?" I said, "That's being a coward. If I were you, I would be so, so proud living in the same house. Because each time I will be recalling, this was the effort of my wife, this was the effort of my wife. Then I would feel very happy. But if you have taken it that way, I don't have any objections." Sooo, God has been so great to me, and I'm alive up to now. Otherwise, for him he had given up.

How I Got to Be Good at Planning

My plan ... I think it was just God given. I started that responsibility when I was still a young girl. From the time when I became twelve, my father entrusted a lot of responsibility in the family to me. The key to the stores was in my hands. The key to the fridge was in my hands. I had to check whatever is missing in the fridge. I write it down, present it to him. I check the store, what it needs. And we were in a very good family, actually.

We had a time of all these meetings. Two Sundays a month, we used to have a family meeting. And when those others who were in the boarding

110

schools are not there, I was the eldest who was at home. I held the meeting. We shared views, we planned together ... for the family. And when we get on holiday, before we go back to school, we usually have a family meeting, where my father, my mother, and my step-mom would be there. And my father would talk to us very openly. And then my mother and the other wife, they would say what grudges they have, what bad the children are doing maybe, whether you are not working enough, whether you are not taking care of the family. They would air their views and then also give us a chance to present our side. Yah, we would also speak. And actually, my father would give us more chance of planning how we want things to be done for us. That's where I think I got that experience of being good in managing a place.

By the time I was born actually, my parents were not badly off. My father had bought his first car and built our home. By the time I was born, he had already bought his first car. It was a Peugeot 504. And he built us a nice house. It had five bedrooms and each child had a separate bedroom. So we grew up a very united family, just like that. That's, I think, where I got experience of managing a place.

And for me, I went to a boarding school when I was in senior level. My primary was all throughout at home. And I was the manager at home. My father would even tell us, "Can you plan our diet?" I'd say, "Yah, yah, yah, Daddy. This is what we have to have for lunch. After, we have to have this. Tomorrow we want to eat this." Just like that. Yes, I was doing that from the age of twelve. I was a good manager and actually, I wouldn't say I was so hardworking but I was much, much better than my elder sister. And I grew faster than my sister. I became bigger than her in height, in body. She looked smaller than me. And, as a result, my father would give me more work than her. I was that type who was always working hard. I started working from the age of twelve. I knew everything. I could plan. And my father, being of that class, he gets a lot of visitors. We used to get so, so many people in our house. And we had so many relatives who were living with us. So when I got married I didn't find it difficult to be in management. And even my late mother-in-law used to ask, "Many of the girls who go to school don't want any work

to do, like field work." Why am I different? She asks me that question. And I would tell her, "I was brought up in a family where my parents used to believe that you can provide for yourself from land. We used not to buy food in our home."

My father actually was not the type that wanted us to work so, so hard because he said he grew up an orphan, he suffered a lot, he didn't want his children to suffer. But my mother had a different view. She said, "We are not permanent of this earth. We don't have very close relatives." My mother didn't have a brother of her own. My father didn't have a brother of his own. My mother had sisters but no brothers. My father didn't have a sister; he was the only child of his mother. So she said, "Let these kids learn how to do everything for themselves. Because, if the worse comes to the worst, they'll stand on their own feet." My father would say, "But they are going to school. They will be working." She'd reply, "Do you know that work can also come to an end?" That was my mother's view. So my mother taught us how to grind, how to pound, how to cook, how to weed, how to dig. We would always go to the fields when we were on holiday—all of us, all the children at home. They'd assign us some work and we didn't feel bad about doing it.

And I grew up in a fenced home—no going to the neighbour's place, no playing outside your own home compound. And that one was even worse or better, because the fence extended from home, and all the fields were enclosed. So it was actually an enclosure. And that's how we grew up. And people wonder why I don't bother about going out. That's how I was brought up. We've never been moving to people's compounds. When you want to come to town, which used to be on Saturdays—that's when we'd come for shopping or marketing. He would give us the vehicle and everything is on a paper. And, after shopping, we are just in the car and home. That's how we lived. And we used to only leave home to come to church. It was very rare that we used to visit relatives—very, very rare. And, if we have to do it, he drops us to the place where we are going, we spend a day, and it used be at my maternal uncle's home. He was a magistrate. We'd go to his home. It was two

miles on the Kampala road. We stay there and then by about five p.m. he'd come and pick us and take us back home. That's how we grew up.

Reflections on My Father's Example

It's just unfortunate that I don't have transport. I really wanted you to see our village, the old house of my late father. We call it a "memorial house." We never destroyed it. It's so, so old. People asked us, "Why don't you break this house?" We say, "Why do you want us to break our relationship with our parents? This is where they put us. We feel proud seeing it like that." And actually right now, the grave of my father and my mother has sunk and has broken down. We are planning to rebuild it. And the culture says, when you're doing it, you are supposed to have prayers, call relatives, have food. That's another expense. So we are thinking maybe we could do it in December, if all goes well.

The oranges have grown now so old ... but when they want to cut them I tell them, "No, no, no. Plant your own orange. The home is big. Plant your own. Leave that one. That one is for my father. Leave it there." I look at it as my father. And I'm so, so proud of my late father. That was a man! Well, well organized. He was so organized, that man! He really worked very, very hard. Because many people work, get to retirement age, but they have not even put up a structure. But this was a man, by the time I was born, he was already building a very nice, permanent house. And each time, every two, three years, my father would buy a new car. And people used to wonder where my father used to get his money from because he was a medical assistant and their salary was so, so low. But he was able to do it because he was so, so hardworking on the land. In spite of having a large family, he stopped buying food. So each money he gets, he banks it. He was not buying food. It goes in for school fees.

But, food! My father had ducks. My father had cows. My father had sheep. My father had goats. My father had very, very big poultry. We didn't buy chicken. We didn't buy meat. If we wanted to eat meat, he'd say, "What do you want to eat, a goat or a sheep?" And we'd gather round him and say,

"Daddy, we want a sheep." He'd say, "You go and pick the biggest one." They'd slaughter, put some of the meat in the fridge or we'd dry it, and you continue eating. Beef would never get out of stock. Cassava would never get out of stock in our home; neither would sorghum and millet. What I'm doing, I actually inherited from our own family. That is what my late mother and my father used to do. They had many workers in the field. Food was just constantly coming in and out, just like that.

So life is a struggle. And, so long as I can still sit like this, plan and manage, I'm not going to stop my struggle. I'm not. I'm not. Because I know where it helps me so, so much.

CHAPTER IV
Juliana Munderi Denise

JULIANA'S STORY COMES out of the lush mountainous region in southwestern Uganda, on the border with Rwanda and the Democratic Republic of Congo (DRC). The people of this area are known as the Banyirwanda or the Bafumbira—the first name indicating their relatedness to the peoples of Rwanda and the second, preferred, name both distinguishing them from the Rwandese in terms of the development of their language and culture under the Anglo versus Franco colonial influence and, more importantly since 1994, distancing themselves from the Hutu/Tutsi distinctions that fuelled the Rwandan genocide.

Kisoro is sometimes called the "Switzerland of Uganda" because of its mountainous topography, its forests and lakes, and its cool and often damp climate. This is a lush, fertile area with hills and mountainsides densely cultivated in patchwork patterns. Tiny houses with zinc roofs dot the land—

unlike the more clustered villages of the north. At the base of one valley lies Kisoro town, the district's main urban centre and the last stop before crossing into Rwanda or the DRC.

Civil war is not part of the history of this area. It tends, rather, to be a safe haven for refugees spilling over from conflicts in the eastern DRC and Rwanda. Thousands of refugees flow back and forth, at critical times necessitating major humanitarian relief efforts. The influx of such numbers puts strain on an already tense situation where local people live with high levels of poverty caused by severe land shortages and related food insecurity.

Land shortage in Kisoro is due to the ever-increasing population and the corresponding decrease in cultivable land. Soils in this area consist primarily of volcanic rock, fertile but difficult to work, particularly on thirty-degree inclines. Already-small parcels on steep hillsides are repeatedly subdivided to provide for the traditional inheritance of young men in the family. Eventually there is insufficient land for the men. This means that women who marry such men have no matrimonial land on which to cultivate food for the family. Their choice is either to rent land, if they can afford it, or hire out their own labour for wages barely sufficient to provide a day's rations of a single meal for the family. For many, the daily struggle is literally to get food to eat. Hunger is ever present, to greater or lesser degrees.

Without adequate land and food, there is little access to cash and therefore an inability to afford luxuries such as education for children. Children also provide essential labour in food cultivation and so are critical to a family's survival. Where choices are made for education, girls are given less opportunity. Illiteracy rates are thus very high in Kisoro, especially among women.[84] This situation, together with the overall poverty,[85] translates into disempowerment among women and a frustrated resignation among many men who lack livelihood opportunities.

It is these underlying issues of poverty and land pressures that create the conditions for community and even regional conflict. As well, the related issues in Rwanda and the unrest in eastern DRC simmer beneath the surface and constantly threaten to spill over into Kisoro. From within this context, Juliana Munderi Denise tells the stories of her life.

Introduction

My connection with Juliana came about through Dr. Deus Nkurunziza, a Catholic priest and a professor at Makerere University. Upon hearing of my research he told me of a woman in his home area who was a real "pusher" for women's issues and wondered if I would like to speak to her. Some weeks later, I accompanied him on the eight-hour journey to Kisoro. Only on this trip did I come to learn that Juliana was actually his first cousin.

Deus's duties would only allow him to stay the weekend but I was to stay almost ten days. I was put up at a small convent for retired nuns, about a

fifteen-minute walk from Juliana's home, to avoid any undue inconvenience by the surprise nature of my visit to her. This arrangement had both pros and cons: it maintained her space and control over our interactions, but it also hindered our communing over shared meals and becoming familiar with one another through the daily tasks of living—something I found to be important in building relationships with some of the other women.

My introduction to Juliana was made that first evening. After a phone call from Deus to find her whereabouts and inform her of our arrival, Juliana appeared and filled the room with her presence. A tall, stately, elderly woman, she presents a mixture of familial informality and the formality commonly found in educated African women. She appeared thrilled to see Deus and was exuberantly welcoming of me—in a flurry taking out a bottle of V&A sherry that she'd come with and insisting we all have a drink in celebration!

Once told of the purpose of my visit, and that I would be coming daily to visit and interview her, her welcome, however, became tinged with cautious hesitancy and subtle suspicion. All of Deus's embellished affirmations about her importance to the study and generous introductory comments about me would only redeem the moment; it would be up to me to win her trust over the next several days, which I did. However, a certain caution would continue to weave its way through our relationship, at times more or less apparent.

She was adamant about not having her voice recorded, and no amount of explanation or reassurance from anyone could change her mind. Whether this came out of her experience as a politician and not wanting to commit herself to being directly quoted or out of the old cultural taboos against having one's photo taken or voice recorded, I would never know. I resigned myself to taking notes and rewriting her stories after the fact. Thus, while Juliana's stories are told in the first person, they are, unlike the other women's stories, recreations from my memory and notes soon after the telling. This is as she wanted it. When I returned some months later to edit the

draft with her, she was overjoyed at seeing her stories. Her exclamation of "you got it right!" was my much-coveted seal of approval.

In this chapter, the first section presents my reflections on Juliana's home setting as the backdrop to the telling of her stories. I then provide a brief overview of Juliana's life as a prelude to her own stories. In the second section, Juliana tells her stories. These initially follow her chronological life story and then, in discrete snippets, she tells about her various activities and community involvements.

Juliana's Stories in Context

Juliana lives in Mutolere, a suburb of Kisoro town that grew up around a Catholic mission with a church and hospital that are still its focal points today. In spite of seeming quite isolated from the rest of the country, both Mutolere and Kisoro town boast numerous modern, urban-style houses and buildings among the more typical small local houses of mud brick or cemented stone. Mutolere hosts a couple of small trading centres with tiny shops and canteens situated at the two main crossroads. The land surrounding these structures is heavily cultivated with banana groves, cabbages, climbing beans, potatoes, and other food crops.

Juliana's house in Mutolere is near one of these trading centres, up a slight rise, past her large grove of banana trees on the left and a plot of beans on the right, then down a short, rocky, and rutted lane—along which her son and his family also live—through open gates, into a small, walled compound bordered inside and out by flowering plants and bushes. Her house is cottage-like in size and design—brown stucco outside, a verandah with a small window on each side, and an attached shed for her vehicle to the far right. The main sitting room is simple, with four low cushioned chairs along two walls, a worn woven mat in the middle, a few wall hangings—crucifix, a portrait of Jesus, and a stopped clock hung high—and, straight ahead, a curtained doorway to the other four rooms of the house.

One day she takes me through the curtain into the dark kitchen and out the back door, where there is an enclosure for her few cows and goats, an

outdoor pit latrine, and an area where a couple of young girls sit peeling *matooke* (cooking bananas) in preparation for the evening meal. Barely separated by shoulder-high stone boundary walls, she is cheek by jowl with her neighbours; she knows everyone's stories.

Juliana's family is prominent in the area. Many of them are well educated—among the first in this area—and several have traveled internationally. They are strongly connected to the Catholic church, with more than one having entered religious orders. Juliana is in her early seventies. She is a retired teacher, headmistress, and politician. She is well educated and well traveled, having been to Europe for various postgraduate training programs. She is a mother of four—three girls and a boy—and was widowed early in life. She never married again, and has raised her children on her own, with the assistance of her family.

Since her youth, Juliana has shown a certain stubbornness and independence of thinking, as evidenced by her determination to go to school and later, as a new widow, by her refusal to be "inherited," as is the local custom, by her brother-in-law. As such, she has been and is still a leader in her community, forging uncharted paths and being an example to others. She is a landowner in a context in which very few women can afford land. Even more radically, in a place where every inch of land is deemed necessary for food production, she is deeply committed to using her land for conservation. Keenly aware of these issues, she is an advocate for women's rights, particularly those related to land and literacy. She worked tirelessly as a politician in this regard. Juliana has taught both formally and informally, in secondary schools, colleges, and community literacy programs. She values education highly and now pays the school fees for several teenage girls.

Juliana lives intimately connected to her community, intentionally maintaining a simple lifestyle, mediating neighbourhood disputes, gathering stories from local women and the shepherds about traditional beliefs and practices. She advocates for the local language, and even writes children's stories in it. At the same time, her life experiences and her personality also set

her slightly apart. She is of the people, yet she is also different from them—in her visions, aspirations, concerns, and capacity to challenge for change.

Perhaps most significantly, Juliana is situated at the crux of several dichotomous and potentially conflicting worldviews: she is the grandchild of a strongly Catholic catechist and a powerful traditional priest; is schooled in Western-influenced, formal education systems, and yet remains deeply connected to and an advocate for traditional culture and its life-sustaining values. She has lived independently, with the power and privilege afforded by her education and her family's status, often making strong decisions that countered cultural or societal norms, yet, as a woman, has experienced the social and cultural limitations of gender in terms of roles, responsibilities, and opportunities. It is against this backdrop that her life has been lived and her stories now unfold.

Juliana's Life as She Tells It

How My Family Came to Be in Mutolere

I will begin by telling you the story of how my family came to be here in Mutolere. It was like this: My grandfather's sister had gotten married to one of the chiefs from Buganda—a Muganda administrator—so she lived there in Kabale. My grandfather, Yohana, and his brothers decided to go and live there too, to enjoy the life of living among royalty. They were like militia who brought people in for punishment of offences such as not paying their taxes or for beating their wives, things like that. Then, as the colonial administration became serious in Christianity, Yohana was sent to the centre of Christianity in Mbarara District, to be baptized and indoctrinated into Catholicism. Coming back from there, he rose in ranks and so was made a chief. He married my grandmother, Marita. They had four girls and a boy— Deus's mother Salome, my mother Gatarina, Sister John Chrysostrom, Cecilia, and the boy Gaburyeli.

From Kabale, Yohana was sent here to Mutolere to open up the area for priests to come in and set up various parishes. He and his wife were essentially missionaries. This was a tough time. He was having to take land away from local people for the *bazungu** missionary priests. He was preparing the way for them. Then the priests came. Yohana was given a large area of land, which is where the family is now. He kept his daughters close to him by giving some land to their husbands for a small price. This is highly unusual, as most women traditionally go to their husband's clan once they get married.

My grandfather, Yohana, was the administrator for this area so he was well known in regulating and governing the area, especially in terms of shifting abode, because this is a border region. He was important in enforcing the borders so that people were either in Rwanda or Uganda.

My other grandfather, Mateke, was a chief priest of traditional African spirituality for the clan. His theory was one of being someone between people and God. He was someone who cared much about spiritual matters and was powerful. He refused to be baptized. The priests tried to bribe him with tobacco, clothes, and a nice jacket, but to no avail. Finally, one day, the priest asked for a certain tree to be used in the brick kiln to make bricks for the church. This big tree was sacred and used for various rituals; it was like a family altar. But, Mateke gave it and cut it down. It is interesting that something so-called "Satanic" was used in building the church. One would think it would defile the church.

Yohana agreed for my mother, Gatarina Catherine, to marry the son of the traditional priest. This son, Yosefu, was educated, a carpenter, very intelligent, and a Catholic.

At that time, every family had been required to send one child to be educated and indoctrinated. People thought that they were sending their children for "silly" things to learn, only to find out later that those who were carpenters, masons, teachers, and such were the ones who then got good positions. So it was not so silly. This is how civilization came here.

* *Bazungu* is the Ugandan Kiswahili word for white people, in the plural. This and the singular form, *muzungu*, are commonly used throughout East Africa, even though every language has its own specific word.

My mother, at age twelve, was sent to the religious centre to be baptized. Often the children of the unfavoured wives were sent, as it was said, "let them be as unfortunate as their mothers." My mother had also grown in the chief's court and so was exposed to another foreign culture because these were Baganda, while she was Bafumbira. Here she was taught different ways of sitting and such things from that culture.

My mother was one of three wives, but she was the first wife. My father built all the government institutional buildings in this region. He was never here at home but traveled with his work. One wife was with him in Kabale and the other two were here in Mutolere. My mother would go to visit him with her children, stay for a while, and come back to the main homestead. In total, she had five children—three girls and two boys. Stephen, the eldest, started in the priesthood but stopped. Damion became a doctor. Of the other girls, Bernadetta became a nurse and Restituta became an accountant.

Deus's mother married an agricultural man. She was highly educated herself, as she and her sister Cecilia were both teachers, teaching English. And these two sisters educated their nieces and nephews (to varying levels). We would go and stay with Deus's mother and father in Kabale and they would pay our expenses for school. They were very generous.

My Story of School and How I Got Educated

I was born in 1935. I started school in 1942, so I was seven years old. At that time, you could go up to P5 here and then you had to go to Kabale, eighty kilometres away. P1 to P3 were taught in the vernacular. Thereafter was in English. The missionaries would send a truck to pick up the boys and girls from this area and drop them at the various schools in other districts.

After I finished P5, my father sent a message from Kabale to my mother that, since my brother Stephen was far away at school, my mother should keep me home to help with the work around home. Upon being told this, I cried my heart out all night. Meanwhile, the truck left with the other children on it. The next day I went up one of the hills—they call it "Sanctus"— and told my friends and sisters that I would stay there in one of the small,

cave-like, dug-out areas and would not come down. They brought me some small food. That evening, after not seeing me all day, my mother asked where I was and was told I was up the hill, and that I said I would die there. My mother thought quickly and wisely and told my cousins to tell me to come down and she would send me to Kabale the next day with one of the local men who worked with my father there. He was walking to Kabale and I would go with him to my father and he would tell my father that my mother was sending me to help with the work at the home there. In essence, she was playing a trick on him to enable me to go to school since, once I was there, he could hardly send me back. And he obviously didn't need me to work in the home, so he would send me to school. This plan of my mother and her ability to send me such a long distance from home I attribute to her own experience of traveling far from her home for religious teaching when she herself was just twelve years old. I was eleven then. I went to P6 in 1947.

I walked with the man, up and down hills, for the whole of one day, to arrive in Kabale, with my legs and feet and hips excruciatingly painful and absolutely exhausted. My father was obviously surprised but, as per my mother's plan, he bought me the necessary supplies—my first knickers, suitcase, and bed sheets—and took me to school. I finished that school and went farther from home to a girls' secondary school run by nuns in Mbarara District. And then farther away still to the Teacher Training College (TTC) in Toro District, Fort Portal side. This changing of schools was an added social advantage because now I can speak all those languages of the different areas.

During one of the holidays each year, several girls were unable to get home here so the nuns planned events for us. They took us to near Kampala, at Kaazi on Lake Victoria, where we were involved in Girl Guides. I was an excellent Girl Guide. I was also the one to bring Girl Guides here to Kisoro.

So I was unique compared to my cousins—because of my own stubbornness and my mother's determination. I attribute all that we are as children to my mother, as my father was never there with us.

Continuing My Life Story

After TTC, I worked in different areas for about five years. Being a "mistress"—a schoolteacher—was such high status in those days. All the young female teachers had their eye on a particular man as the one they would marry, and we would watch his behaviour and check up on the men for each other. For me, I always knew I would marry Munderi Denis, who was a friend of my brother. And I did. So I married in 1958 at age twenty-three. We lived and worked in Mbarara. I had two children with him—two girls. Then he died in 1961 and I became a widow.

It was the tradition here that, when a man dies, his wife is remarried to one of his brothers. After my husband died, his family wanted me to marry his younger brother. But this brother was much younger and had his own girlfriend at that time. My husband and I had paid his school fees so I saw him as more of a younger brother to me. I felt I couldn't marry him and I told them so. We have broken that tradition gradually, with education. Most educated women have chosen not to do this.

The tradition of widow "inheritance"; that is, of a widow being automatically given to a brother of her late husband, was a means of protecting the woman from poverty, destitution, and social vulnerability after the death of her husband, in relation to whom she would have had access to land, resources, and social status. This custom was also a way of maintaining the man's children within his family, since culturally children belong to the man; the family of any new husband from outside would not be able to claim the children and therefore would be unlikely to care for them well.

Here, widows are expected to have children even without being formally married. When I produced my third child, after my husband had died, my aunt praised me and said something like, "you can't keep a fertile ground untilled." I really appreciated this. I had two children after my husband died but I never married again. My brothers Stephen, the engineer, and Damion, the doctor, helped to raise my children. It's amazing the support people can give you when you're in trouble.

In 1964, when I was pregnant with my third child, I went to Rwanda, in part out of fear and embarrassment about the pregnancy and in part for the job. I was at Ruuaza, across the border, teaching English for two years at a type of TTC there. It was from there that I picked up a bit of French before then going to Paris to study it further.

The parish then transferred me to Savé, to an institute for women, to teach English. This place is way beyond Kigali. I went with my children but only reached halfway when I thought very quickly that this place was too far to go with my children and that I might never get out of Rwanda and get back home. So I told the driver that I wasn't dropping off and he should take us back. And so that's how I came to be back in Kisoro and Uganda. This was one of the decisions I've made in my life that was made very fast. So I came back and was teaching at Kagera, where my mother's village is. I came back to my mother's place.

With money from my husband's insurance, I decided to build a house in Kisoro. My aunt, who lives near my present house, told me some people were moving and selling this property. So I was able to buy it and start to build this house. By 1967 it was completed.

I have always liked learning and occupying my time with reading. So, when the opportunity came in 1967, I went to Belfast, Ireland, for further training as a teacher. During the two years I spent in Ireland, I left my children at home with my mother and sisters.

After Ireland, I came back to Uganda and went to the Institute of Education at Makerere University, where I got my Diploma in Education. I then taught at the Uganda College of Commerce in Kampala. I was a lecturer and warden teaching French up to 1979. I was taking care of the women's hall.

From there, I also went to Paris in 1979, for one and a half years, and got my Higher Diploma in Business Studies. The French government had sent me to Paris to study business French.

Eventually, after being overseas and in Kampala for some time, when my two older daughters were now in university and Willi was in primary

school, I decided to come back to Kisoro, to my home, and make a home for my own children.

So, in 1981, I had been asked to come back and start St. Gertrude's Girls' Secondary School. I came as the headmistress and started the school, which is still one of the most highly regarded girls' schools in this region.

After four years at St. Gertrude's I left and started farming. My son-in-law bought me some cows and knitting machines. So I started the sweater-making industry that flourishes in Kisoro now.

Thus ends her chronological account of her life story. From this point on she tells of different areas of her life, her interests, and activities. The first of these, her land, is probably the most significant. One day she took me to see it.

My Land

Turning off the main dirt road, we travel up a rocky, grassy lane bordered by volcanic-rock boundary walls. Juliana is at the wheel of her navy-blue single-cab pickup truck, navigating the potholes and revving up the rocky ridges to her fields.

So this is my land. There are several acres that I own—these areas inside these boundary walls. Here there's a small house with three rooms where some boys are staying while they go to school. They also help me out on my land with weeding and other chores. Let's walk over here.

I bought this land gradually from 1974 to about 1984–'85. My children encouraged me to buy it. We just bought piece after piece gradually. There's an airstrip nearby here. The previous owners sold the land in a rush when word came out that the airstrip was going to be built. That was during the Rwandan crisis. But it's hardly ever used. So they later came to regret having sold.

Only a small portion of my land is cultivated. Some women are renting it for two years. The rest is used for grazing my few cows. Right now they seem hungry because there's not enough grass. A women's group was cultivating over here but they weren't happy with me. I told them I didn't want

them planting these climbing beans. I was trying to protect my tree seedlings. They didn't like that. They wanted to grow the beans so, when I insisted, they left.

Most of my land is uncultivated. There are lots of herbs and medicinal plants here. It's one of the few places where they can grow now because most of the land in this area is so heavily cultivated with food crops. People come here and pick the medicinal plants. They don't have to ask me, they just come. See, here there are raspberries. There you see the pine trees I've planted. We have to protect them from the cows. I want to create a kind of forest, for recreation, camping, picnics, that kind of thing. I think it would be nice for people to come here. And I let the Scouts and the Girl Guides use my land for free. They can do their camping here and have picnics here.

Here there are certain ferns and trees that aren't growing elsewhere because almost all land is cultivated. So in a way this is a kind of conservation. People locally think I'm strange. People think it's riches, but they also know it's where I graze my cows. Sometimes I feel it's really not good to have so much land that's not cultivated when others have not enough land for growing food.

In 1986, I planted a whole lot of trees. Now we are harvesting them and I'm having furniture made out of the lumber. I'm making things like cheap cupboards—you know, for women to use for food storage in their homes. We're only charging around 30,000 shillings.* Women are coming to me saying this is really a good thing I'm doing. But they can't afford. Very few have bought them. I fear there is going to be much poverty. They think it's strange for me to plant trees on my land.

The subtext here is that it is a taboo in the local culture for women to plant trees—thus the significance of Juliana as a woman not only owning land but also planting trees. Back when she did this, it must have done more than raise a few eyebrows within the community.

* USh30,000 equates to about US$18, but keep in mind that these women, as day labourers, only make about US$1/day, which isn't even enough to feed their families on.

Seeds Project

Women are not feeding their husbands and children properly with vegetables. People rely so much on cabbage because it was brought by the *bazungu*, but it is so poor in nutrition. People's nutrition has deteriorated so much because of relying on just a few food crops and not eating the diversity of foods that they used to in the past. People have gotten into rushing, rushing ... for money and for so many things. Not much time is devoted to really getting proper meals among these poor people. People mostly eat cabbage and beans, sometimes bean leaves, but these are considered famine food in spite of being very nutritious. So I've started a program of producing seeds and giving them to women. Women often come in my gardens for vegetables, but I then give them seeds to go and plant in their own homes and fields ... so they're not just perpetually coming for more. They grow their own, and they increase the diversity of their family's diet, thus increasing the nutritional content. And I feel so happy—so many have planted these!

People really are hardworking here. This wall was built by a man who is one of my neighbours. His wife left him a while ago, after they'd had a quarrel. She had been gone for two months and had left him with the five children to look after. So I talked to the man and told him his wife needed to come back, that he couldn't care for the children himself and they would suffer. We discussed the situation. I then went on his behalf to the woman's parents and I had to negotiate with them to get the woman to return home. The father said the man had not paid any of the dowry. I said okay, but even so, this woman has produced five sons for him. That should be enough reason for him to allow her to come back—so these children don't suffer. In the end I put up some money as part of the negotiation and the wife came back. So, since I had paid this money and helped get his wife to come back, this man wanted to do some work for me at my farm. I asked him to mend this wall here. He's really worked hard. Look at this wall. He's really done a good job.

The Children's Books I Have Written

Juliana goes into her bedroom and returns bearing five small books.

These are some of the little books I have written and had published. They are for children but also for their parents. They are in our language, in Rufumbira. There are about five of them.

While in Paris, I went for some training in Morges, Switzerland, to learn how to write school textbooks. This was organized by the UN, by the World Confederation of the Teaching Profession (WCOTP). You know, this was one thing we were never taught by the British [colonizers]. They never taught us how to write our own books. They withheld that knowledge from us.

The more you travel out of your country, you have more appreciation of your way of life and you are in a better position to stand up for it and talk for it. You see other cultures and you appreciate more of your own culture. When you travel, you understand people better. The more people you meet, the more exposed you are to their characteristics and you appreciate them.

I write stories about things that perplex children's minds, the things they wonder about, and the things that parents and other adults often push aside and don't bother to explain to children. So my books are for children, but they're also for adults to realize that they need to talk to their children.

This story is called *My Moon*. It is one that I imagined. It's a story about what I experienced as a child and what, as a teacher, I know children think about. You see, children here are intrigued by the moon. They eagerly look for the new moon and, when one sees it, that one will stand on their hill and call over to the others on another hill that they've seen their moon. Even today, these calls echo across the hills between these children.

The story itself is about five different children who all see the new moon from different places: going to grandmother's house, between the horns of a cow he is herding, through a doorway, from a window, on a hill. And each claims to have seen "my moon"—their own particular moon. Coming together, they argue and tussle over whose moon is the real one. An older boy, overhearing the arguing, asks what the conflict is about. Hearing

their various claims, he tells them there is only one moon. They insult and abuse him because he doesn't know what he's talking about, that there are five different moons. He explains that he's a seventh child and as such (because seventh children are believed to have "tantrums," and when you throw tantrums, people say, "are you the seventh child?"), he would cry for nothing [no reason] and his parents would take him outside and show him the moon and he'd be okay. So he knows there's only one moon. They abuse him further. A grandfather, overhearing, asks what's going on. Hearing the dilemma, he tells them all to gather the next night in one particular place with him and they will see whether there is more than one moon. The next night they gather and look up at the moon and realize there is only one moon. One little girl apologizes and asks for forgiveness. Grandfather, arriving home, gives her some roasted maize as a reward for asking for forgiveness. It ends with the little girl saying how they're told in school and in catechism to ask for forgiveness from friends and from God.

Another of my stories was influenced by and adapted from a similar Canadian story. But it was also influenced by my own childhood experiences of having vivid dreams and nightmares. When children dream like this—of flying across the sky and of beasts and animals, and things like that—adults just brush them aside and say they are "growing up." This never satisfied me, but that's the way it is.

So I wrote a story about a boy whose name means "upside-down." Asking his grandmother why he was so named, she explains that most children come out headfirst but he came out legs first and so was upside-down. He ponders this and says, "Aren't those who come out headfirst actually the ones upside-down?" He is told to ask his teacher. He's in P3 and asks his teacher why some children come out headfirst and some legs first. Put in an awkward position, the teacher says the boy will learn this in P6, obviously brushing him aside and leaving the boy still perplexed. Thus, the boy dreams about being in an upside-down world, of meeting children who are upside-down, of them asking him why he's upside-down and him telling them they're upside-down and not him, of going hunting for fruit in the bush with

them, of finding a hole in the side of the hill and them warning him not to go near because he might get sucked in, of a type of whirlwind blowing him into the hole, and of him waking from his dream to his grandmother shaking him and asking what he's been dreaming so much about.

Here, grandchildren typically sleep with their grandparents to keep them company and also that's when they hear stories. That story can also be about seeing things from different perspectives and about being able to converse with and get along with others of different perspectives.

Some of my books are used locally in the schools here.

Language Orthography

I went to Kisoro for a meeting this morning where they were discussing the orthography of Rukiga and Rufumbira, our local languages. It was a meeting at the LC5, district level. There are going to be changes to the primary school curriculum. Beginning in February 2007, nationally, P1 to P3 are to be taught in the vernacular; the local language is supposed to be the medium of instruction.

There need to be changes in the way we write Rufumbira. Rufumbira is similar to Kinyrwanda* but different because they are francophone whereas here we are anglophone. It was only in 1995 that Rufumbira was added to the National Constitution. Before 1995, they did not recognize our language in Uganda. Before, it was always written like the way it is in Rwanda.

For us, in our language, we have words that sound the same except that one form has a double vowel. This significantly changes the meaning. An example is the word in Rufumbira for water is *amaazi* while the word for feces is *amazi*. The way our languages have been written up to the present is that there is no distinction made between these words which have got long and short syllables; they are both written with only one vowel. When reading

* Kinyrwanda is the language spoken in Rwanda. Rwanda was colonized by Belgium so the local language has been influenced by French linguistics. Rufumbira is basically the same language, only it is spoken in Uganda and so has been influenced by English linguistics—again, another effect of colonialism.

in our languages, a person has to decipher the meaning within the context of the sentence. This is difficult for most people, but even more so for children, who are now to learn these languages in primary school.

I feel strongly this orthography needs to be changed to be consistent with how the language is spoken. And the orthography must have the same principles for both Rufumbira and Rukiga, because both children and teachers mix in schools in both areas.

So now the Ministry of Education and Sport has sent a notice around to the districts instructing the local councils to find people who are "competent, interested, and have time to do some writing," to form a Language Board. This Board is supposed to discuss and decide on a consistent orthography and on the language textbooks to use in schools.

People have been opposing this idea because they think we want to change the language. I'm only saying we should change how it is written. There is so much political opposition. Maybe they think because I write books ... You see, I write my books in the orthography with the single and double vowels. And I know of two other Rufumbira writers who also do this. So people say, the writers are just imagining this problem. A mother language is an essential right. Let the Bafumbira take a common stand in its literal establishment.

Juliana went on to describe her many efforts to advocate about this issue with the various authorities. With a certain satisfaction, she updated me a few months later.

It took two weeks last month. The Language Board has now developed a Rufumbira dictionary and grammar book, and has chosen textbooks to be taught in the schools. People now think I did something good for agitating for change. They now recognize the importance, and realize it will be easier to read and comprehend matters in Rufumbira. They see that it will be easier for our children to understand.

Paying School Fees

I pay school fees for five girls in secondary school; some are my relatives but others are not. They come to my place during school holidays and help me on my farm. One girl is so brilliant. She got such high marks in her P7 exams* that the headmaster came and told me about her. He said that we couldn't just let her drop school because of lack of school fees. So I asked why he didn't pay for her but he said he didn't have the money. I left it. Then, when school started, I asked around to see if this girl had gone to start secondary school. I found out the girl hadn't because her family couldn't afford it. So I decided to sponsor her. She is brilliant, especially in sciences. She could be a doctor … if not, then a nurse. Though we'll have to see about the fees. It's such a waste to see these girls unable to attend school when they are so brilliant.

Involvement in Literacy and Local Politics

About being involved in local politics, I have always been active. I always spoke in the favour of women. I had spent a lot of time setting up and visiting functional literacy clubs and women's groups in the district. And that's how I started my political life.

I went all around to teach in women's literacy groups. I took a big role in these reading campaigns. Men never go for these campaigns for literacy; it's the women. This *Functional Adult Literacy Program in Rufumbira*, put out by the Ministry of Gender, Labour, and Social Development, I translated and edited the 2001 edition of the first primer. Now I want to translate a second primer. In my life, I have searched for excellence and I have tried to give it to others.

On Wednesday mornings I used to go and, on my own, teach the Batwa† women and children to read and write. They refuse to go to school but they're very interested in music. I asked them to do their riddles and

* In Primary 7, students in Uganda sit highly competitive national exams and must pass to be able to continue their education.
† The Batwa are the indigenous peoples of the region, commonly referred to as the pygmies, who live in Uganda, Rwanda, Burundi, and Congo.

songs. Then I'd pick some words from these to teach them to read and write. They have wonderful traditions really. I want to start doing this again.

Within Kisoro town there is a small community of Batwa who live in absolute poverty, dependent almost entirely on people's handouts. Like many indigenous communities, they are among the most disempowered and disenfranchised and suffer incomprehensible social stigma and ridicule. The fact that Juliana, a person of real social status and influence, would voluntarily take time and interest in trying to impart some level of literacy to these women is noteworthy. Few of her social stature would bother.

I was the Women's Representative for Kisoro in Kabale District, before Kisoro became a separate district in 1993. I left my position last July. I'd been the vice chairperson at the district level, which is the highest local level (LC5). This is a big position for a woman especially. I felt very famous. In the last elections, I didn't campaign [run for office]. I gave the chance to a younger woman so that she could get the same experience as I got. This woman is the Women's Representative at the Sub-county level, so a bit lower, but still significant.

About My Political Success

Anything I try, I get. Really, it's like that. Also, I think I have confidence. This confidence comes early in life through school education. And I was likable. People would chat to me and I would chat openly. I was a good talker throughout, up to today. I talk easily. Here, if people don't talk, people wonder what type of person you are. We're a talking community. If you meet someone on the way, you don't just pass by as if you've met a stone—you talk. How do you not recognize God's creation?

People appreciate someone who has experience and knows of other places—so long as that person is still close to them. You have to have that combination. *Muzungu* isn't just used to refer to white people. It's also used when talking about someone with influences "from away." People never thought I was that. They come here and we chat. They see me go to my gar-

den and work. They find me eating food they think a rich woman wouldn't eat. Yah, things like that.

Here, let me show you the shoes that brought a lot of votes. They are made of rubber tire tread. They're comfortable and I was going in rough places. People would comment that "if this woman can put on these local shoes, she's one of us."

Advocating for Women and Land

My experience I got because I was also the Secretary for Production (in charge of agriculture, veterinary, and forestry) at the LC5 level. I got insight into the production activities all over the district. It has made me understand the whole district. I have reached everyone. And I know what improvements could be made. It exposed me. I could see how their life could be better, what is lacking here. I also appreciated our beauty, the beauty of our district.

Then I was the Vice Chairperson. The Chairman was a man. I made a notebook of all the complaints the women would come with and I would direct them to where they needed to go. Women have got painful complaints ... and most of them are starting from land and property ownership.

There are so many cases about women and land. They weep so many tears about land.

So most of these women would come to my office and I would hear so many pitiful cases. There are stories of widows whose brothers-in-law come and take their land after the husband has died. And others where, after the husband is gone, all of a sudden out of nowhere a person comes with a boy, saying he is the son of your husband and so is entitled to the land. And what can the women do? When they have lost their husband's land and are destitute, if they go back to their home sometimes they are disowned, sometimes their own brothers chase them away with their children.

Women have no land. They can only hire their labour out for working other people's land. And they only earn between 1500 and 2000 shillings* per day, or three or four kilos of beans when they're hired out. People like to

* About US$1 per day.

eat bananas, sweet potato, Irish potato, but when there are no beans in the house, then there is famine. And this is the case for many families these days. If a woman has one or two gardens, they may be an acre or less. Yet, in a crisis, a woman would sell her garden, leaving her with no resource and now having to hire herself out. In my case, all the land I own because I bought it, but other women really, they have no way to get land.

The shortage of land here affects everyone. But something is missing. Women are not well informed about government policies. So I would lobby with chiefs, with families, with husbands. I fought for many women. I helped so many women to get their property and to know their rights. I wish we could make a campaign about women and land ownership.

Elders' Council

Two years ago, I went to Mbarara for a four-day session, as the representative from Kisoro District. At this we also talked about the pensions of elder citizens. There is an Association of Elders of Kisoro. It has its own constitution and is just starting up. It's a new thing. Now it's in the system of the government that there should be representatives for women, youth, elders, the disabled, all those who are vulnerable. I am the representative on the Village Council (LC1).

We made a big rally and cited four or five examples of difficult situations faced by elderly people. It's a very sad state. Things are changing. It's a difficult life for the old people. Some starve; some have no food at all. Others have to rely on a daughter-in-law. It used to be that elders were respected and cared for by their children, but now … maybe someone hasn't enough land to cultivate for his own children or decides to be indifferent to his parents.

Traditionally, the youngest child stays in the house when a parent dies. But in those days, houses weren't permanent. Now houses are permanent so no one wants to move … and it can't be demolished. Many elderly men are getting into squabbles with their children. Some families go the extent of partitioning the house, the gardens—half for the father with his new wife and half for the grown children. In these ways, the old people were threat-

ened so we brought it to the notice of the chiefs and village councillors to try to solve it communally.

Knitting Project

My children sent me to Zurich, Switzerland, to learn knitting. I came back with three machines and set up a knitting workshop to teach girls and young women how to knit. They were the first to knit sweaters for the school children and now every school uniform has a sweater as part of it. This did not exist before. Knitting thus spread in the region, with others buying their own machines and setting up. This is one contribution I feel proud of.

Held within this snippet is an amazing story of a project Juliana started that transformed the local economy for many women, provided them with skills training, and created opportunities for an alternate source of income. As she explains, it also very practically resulted in the production of sweaters for children in a climate that is generally cold and often rainy. Such a seemingly small intervention continues to have tangible and long-lasting ripple effects.

Collecting Stories of Traditional Beliefs and Practices

Like many sent away from home for schooling, Juliana's learning of her culture at the hands of her elders was cut short early. Like most taught in Western and religiously influenced education systems, she would have learned that traditional ways were "backward" and "uncivilized." Since she moved back to Kisoro, she began her inquiry into the value of the traditions handed down from her ancestors, in the wisdom practices that sustained them long before the white people came and imposed new cultural ways.

I'm collecting stories from women because these stories are dying out. I am especially interested in children's herbs—those used for smearing, bathing, breathing. Women here have so many herbs they use for themselves, from the time they get pregnant through to giving birth and then to keeping the children from getting sick. I bathe my grandchildren with herbs from

time to time. There are herbs for fevers, for breathing—chest problems, for malaria. I've organized a group of five women who know some of these stories. I've taped them. This is an ongoing process and project that I'm doing.

Another interesting area of research would be traditional agricultural practices. There are lots of taboos in agriculture here. For example, a child will be told by their mother never to uproot or remove a certain plant from the soil when digging. Why? Because it brings fertility to the soil. Another example is, when thinning sorghum and transplanting seedlings, never turn the seedling upside down. I don't know why exactly but these beliefs intrigue me. I want to draw other people's attention to these. It would be good for people to have more information about them. But this is difficult for me to do by myself.

I sometimes sit and think about some of these traditional beliefs and practices. I wonder to myself why these might have come to be. Why did our people in the past develop these? What was their rationale? Is there something they might have known that we have not yet discovered? The schooled or so-called "educated" shun local practices.

Another belief is that when a girl gets her first monthly period, the older women cook all types of green vegetables for her to eat. This is like a treatment and after it, they test her by having her go to the garden to pick some leaves, particularly pumpkin leaves or those from another vegetable plant called *ntura*. There are particular plants they use to test her. A few days later, the women will go to see whether the leaves on those plants have dried up. If they have then she is known to be a "marked" woman and when she has her monthly period she will not be allowed to be in the gardens. Some women, during their monthly period, when they are in the gardens, cause the leaves of plants to dry up and die. Given the critical importance of food crops, such a person is not safe in the gardens. People say in the vernacular, "someone with a bad back has been to my garden." In Rufumbira, when one has her period, she is said to be in *mugongo* and when a woman has this effect on plants, she is said to have a bad *mugongo*. I wonder to myself how this is possible. Maybe some hormone is given off by the body, I don't know. But I

believe it because I've seen it happen in my own gardens. For this reason, I don't allow just anyone to go and harvest or pick vegetables in my garden. I do it myself or I ask them if they are menstruating!

Tradition of "Pulling"

Then Juliana launched into another area, not meant for the research but of mutual interest, about the practice here of teaching girls of around twelve years old to start pulling their labia to lengthen them. I was familiar with the practice from the Lozi tribe in Zambia, but I listened and only told her of this once she'd told me all about it here.*

She told me she's lain in bed and asked herself what this practice is about. Of course it is said to be for the pleasure of the man, something for him to play with, but "I'd think about it and think, now why this, what was it for?" And she has come to think of it as a pleasuring of one's self and sometimes a pleasuring of each other among the girls. They were encouraged by the adults. She tells how, when they'd go to the gardens or in other places, they'd sneak off with a friend or friends and "pull, pull, pull"—yourself and sometimes for each other. It was a kind of "sexual excitement." So it wasn't just for the men but also for women's pleasure. She supposes that during the sexual play between a man and woman certain friction would stimulate the labia and clitoris and thus pleasure the woman. I couldn't believe she was telling me all this and she laughed about it. "Oh Jennifer, you've met a mad old woman." She said that if I told Deus what we'd talked about, he'd exclaim, "She told you what?" Toward the end she said, "Today we have talked many silly, silly things ... but (reflectively) they are also about peace."

Later, as if to explain further, she said, "I believe that a good sex life is the foundation of a good home unit. Conflict starts in the homes. In solving conflict,

* This discussion, due to its private nature, was not intended for inclusion in this text. However, when reviewing the transcript, Juliana gave serious thought to this and felt it to be relevant to the topic of peacebuilding. She thus decided to keep it as part of her story once she had made the relevant edits.

it is important that women are aware that they have to be appreciated in bed. So girls learn how to be good sex partners." "For us, preparation for marriage took two years. It took a long time. Women got prepared for the marriage bed, herbs, the what and what, things about breathing ..." And she trailed off as her daughter-in-law, Miriam, and her grandchildren came in.

Such topics, of sexuality, are rarely spoken of so openly in this context and especially not to a foreign outsider. I am honoured by Juliana's trust. She has touched on a topic rarely discussed in relation to peacebuilding, and that is the appropriate, cultural preparation of young men and women for their marital relationships. For, with families as the foundation of any society, such relationships are critical to community harmony, development, and peace. And male–female sexual relations are indeed central to this, with silent but radiating implications to the rest of life.

My Grandmother, the Midwife: Traditional Healing

Later, when we resumed our discussion about traditional beliefs and practices, she told me about her maternal grandmother and I understood even more her interest in these things.

My grandmother, Rizabeti, the mother of my father Yosefu, was a traditional birth attendant or midwife. Women in labour would call her when they had a problem giving birth and I would go with her, over the hills ... sometimes stay a week with the woman ... and sometimes people would give us gifts of beans or even, one time, a goat. My grandmother had learned about herbs from her mother but I was too young at the time for my grandmother to pass this knowledge on to me.

It was thought that my grandmother's mother had put some "medicine" in her hands [*she makes marks on the backs of her hands to illustrate the incising*] to enable her to negotiate the womb so easily. She was also very gifted in assisting and negotiating after-birth obstructions. Some people think that this grandmother put some "medicine" in her grandson's, Dr.

Damion's, hands because he is a very skilled gynaecologist. He is German trained. But he was a favourite of this grandmother and he always went around with her. They had a wonderful attachment. Many women talk of how he has helped them in their deliveries. He is well known and well loved here in this area.

We then moved into talking about natural or alternative healing and I asked her about bonesetters in the area—people who, without the assistance of x-rays, successfully set broken bones and assist in their healing within a few weeks. I was familiar with the work of some near Kampala. Perhaps surprised by my interest, especially since I'm an educated white person, she got excited and told me of her experience.

There is a woman across on the other hill who can heal from a distance, without even seeing the person but simply by being given their name. I know her because she did this for my son. She doesn't do other healings but mainly to mend a bone or joint. Here they say she "heals the name" because she only needs your name to heal you.

On Religion

Christianity helped me to be what I am. You know, in Uganda there has been a type of competition between religions—Protestant and Catholic. In schools there was rivalry and competition between children. It was very real. I admit I always feel good when I hear about someone who's Catholic achieving something. For me, religion really gave me a chance to excel. Although now there is more and more mixing because people are mixed up in the schools.

You know, here we have two religions—Catholic and Protestant. And the Catholics did not destroy our traditional beliefs and things [*gestures to her wrists and forehead, referring to bracelets and beads*], but the Protestant religion discouraged wearing traditional ornaments like beads, bracelets, and headgear.

Our talk flowed back and forth with quiet reflection until finally she said: "Why don't you stay in Uganda? We want you here in Uganda. Anyway, we will wait to hear slowly by slowly. We are developing a circle of friendship."

CHAPTER V

Rita Nkemba

RITA'S STORY IS BASED in Kampala, Uganda's capital city, located on the shores of Lake Victoria. Originally built on seven hills, it now spreads over many more. This hilly topography challenges the road network that now transports far more vehicles than were planned for and so results in serious congestion. The downtown core of Kampala boasts numerous high-rises and other modern buildings. Its city centre is full of bustling streets and a vibrant formal and informal sector, modern shopping plazas, and traditional markets. All of this is in contrast to the "looted shell"[86] following the chaos of Amin and Obote, when civil wars virtually destroyed the city. Kampala is now described as "the pulsating heart of Uganda's cultural and intellectual life."[87]

With a population of over 1.2 million, Kampala is the largest urban centre in the country, with all the associated urban issues of a developing

country—large peri-urban and slum areas, inadequate water and sewage supplies, "load shedding" of electricity due to fluctuating water levels in Lake Victoria (the primary source of hydroelectric power), and inadequate and poorly maintained infrastructure. However, in contrast to most comparable African cities, Kampala is relatively safe. There is a healthy middle class with disposable income, but extremes of rich and poor are evident in neighbourhoods with large, modern homes and tropical gardens behind high walls in the suburbs, contrasted by overcrowded shanty and slum areas on marginal lands.

The bright lights of the city attract many from the rural areas, who often end up disappointed with the lack of livelihood opportunities, high rates of unemployment, and the relatively higher cost of living compared to the village. For some, Kampala's streets become home and begging a means of survival. Among these extremely poor are those who have disabilities and those who have been displaced by war and insecurity in their home areas. Certain periods during the LRA war in the north saw large numbers of children fleeing to the city's streets to avoid abduction or because they were orphaned. More recent years have seen women and children arrive from the eastern region of Karamoja, where there has been heightened gun violence and insecurity.

Like every major city, Kampala is a place of contrasts and contradictions, of immense opportunity for some and hopeless despair for others. It is in this context that Rita Nkemba lives and works and out of which her stories emerge.

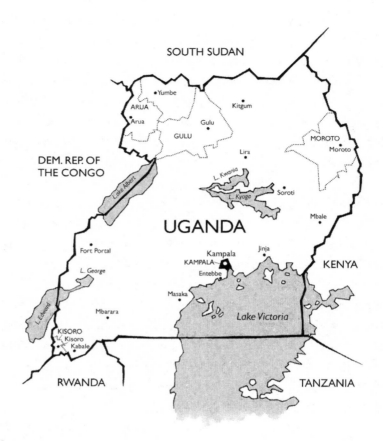

Introduction

Mingling in an international group celebrating American Thanksgiving at our neighbour's, I met Marsalis, a Scottish missionary nurse working with street children in Kampala. She talked about her work with Dwelling Places, an organization committed to helping children and families on the streets, and about Rita Nkemba, the dynamic woman behind it. I had wanted to find a woman in Kampala dealing with some of the urban sources of conflict—poverty, high unemployment, lack of proper housing, food, water, and sanitation—and street children represent one consequence of these issues. As well, I had hoped to interview a woman from Karamoja, in the northeast, since I knew that some of the conflicts there—drought, cattle rustling, and gun violence—were resulting in Karimojong women and children coming to

beg on the streets of Kampala. Having not yet found a Karimojong woman, I thought Rita's work with this group of street people would enable me to make the linkages between the conflicts in Karamoja and those in Kampala. I asked for Rita's number and, some weeks later, called her up and went to meet her at her office, on one of the side streets in downtown Kampala.

The sign for Dwelling Places is small and hangs high amid a jumbled assortment of other signs advertising a photo studio, salon, clinic, clerical services, and various other offices in the same dingy building. The offices of Dwelling Places are upstairs. Through the doorway lies a small, makeshift office with two desks—one with a computer on it—some bookshelves along the wall to the right and, between the desks, another open doorway leading to two more small offices. The last one is Rita's.

Several young people are busy around the office, sitting at or leaning over desks, working together in this cramped space. A young woman leads me to Rita's office in the back. At a desk is a woman about my age, nicely dressed, looking like a fairly typical professional woman in Kampala. With a friendly smile and warm welcome, she asks how she can be of help to me.

I reflect on the fact that I have had no proper introduction; no one has vouched for me; I am essentially a stranger who has walked in off the street after a brief phone call asking for a meeting, and so I am prepared for hesitation and resistance. To my surprise, I am met by genuine openness and a real willingness to talk about her work in setting up and directing this organization. Rita is a busy woman. She launches into telling her stories immediately. She stops only when lunch arrives and then asks that we meet again another day.

So a few weeks later, when she has an opening in her schedule, I return.

The second time, we meet at her office, then head to a local café—Javas— where the smell of coffee makes me think this is the Ugandan version of Starbucks: air-conditioned, a world apart from the street.

Over sweet masala chai for me and a large mug of mocha for her, the stories spill forth. Few prompts or questions are needed in the next two hours.

Words flow through her, inspired, connected—a continuous river of knowledge and experiences, emotion and analysis, infused with a dynamic passion.

In a relatively short time, during these two meetings, Rita told me many stories. I realized that, due to her openness, more time was not necessary. Nor, for her, was it desirable, given her very busy schedule. As well, since we both lived in Kampala, there was not the opportunity to visit her home or be part of her daily life as I had with the other women. Shadowing her at work seemed inconvenient and awkward. So I inquired into opportunities to volunteer with her organization, to be able to interact with the children and the staff at the rehabilitation homes, and in this way to get a firsthand sense of Rita's world—this passion that has become her life. I volunteered for several weeks. Later, during the editing process, Rita and I met regularly at Javas to talk and review her transcript. I spent hours listening to some of her more recent challenges and frustrations. In these ways we continued to build and deepen our relationship.

In our initial meeting Rita focused more on talking about Dwelling Places, the organization, with a brief overview of her own life and involvement. She wanted more focus on her work than on her personal story. Later though, she seemed to realize that my interest was in her life and its connections to her work so she began to tell more about her own background, experiences, and challenges. These were, however, intricately intertwined with her work with street children, for this is her passion and her life purpose.

Within the last couple years, Rita's energies and focus have been shifting to the situation with the Karimojong people, who she is finding in increasing numbers on the streets. As this is becoming a preoccupation for her in terms of the challenges and struggles involved, it features centrally in her story. It is around this main story that her other, more personal stories get told. She is increasingly burdened for this group of marginalized people, the women and children of whom come to the streets of the city to flee the insecurity of drought, famine, and violent conflict in their region. The direct correlation between this insecurity and their numbers on the street led to a

significant rise in numbers in 2006, which is when Rita became more involved with helping them.

The Karimojong are a pastoralist people from the northeast of the country in the Karamoja Region. Theirs is the most undeveloped region of the country, with a harsh, semi-arid environment that keeps people constantly on the edge of survival. The Karimojong are cattle keepers; their wealth and survival is invested in their cattle, and cattle-raiding is a part of their culture. Over the last thirty years, the nature of these raids has changed with the influx of guns from Sudan, Kenya, and local army barracks. Where raids were traditionally guided and blessed by elders, carried out using spears and with unspoken but understood rules of engagement, they are now more often planned by young men empowered by the gun, who kill without regard and steal for their own gain. The availability of guns and lack of opportunities for education or employment are now mixed in with tribal animosities and grudges, making for a volatile and lethal conflict.

In such insecurity, many of the victims who survive are women and children whose villages have been destroyed, husbands and families killed, and wealth and resources stolen. They are drawn to the streets of Kampala—eight to twelve hours away by bus—most in extreme poverty and desperation, some drawn by rumours of opportunity, others to exploit children to beg for them. For all, Kampala is a strange and dangerous foreign land far from their home. Many become casualties and victims. They are the objects of derision and cruel stigmatization and mistreatment by other Ugandans influenced by the generalized bias against and perception of the Karimojong as backward and uncivilized. Such sentiments are further exacerbated among the urbanites who react with great indignation and disgust at the increased numbers begging and so making life uncomfortable for those walking or driving the city streets.

Public complaints and the approaching international event of the Commonwealth Heads of Government Meetings motivated the government to try to clear the streets by initiating a program for resettlement of the Karimojong to their home area. The main thrust of this took place from Decem-

ber 2006 to March 2007, though with many complications. This short-term fix, however, ignored (or failed to make connections to) the root causes of this internal displacement.

Rita, in her advocacy for the Karimojong, faces ongoing and increasing political opposition. What she tells here is the beginning of a story she is still living out, a story with an unknown ending, ever changing and evolving, and incorporating much drama and suspense.

Rita's Life as She Tells It

Dwelling Places: An Overview

Dwelling Places is a Christian organization. It is a ministry. We focus on three groups: street children, abandoned babies, and high-risk slum families. We recently added and changed a category to address the Karimojong. Our aim or vision is mostly toward street children. Our Vision Statement is "until every child has a chest to rest his head on and a place to call home." And our Mission Statement is "to rescue, rehabilitate, reconcile, and resettle street children." We are questioning where to put abandoned babies. So we're thinking of changing to use the term "homeless."

We have found that most street children are really not orphans. They lead you to their parents. About 80 percent of the kids on the street actually have families. These are often single-headed families with mothers living in the slums. Therefore these are high-risk slum families. We don't want to separate the kids from their parents. We want to build trust. So we work with the child from within the family and watch for push factors—the causes of why the kid is on the street. This is usually not child neglect but extreme poverty.

We have the Family Empowerment Program. In this, we add all the siblings into the program. We pay for their rent and for the kids' education. A social worker makes an assessment. If the whole family is on the street, we

find a house for them in the slums. The end result is to help them work themselves out of the slum. If we find a group of kids on the street who are peers or siblings, we take the whole group off the street and house them.

This is not an organization for orphans. There's a start and a stop. We stay in the life of a kid for up to five years. After that we want to commit to be involved until they get their first certificate in some level of higher education that would determine a successful independent living. So we pay school fees and 35,000 shillings* per child per month for those in foster care.

We also have a Transitional Rehabilitation Home (TRH) in Mutundwe. Here we take a multidisciplinary approach. In terms of education, we have a catch-up program. We work toward the kids' resettlement into mainstream schools and provide assessment for them to catch up. It's a kind of accelerated education, so that if a kid is fifteen years old, they aren't put into grade 1. We also teach them the basics of a home: housework, health, hygiene, behaviour change. This is part of the Holistic Care Program. For two years, every staff is given a group of children to take care of individually. They are to be responsible for each child's holistic care—to check whether they have brushed their teeth, if they have enough panties, things like that. There were eighty-four kids in the home in 2006. We are expecting there to be ninety-six in 2007. We have twenty-five staff in total. Some staff have a double function—one may be the accountant but also responsible for a group of kids. Like our Fundraising and Advocacy Department has its offices in downtown Kampala but all staff are involved when it comes to caring for the children in the TRH. They work here and have five kids each. We have indicators of how we are performing in caring for the kids.

We also involve parents in the program. They visit their children once a month. We have 347 children that we currently care for—17 are in foster-care homes, 97 are in the rehab home, and the rest are with their relatives. We meet with the mothers once a week for fellowship and economic empowerment lessons. We are concerned about the economic, spiritual, social well-being of the children. We make sure parents are prepared to receive their child.

* Approximately US$21.

We do a lot of networking—so, so much networking. We recognize that we cannot possibly do all these things by ourselves. So, for example, Mildmay* provides ARVs† for the children and clients who are HIV positive. We provide transport to them and supplement their food while they're taking the ARVs. As well, we are part of this network—the InterNGO Forum—that meets once a month. There are about twenty-five other organizations in the network. It's coordinated by the Tiger's Club in Mengo-Kisengo—an organization especially for street boys. Then at our office, we also host the Children at Risk Action Network (CRANE). I'm part of the steering committee. This network is made up of thirty organizations—not just for street kids but for kids at risk in general. Its vision is: a joint Christian response, where actions to influence effective and efficient care for children at risk are enhanced.

Networking reduces our financial costs. For example, some doctors locally offer us free services. We also keep talking about our work: through the media; to small groups. We don't wait. We need foster parents, so we have to advocate for the kids. We don't just wait for people to offer. Ultimately, we want the kids to have a family to link to. There were only three kids who had no place to go this holiday—and actually they're in my house. I have two children of my own [biologically] and I have adopted seven others. Now in my home, this holiday, there are sixteen people but it's lovely, really lovely ... if you have food and a place to stay. At our home table—it fits ten—we had to rotate people at the table to make sure everyone got fed.

Dwelling Places: Beginnings

Dwelling Places has been around for four years but I have been involved doing this work for eleven years. After university, I got married, I prayed for work. I got married in 1995. I stayed at home because I couldn't find work. But I consider myself a very enterprising person. I basically look out for challenges. I ask why and why not a lot. I don't agree to impossibilities. Let's look

* Mildmay is an organization providing HIV/AIDS treatment and also involved in training healthcare professionals.
† ARVs refer to anti-retroviral medications used to treat HIV/AIDS.

at the possibilities. I don't believe things are impossible. I guess, in reality, you can go as far as you can go but it is not impossible. Everything is possible.

I'm a singer. I sing. I used to sing in church. I wanted to serve God but I wasn't sure if I wanted to do this in singing. Singing has its limitations. Talent is talent; it's not something as a career. I wanted something else. Then God gave me Isaiah 58:12, which says, "Your people will rebuild ancient ruins and will raise up the age-old foundations; you will be called Repairer of Broken Walls, Restorer of Streets with Dwellings."

I don't come from a family that's been poor. I can't say I understand. I depend on the grace of God to show me. I look at myself as a channel to fulfill these people's needs. Whatever I've been able to achieve, it's by the grace of God. I wasn't taught to do it. God opened my eyes to street children and burdened me specially with their needs.

Initially, I worked with an organization called An Open Door. It's a group of people from Wales (UK) who wanted to do something in schools. They thrived on my vision until we eventually had to split. It wasn't really a good split. The leader there thought I was working for her but I was fulfilling God's call or vision for me. I took a break a bit and worked for one year in Pride Africa [an insurance company] but I am not an accountant or mathematician. I had pressure from my mom to work and earn a living. In order to convince my mom, I went for a postgraduate diploma—for nine months—in Public Administration and Management. I learned how to manage an organization—in addition to gaining skills and character and vision. It gave confidence to me to do what I do. It exposed me to other areas of learning.

I ask a lot because I don't always know what I'm doing. I ask stupidly: "What do you mean by that?" and people look at me: "You don't know what it means?" Most people in my life in the last ten years have been my teachers, whether staff or partners. I respect all the members of the team. I can't train them. I listen a lot. I can't say I know how to do it. Until 2004, I hadn't even recruited staff. Most staff came voluntarily, and have done well. Others have come, put a lot of initiative into it, and addressed a gap and created their own

jobs. I still don't have a job description—director, executive director—so you can give me whatever title you like.

At one time I wanted to get the ministry to a professional level but I couldn't. This year, 2007, I really consider myself a professional. I'm planning on writing a manual for my organization. If we have new staff, I can take them through all the areas. Experience has really taught me. And falls ... so many falls, especially in accounting to donors. I think transparency has been one of my strengths in donors sticking with me and not giving up on me. Like I never used to keep receipts. I didn't know why you have to. I'd buy something and then the kids need food so I give money for food and, "What do you mean I'm supposed to have a receipt? The kids needed food ..."

Karimojong Crisis

The Karimojong have been a challenge to resettle. God has really burdened me for the Karimojong. I've been praying for them for two years. Last year in June (2006), the Karimojong increased on the street. We took 115 off the street, put kids in schools, and took them to Kampiringisa National Rehabilitation Centre. This was a juvenile prison but the government, since 2002, has had a program for street kids there. We registered 312 others. Between June and August last year (2006), 986 were registered through our Karimojong project. This is a quarter of the numbers out there. The majority from the Karimojong who are suffering are the women and children. And there is such stigmatization. They are not displaced as such. There are "push" and "pull" factors, but which is greater? They are both strong.

There is the problem of language for working with the Karimojong. We made a breakthrough with some Karimojong students at Makerere.* We offered them the opportunity to volunteer and offered them lunch and transport as support for them doing this work. Now we're paying for two staff which we have given to the Rehabilitation Centre.

* Makerere University is the main national university in Kampala.

We are participating in their resettlement to Moroto. We had a centre in Katwe* for the last two months but it was becoming too expensive so we've had to shut it down. The landlord hiked the rent to five million shillings† and was essentially telling us to get out ... problems of hygiene and such. So twenty-five mothers and fifty-six kids had to go to the National Rehabilitation Centre and wait for the government strategy. On January twenty-fourth, the government is supposed to take them to Moroto ... to be there in time to prepare for the opening of schools. We want to be part of the government strategy but if they don't move on this, we will transport our own group on the twenty-fourth, no matter what.

At this point I began to realize just how much Rita was involved in, the urgent issues constantly emerging and requiring her attention, and I wondered aloud how she kept from being overwhelmed by it all.

I think the first six years went by without my noticing it. Every child presented different challenges and needs. As we overcame these it became like my reason for living.

When I split from the Open Door, I suddenly realized it had been six years. I also had none of my own [biological] kids when I started. When I left that ministry, I lost my sense of direction. I knew this was what God put me on the earth for. Still, God opened the door for Dwelling Places—and we've grown so fast, but I think it's because of my experience with Open Door.

Now we have growing pains of growing too fast. So we have to deal with these by slowing down, consolidating. This is a challenge for me. I can't sit down there. I like to see things change and move. I can be a pain to administration. I've decided I'm going to throw myself into advocacy and fundraising.

I also need to invest in my family and some business. I want to take care of my kids. So this year my goal is to step out of administration. This way I am behind my staff and not in front of them. I am going to be traveling a lot for fundraising.

* Katwe is a peri-urban area, one of the many shanty suburbs on the outskirts of Kampala.
† USh5 million equates to US$2,941.

Last year, from December 27 to January 8, I tried to stay away. This is the only time I have had to stay home and be a mother. My own kids are a girl of nine years and a boy of five years. The other kids are teenagers who I've adopted ... none of them are my relatives.

My Future Plans

My personal vision is to work myself out of this seat in the next five years. I'd like to be there for my girl through her teenage years. Since I've invested all their infancy in Dwelling Places, I'd like to invest all my time of their teenage years with them. I'm working toward that. That's why I'm carrying out some business at my actual home.

I'm trying to mentor others to be able to run this, and in five years we will recruit an executive director. Then I will just be on the board and be available for consultancy with other organizations and to speak at conferences ... as long as my priority is with my own children. Most of my teenagers, I'm training them to be independent—even if they will be on their own or staying at home, but they will be independent. But I also want another baby—it's also in my vision—something to tie me down. It didn't work for the first two kids, but I also want to be a wife, a daughter, a sister ...

My husband is William. He's an engineer. He works with Uganda Transmission. He is the main support at home. I think he has been a better husband to me than I have been as a wife to him. I'd like to run my home like my home and not like an organization.

This is not to say I've retired. I do want to work in the public service for Uganda when I make forty-five. I'm now thirty-five. In ten years' time, my vision is to serve my country. And to serve the world in fifteen years—possibly in the UN. All I need is life. And it's God who gives life so I just need to stick to him. God says, "My people perish because of lack of vision." So, our responsibility is to have the vision and he's responsible for the direction. Because all doors can be opened and look like an opportunity, but God is the one to say which one to go through, and through this one you'll find your miracle.

Some weeks later, Rita told more stories, picking up on some of the earlier strands, interweaving them with new stories and insights. In her typically down-to-earth and rather transparent manner, she spoke about an issue in the forefront of her mind at the time—the organization's deficit and challenges in fundraising.

Our Deficit and Fundraising

In 2004, we had to cut twelve staff. We have a deficit. We have a US$250,000 annual budget. Three-quarters of the budget is sponsored or funded. So we have to raise a quarter of the budget. This year we are starting the year with a deficit of a quarter of the budget—plus the other quarter that's supposed to be raised yet for this year's annual budget. I say, "Believe God and work hard." I just believe God will provide.

This year I will be out of the country for fifteen weeks to do fundraising. I go to the US once every two years. Mostly, however, I go to the UK. This year I'm going to Canada to visit one of our funders—Samaritan's Purse Canada. I will be focused on trying to get all the 238 children sponsored.

Child Sponsorship

See now, we have worked it out. As a ministry, we've really come a long way. It's like family planning. You're parents and you don't plan for the kids, but they are there. They are there! You haven't planned for them but they are there so will you wake up in the morning and throw them all away? They're your kids so they're your responsibility. So what we have to do is really work hard at finding ways in which we can raise the money to meet our needs. And one of the ways is really getting all of the children sponsored. Right now it costs almost US$98 per month per child to take care of the child. And because of our holistic support for these children—education, welfare, clothes, and stuff—it can be expensive. Education is the most expensive, because it's US$30 per month per child and then medical support and then

shelter. Because you've got to factor in the issue of shelter because most of the children that we work with came from the streets. Their parents may be there but they are living in shelter and we pay the rent. In their homes where we manage to trace their parents, they live in rented shelter so we factor that in.

And yet before, when we started our child sponsorship program, we only said that it would be US$25 per child per month, but that was because we were looking at what others were doing. But it's not true. It doesn't cost US$25. We discovered that some other organizations actually multi-sponsor the children. So they say $25 because that's what's almost their affordable costs. But like every child has like five sponsors and what, and then they will add it all together and it comes to the cost of what their budget is per child. But for ours, we know that it's US$98 per child without any administration costs. If you want to add administration costs, you can get US$2 but for us, what we want is that when we do child sponsorship, that's what it is—100 percent child sponsorship.

But we have another fund which we call the Two Thousand Dwellers Club. That Two Thousand Dwellers Club is the fund for operations. There people give an equivalent of 10,000 shillings* per month and that goes to the operational expenses of the organization. So that's how sometimes we find that we can't get staff but we can look after the children. When we go to donors, donors don't want to give money to administration costs. So you have to look for ways in which you can raise that money because you need the people to look after the children and you need to take care of them well in order for the staff to do well, to take care of the children well.

Two Thousand Dwellers Club

Anyway, so we have the Two Thousand Dwellers Club. And originally, it's really intended for Ugandans, and especially those who are my friends because many of my friends ... [*Rita's unfinished thought gets picked up later, once she gives some background.*]

* Approximately US$6.

You know, being young, I've always had to travel abroad to go and do fundraising. And you know you have to stay away for a long time from your family, from your children. I know one time I was flying back home and I really prayed and said, "God, you know I don't want to do this all my life. And when I come here, I have to stay long enough in order to raise the money that I need to take care of the children." And then God gave me an idea. Because, you know, I've been working and I've been working faithfully in the field with street children for ten years now. And so God gave me an idea.

You know, like very many people meet me on the way and they say, "Oh, Rita, are you still doing those things?" Because the moment I finished university, I started working with street children and so many of my friends never understood me because I went to a kind of posh school. So most of the people that I went to school with are now like doctors and what. You know they had a very good opportunity to go to good schools. I went to King's College Budo. It's a very good school. And I went to Gayaza Junior Boarding School, a very, very good school. I don't come from a very affluent family, but most of the kids who were in there were from affluent families so they can afford to go to many places. So when people used to find me on the streets they'd ask, "Eeeh, Rita, are you still doing those things?"

And now most of those that we went to school with have families, have grown, have got to the level where they've stabilized, have an income to give away. So God gave me that idea that, "you know, really throughout the schools that you went to, from primary to secondary to the university, there are at least two thousand people in Uganda who know you. So why don't you start something that will mobilize two thousand people in Uganda who can give regularly because they know you. They know you've been there. They know you've been in the field. They know you have consistently stayed and gone on working." So that was my target group. But I'm sure there are others coming in because they hear about me. I call it the Two Thousand Dwellers because it's Dwelling Places. So I'm saying that dwellers breed

dwellers. They take the word around and say, "Hey, let's join this initiative." So, in Uganda at the moment, we have about 160 so far. It started last year.

Actually, most of those I've been talking with are saying, "Oh I want to subscribe for a year," "I want to subscribe for two years." And then you keep them informed. You tell them, "Hey, this is what's happening." You get them into an AGM [Annual General Meeting]. You say, "This is what has happened." Now, with the Karamoja issue of children on the streets, we've been informing them that, "Hey, you people pray or do something or do you want to give extra?" You know, for the extra activities that are taking place for the Karimojong. Or even when they themselves walk on the streets and they find kids, they are like, "We found this kid." Some call us and say, "Have you seen this child?" So, we've kind of rescued about three kids because a "dweller" gave an important call and said, "Oh, I saw a child who was burned over there" and then we get straight over. And because we are linked with different social services, we can quickly be able to respond ... without just responding because you found a child there and you gave him a hundred shillings on the street, then tomorrow you find them again, then tomorrow you find them again. Do something sustainable. Support an organization that you trust and hold them accountable for taking care of the needs of the children as you see them on the streets.

Yah, so that is it. Those are the two ways in which we raise money really. But like right now, out of 238 we only have 175 children sponsored and they are sponsored at US$25. So that's why you see we have such a huge deficiency. So my goal this year is to try and make sure that all of them get sponsored fully. That's why you see I'm going out. Child sponsorship doesn't work very well in Uganda.* It's expensive. So now I'm just looking for ways and strategies of getting these ones sponsored. Once that's solved, then I don't think we'll have such a problem with taking care of the children and what.

We face a challenge because abroad we don't have lots of people who are willing to raise funds for us. So, if I don't go nobody can raise it. In

* Child sponsorship is not part of the culture in Uganda. Most people have many children in their own extended family to be concerned about and most do not have discretionary income to use for charity purposes.

Uganda, we can fundraise but we are limited. There's not so much that you can raise locally. And I know there are many donors out there in Uganda locally, but what you go through to get that fund! We don't have that experience or expertise. Then, of course, you have to get a professional person to write. But my challenge with them is that it doesn't go with the feeling. You know, like when somebody writes a proposal for you, they don't know you. They don't care. They are making money. They don't know the children. But for you, if you are going to sit down and write and tell the people the story, you can feel it. You have cited examples. You have very good success stories. You almost even laugh when you share your experience. So it's good, well and good, to be able to raise the money through proposals and whatever, but I would rather that kind of proposal be written by somebody who has been there, who feels it and tastes it and has smelled it ... you know, the challenge of having to raise that money. Then you are purpose-driven rather than money-driven.

So we do have a fundraising department now, Advocacy and Fundraising. And those people are part of the organization. They have a responsibility to children as, in the organization, we have a program that we call Holistic Care, where almost each staff member is allocated a few children to parent while they are with us in our care. Even the fundraising people have children that they care for so that they feel it, they know them, so they are driven to raise funds for these kids. Like if we are lacking somewhere financially or if their child doesn't have underwear, doesn't have slippers, and they come and say, "Eeeh, my child doesn't have slippers" and you come and say, "You know, we don't have money," they feel it. And so they say, "It's my responsibility to do this." So I just hope that they can be able to get the training and education, whatever it takes to write the proposals so we can also tap into the resources of the local governments.

Efforts to Help Resettle the Karimojong

Having previously explained their plans and involvement in the resettlement of the Karimojong, Rita now provides an update on the situation.

The government, they've come through with their strategic program and what but it's been delayed. It's been delayed because they are trying to put things in place. It's been a challenge to us to have to explain to the Karimojong why they are not yet back home. Because we had to get them from the centres to close the centre in Katwe, then take them into Kampiringisa, this place that used to be a juvenile prison. So these days, all those people, every "carer" is proposing to take them to a place that everybody knows is a prison. But right now it's not a prison really. It was renovated and it was allowed to receive children, small children. And so the environment is quite calm. But it's got its challenges because sometimes there is no food. There is a lot of pressure: lots of people and children but very few facilities that are very limited—you know, sanitary facilities. But this time here, we have women, pregnant women going there, as well as babies. We actually had one who tried to give birth and failed and so we had a caesarean birth *in* the rehabilitation center! But anyway, having to go back and explain to them that now this has been taken over by the government and yet we had promised them ourselves to take them home ... it's hard.

I went to the government authorities and I'm saying I have these people with me and I need permission—they want to go home. And the government was saying, "Yah, that's good, but we are not yet ready in their homes to receive them. We have got to put in place x, y, z, and address the causes." I understand that, but it's just taken too long. And the political people—the politics involved in that ... I tell you, I really wanted to go up there one of these days and be a politician. I just watched and listened to all those people who are in these meetings and none of them had been to the places that they were proposing to take this people. You know. This one is saying that. Others are so ignorant about the places that they're talking about.

I remember going in Karamoja, in the area where they were proposing to take people from Kampala. There are only four buildings there but they're planning for 1,500 people, with mothers and babies and pregnant women and children and men. In four buildings, 1,500 people ... small buildings. You know, they have only like what, five rooms. They were saying, "Oh well,

what we are going to do is we will put tents outside here and this will become some kind of mini camp."

And you know, because you're a small NGO, nobody knows you that much. Maybe they could have known what you do but they have never come to actually see. Not even one probation officer, none of the people who are sitting in those government authorities—although it's their mandate to ensure that almost on a monthly basis they visit these children's homes—none of them has been to visit us in the five years that we have been in it. None. None of all those people up there. Not even one probation officer has been to see us. But here they were, passing a lot of judgments on what we have been able to do. And who was I to be able to stand up and talk to them? How should I, you know? It's just me against the whole government.

Challenges of Age

I think one thing about my character is that my mom, when we were being raised, she told me that an elderly person is never wrong. It's a saying in our language. So how can I stand up when someone who has more authority than me, more power than me ... how can I stand up and say to them, "What are you talking about?" I don't have that in me. I don't have that in me so I kind of felt: You know what, maybe politics is not my thing. I would rather stick to helping the children.

I'm kind of like rethinking and saying that, you know what? Maybe if I grow older, and then I can be able to sit in there and be like these people who are fifty years and above. Maybe I can be able to sit down with them, but not in the near future. Mostly because of age. Because when you start talking, everybody like looks at you and says, "What are you saying?" And then again, me as a younger person, it's not that I think I'm less valuable to God, no, but like there are so many years of experience that are seated in those places, you know? And you come with your how many years? Ten? And you come with your passion and people are wondering, "Where are you from?" You are not even asking about money but you're just saying, "How can I help the children?" But they are saying, "Yah, but that can't happen because we need

money," but you know you have the experience of saying, "Even me, I've been here, working with a huge deficit but the children have been cared for." Somehow God has been great. Yah, we have a deficit but how many children have gone to school? How many have passed in first grade? How many have been able to not be on the streets for the last ten years? Even those who have made mistakes because of them getting pregnant and whatever, we know where they are, we know how many. And then you sit down and compare that with "You are here, you have the authority and the power to make things happen but you don't even do one thing, to go and visit one child in a children's home. If it's something about me having less experience, come and direct me because I don't have the experience. Nobody taught me to do what I'm doing right now but God ... if it wasn't for God. But you have the experience. You have what it takes to help me if I'm going wrong or whatever."

I don't know how many ditches I've fallen into as a leader—so many. Then you sometimes struggle to get out of that and only to come out and say, "Ooh, I made it!" But then, you go to find the government authority just stumbling and you go to them and say, "Hey, I'm doing this and this, and I struggled here and there." And they're like, "But why did you struggle with that because we have this policy here." And then you wonder, "You should have told me this like what, ten years ago? I would have listened. I would have walked through that path and not fallen into that ditch." How much time you spent doing things you didn't have to. You know, as a leader, children look to you and they know that you have all the answers. And then the people that you work with, they look to you and they know that you have what it takes to make things happen. I thank God. Yes, I cannot deny because the anointing is there. God has been able to call me to be able to do what I've been able to do but the struggle and the pressure of thinking, of being able to actually invent what is already invented. You know, to reinvent, and then you finally discover that there is massive years of knowledge and information of what could have been done.

My Initial Efforts

I remember, one time, the British Council sponsored me to go on behalf of the InterNGO Forum. I was heavily pregnant with my son. And so I went into Glasgow in this meeting that they said was about residential childcare. On that day, I tell you, I just sat down and cried, because I discovered that I had spent almost five years just trying to reinvent the wheel. And then having to think okay, this doesn't work, this will work. And then finally taking a child into what I later on discovered is what they call a "children's home" ... because, I didn't know. All I knew was that every child needs a home. So, let's just have a house and put the children in here.

If I was a probation officer ten years ago and I came to visit my home ten years ago, I would have closed that home and put me in prison. It was a house without windows, a shell of house which was very dark. It was in a swampy area at the end of a closed road. We had no mattresses. We had sixty children in there. No mattresses. We had to kill snakes every day. Every single night, the children would roll their mats away, they'd put them up and there would be a snake there. We had no medical personnel. But genuinely, in my heart, I thought these kids needed to go off the streets and I thought I was doing a great job.

Every single day I had to take a child to the clinic. Why? Because I did not have the slightest knowledge about first aid. All my knowledge, even my education, went out of the window when I started taking care of street children. Common sense came in—it was my only source of reference. I didn't even have any of my own children yet. I didn't know how to put one nappy on a child. We had babies in there but I did not know how to put a nappy on. Nobody taught me to do what for five years I just tried to do. That's why when I got into this conference, I just sat down and started crying because I was saying, look, who will ever be able to tell us this information? Who will be able to show me how to do what I want to do and do it very well, because I'm desperate to learn? And you know, when I went there, they were talking about so many things that my head almost exploded because I had to take everything in so that, when I come back I could implement it or teach others.

We had one week to learn everything ... and I was pregnant, eight months pregnant!

But that conference changed my life completely, because then I got connected. Since then, every time I find anyone with a passion to help children, I will *always* be there to help them. That's why you see that I'm hosting the CRANE Network in my office. There are thirty organizations subscribed to CRANE. I am there and I watch them come in. I look at their profiles, as organizations, and try to help those that are struggling and go to visit them and find out how they are doing, make myself available to help them improve. Dwelling Places is taking care of 329, and that's just one portion of the population of children at risk. There are the disabled children, there are what. So, if we are many and all of us are touching one part of each child at risk, then many children will be rescued.

Let the government remain where it is. I'm not going to be part of that confusion. If I'm not going to be able to be in touch with the grassroots, I'm just going to be able to use my experience and knowledge to learn about those who are out there doing something for children and make myself available for them and go and visit them, because for me, I wasn't visited. Because there might be some people out there who are doing their best but they don't know how to make breakthroughs. And there may be even some other people who are out there and taking care of children and not doing their best and don't care. But who is the victim? It's the children. So you know, somehow last week I just said, you know what? I'm not going back for any more of those government meetings. I'm going to stick to my job, to make sure that I do what God has called me to do—be there for those kids. So yah, that's in a nutshell.

Refocusing My Vision

The next time I talked to Rita, her political aspirations had been tempered by recent experiences.

What a drastic change, eh? I've got a feeling that God just gave me that opportunity to sit in there and watch and let me be exposed to what can be.

Maybe we'll see with years. When you go up there, you are not in touch with the people. Possibly you can be totally misunderstood if you're in touch with the people. They will never, never be able to get in touch and work on issues, even when you're sixty-five.

Age is a real issue. I was called in this ministry at a young age—not very young, because I was twenty-three when I first started doing this work. I know in my own character and maybe because of my upbringing, older people, whether they are right or wrong or doing the wrong things, you just have to keep quiet. But do I want to be a person who keeps quiet when there is injustice that's taking place? No. So what do I want to be? I want to be able to be the salt, you know, just be the salt.* If you can't be the salt in politics and be able to do the things that you can do.... God will really just have to commission me for that responsibility, because then I will know that it's him. But right now, I'm not going to pursue, like as in my own ambition, basically go up there because I really didn't like what I saw. I prefer staying in touch with the kids, staying in touch with the people, and being able to make decisions at that level. Decisions that I know are going to tomorrow bring change because I am the leader, you know? Not decisions that are going to wait for the parliament to check them out and just see and wait.

Because, we took children, we took people from the centre two weeks before the 24th, early in January, and we had done all the screening and promised them that they were going home. But what date is this? You know, one month just sitting there waiting to go home. Why? Because some politicians need to make their decisions for this and that. But supporters that we're in touch with because they trust what we're saying, they say, "What do you want to do?" I tell them, "I want to take people home." They say, "Okay, what's the program? What's the plan? How much do you need?" And then they say, "Okay, we'll give you this much and we'll pray for you and you will do that." It will just be a matter of saying, "Okay, now that we have the money for the bus, get on to the bus and let's go home." You know what I

* In this she refers to a verse in the Bible, Matthew 5:13, in which Jesus says, "You are the salt of the earth. But if the salt loses its saltiness, how can it be made salty again? It is no longer good for anything, except to be thrown out and trampled by men."

mean? Rather than saying, "Oh wait, because I think the politicians are saying this and this."

I read somewhere somebody said that the name of a child is "Today." You can't pause and wait when a child has a problem. You can't say, "Ooh, wait until tomorrow after I come from school or after I finish this," because if the child wants something, that's why they are vulnerable, that's why they're at risk. Every child is vulnerable in their own way. Whether they come from a rich family, they are vulnerable. And so, when the child has a need, your ears must be fast to listen to what the child is saying, to respond immediately. Whether it's in terms of emergency or whatever it is, you can even just lift the child and just put them here [*indicates her hip*] while you attend to other things. But, in this situation, the Karimojong issue has just shown me that people just sit there and say, "Don't give people food." And then you sit there and say, "Okay, we don't give them food but what do you do now?" They say, "Oh, we'll meet in two weeks' time and in two weeks' time we'll have made that decision whether people will be given food." And you're like, "But excuse me, what about today?" "Yah, we are going to pass a bylaw where nobody is allowed to give food to anyone." Yah, they are going to pass a bylaw that nobody can give any handouts to people on the streets or even in the shelters because that is what they call, they call them "pull factors."*

The Karimojong Predicament

So the exercise is going to start next week. This time they are not going to round them up forcefully.† In a meeting, we managed to get them to agree not to do forceful roundups. We are going to be able to give them social workers. In "we," I mean the InterNGO Forum. It's going to recommend social workers that are going to be trained at this place here in Kampiringisa for a day and then they will be involved in a screening exercise. But next

* "Pull factors" are those factors attracting people to the streets; as opposed to "push factors," those things compelling them to leave their homes for the streets (drought, poverty, hunger, violence, war, etc.).

† Forceful roundups by the police are the usual approach used in clearing the streets of those people who are homeless and poor.

week, there are others who are going to be involved in mobilization, mobilizing the Karimojong to agree to voluntarily go to Kampiringisa.

In this program, they are not allowed to go home on their own because if they go home on their own, they're not going to be on to the data of the people who are going to be helped. So we are supposed to be able to get them here. When one gets on to the bus, one's supposed to be able to go to this place, at Kampiringisa, where screening is going to take place, and from the screening they are supposed to get them on to the buses and take them home, hand them over to the district authority there, and the district authority will be able to help them to go to their own homes. It's not too bad because they're also planning to give them resettlement packages and link them to World Food Program so that they can be able to get food from there, but here in Kampala no one is allowed to give them handouts on the streets. So now, they are going to do this on a peaceful basis for a certain period of time and I think they were saying maybe a week, maybe two which is unrealistic. Because, with the thousands of people who are here, I don't know how many you can be able to ferry in a week.

There are thousands. There are thousands. In our database, by August last year we had 1,227. And, if you remember, you've seen them on the streets, it's gone really up, because you won't see the women but you see the children. But the women are out there; there are so many. There are women who are out there pregnant and some who are breastfeeding, and then smaller children who can't be on their own. Those who can risk can send their three-year-olds, but there are many three-year-olds who are in the shelters.

There are different people who run those shelters but they make money. People have to pay. Adults pay 700 shillings. Per day! That's why you see the children stick on you on the streets, and they beg for that money. They need that, otherwise they don't sleep in the shelters. And others, they sleep outside and then the risk is even higher, the risk is even higher.

If the Karimojong refuse ... But they've been consulted. They've had a lot of consultations and told the Karimojong what's going to happen. So

some have opted to go home on their own anyhow. But those who can't, who haven't been able to make the money ...

The sad, sad thing about it all is that some of these women have been trafficking the children so they hire the children from their relatives or from friends. Then they hire a child and I hear it's 50,000 shillings* per month per child—50,000 shillings per month per child. They hire them to beg. But sometimes when they get to Kampala, some women abandon the kid because they are like: we haven't made the money so I'm just going to get lost in here [in the city]. So then the kids remain abandoned or the kids remain looking and saying, "Can I be with you? Let me beg for you ... but just help me to go home." You know what I mean? So the children get lost and then, in the midst of it all, the city council comes and rounds them up and then the child is in this "prison." They are lost ... completely. So now tracing those relatives of those children is going to be very interesting. It's going to be quite interesting. Or even, when the kids may die from an accident over there and then ... "*Shauri yako.*"† There's nobody. It's no one's problem. We've buried the kids. Recently we buried a kid. There are kids who died from cholera recently, you know. And yet, there's no responsibility. Like, "Oh, that one's gone, that one's gone." And the sad, sad thing as well is that, although many Ugandans see the crisis, very few want to get involved, very few. Most of them would rather blame the government, but very few would even consider getting involved.

Because we've been in these government meetings but we haven't seen any business contributions before, we haven't seen any contributions from the private sector. We've seen the UN, UNICEF, and World Food Program. Otherwise, we haven't seen many Karimojong people themselves, the elite. You know, that's a low-class society. Then the MPs from Karamoja, when they are there, they are just defending themselves. You know, like how someone just says, "Ah, even the Karimojong deserve to be in Kampala. It's their city." But how can they be in Kampala when they are looking like that, when they are not bathing, they have no toilet, they are being stigmatized, they are

* Ush50,000 equates to US$30.
† A Swahili phrase meaning "it's your problem."

being killed, they are being what? Is that what you want, for the Karimojong to live in Kampala? Nooo.

And then again NGOs, for two years we've been really been trying to pray and believe God for people to get involved in the Karimojong issue. But right now I think God has put it so much on the hearts of people. But unfortunately they are looking at it as a nuisance. You know, like, "Ah, let's get rid of this thing and let it go." Quick fix, you know? CHOGM* is coming. Although you hear the government saying, "Yes we need to take care of the people," but then you hear the city council saying, "Well, every city has standards and the standards of this city are that people don't live on the streets." Like when you look at the work plan of the parties and they talk about impact, the outcomes, they say, "Ooh, when we clean the streets tourism will increase." You know what I mean? At the end of that, what is the underlying factor?

You know, I heard someone saying that "a country that doesn't care of its vulnerable people is a lost country because a country is judged by the way it looks after its vulnerable people." And yes, you might say many people in this country, in Uganda, are vulnerable. They are many. And there are many, many dependants. But I guess that's our challenge. We've got to stop judging the government and basically get doing something. And maybe if there's 1, 2, 3, 4, 2,000, 20,000 people who can come together and take care of the people. Let the government shout with their politics and get things going, but we who are down here, you know, we should really get involved and get the people some help.

Yah, so basically that's what they're going to do. That's what's going to happen. It has been very confusing for us as an organization because you have your program and you can't implement it because the government has another program. Then you have to see how you fit into that program. But, in the meantime, there are kids who are waiting, people who are waiting.

* CHOGM refers to the Commonwealth Heads of Government Meeting held in November 2007 in Uganda. In preparation, in Kampala, infrastructure development aimed at city beautification was underway for several months prior. Anything considered to be an eyesore was demolished, including some shops and residential structures. Street children are often categorized as such and face the threat of being arrested and imprisoned to "clean up" the streets prior to such an international event.

In terms of what the government's plans were to resettle these people, she explained ...

The city council and the government is taking them to a certain place, like a camp. But they are hoping that it will be the responsibility of the receiving district to help these people be resettled back to their places of origin. But again, there are some people who don't have their homes because their homes have been burned, raided, and destroyed, but they have designated land and fertile areas. These people want to go home. What we all need to do is to help them stay at home and stay comfortably like us here. They may be poor but let them stay home, in a way that is acceptable. And let their children be in school because all the schools up there are free. But because their parents are always having to bring the children here to beg, and why? Because they can't let their children go to school because they don't have food to feed them. So, when the famine comes everybody forgets Karamoja. It's something that we really have to put our hands together and do it. It's a big problem.

Challenging the National Prejudice

I know from the time that I was growing up I heard people say, you know, being Karimojong was like an abuse, an insult. And we used to have a slogan: "Speed up. We're not going to wait for Karamoja to develop (in order to do that)." From the time that I grew up. But you see, the consequence is that we've neglected that place and now we are facing the consequences. And I started hearing that slogan when I started speaking English. That was a very long time ago. Six years, when I was at six years. Now I'm thirty-five. So how long have they not waited for Karamoja to develop and who is reaping the benefits of that slogan? Us! There is no electricity in that area. There are very few buildings. People still live in grass-thatched houses. People fight for animals, rather than politics or leadership or whatever. People fight. People practice cultural, very dangerous cultural practices of getting a wife. You have to run after the wife and go through different things.

So there are those challenging things. And it can be very intimidating, especially if God calls you to such a place. You're like, "Hey! Hello. Who am I to reverse the slogan?" Now I'm saying right now that, "Hey, I'm challenging that slogan." I'm saying, "I am going to wait for Karamoja to develop. I am going to be there. We are going to do our best to make sure that we help in whatever way that we can." But that is going against, it's like saying you're going against gravity, the law. It's saying, "Oh, today things are not going to fall. They're going to go upwards." When God calls you to do something, that's all he wants you to do. Just trust him. And he is not expecting you to do everything, but he's just expecting you to be his hands, to be his feet, to just stick in there and be the salt. Take one day at a time. Trust him. Faith. And for me, in the ten years of working with the street children, I just know that there is nothing impossible. I know. I know days that we could have not had food. But we always do. Days we wake up in the morning and there is no money whatsoever. You know, you look at the bank account and you know that, by the end of the week, you will not have salaries for staff. But nobody has ever left; in the ten years of service, no one has ever left the organization saying they were not paid.

What Keeps Me Going

Now I have just told you about the deficit that we have. But what keeps me going? Just that—knowing that we've been called. That's all. No one sat down to say, "Hey, this is our plan. This is how it's going to be. This is what you are going to expect. This is when." No one. For ten years, God has been faithful. He has been there, with helping children, with getting people on board. I mean, we've been having people like you. Where would I have known you? How would I have known you? That just shows that maybe somebody somewhere recognizes what God is doing in this ministry and so maybe it's worth talking about. It's worth saying...

Like I always tell my staff, "You know, if you scratch down deep into this person, and start saying, 'How does she do it? Where does she get the

money? Does she have ... ?', you will never ever be able to find an answer. But the only answer that you will be able to find is that God called this woman."

I don't have the slightest experience. I am not an orphan. I have never been a street child. There has never been a day in my life when I slept without food. Or there has never been a day in my childhood when I thought I would actually go without. Why did God choose this person to be the one who is taking care of the homeless? It beats me. In his own providence. And that actually humbles me so, so much because you get to know. I always ask that question: why me? And it humbles me a lot to kind of like, when I see the children, never to even be able to say the words that "I understand," because I don't. You know? I don't know what it is like to sleep on the street. I don't know what it is. So I can never even sit down and tell a child that "you're not appreciative." Because for me, for all the things that I was given, for nothing, growing up in a country where there was a lot of war, trouble, and whatever. How did God choose that I still grow up with both of my parents alive, in a country where there is HIV/AIDS? Out of men being unfaithful or women being unfaithful to their husbands, how did I grow up in a stable family where the parents were always together—no fighting, no quarrelling? So, if I have been freely given, I guess what God wants is for me to freely give. You know, that's all I can say.

And I can never be able to raise a child or even to be an example to a child in a way that I wasn't raised. So, I know that my parents always wanted the best for me. I told you which schools I went to. And especially me, because my brothers and sisters went to day schools almost all the time. And day school is fine. They were good schools. But just somehow for me, mine was different. I was the only one going to boarding school and boarding schools are good in Uganda. If you go to boarding school, you are fine.

I'm very independent. I'm very confident, very confident in any way. I can stand in public. I'm always intimidated somehow when I do it, but I cannot say, "No, I can't stand there because I'm shy or whatever." But I guess it's always been part of God's providence of trying to say, "Let me shape this

woman in the way that I want her to be." So that really humbles me to know that it's just God, it has nothing to do with me.

My Parents: My Support

My father especially is a very tough man, but he always encourages what people's ambitions are. Like he says, "Is that what you want to do? Okay, how can I help you?" And then again affirming, always affirming and saying, "Hey, I knew you would do that." Then again, even now when I'm a grownup, he can text me and say, "I'm just so proud of you." [*She laughs.*] "I'm just so proud of you. I thank God for my family and I'm just so proud of you." Like, my little sister is leading within the choir. She can conduct. And then he'll send a message: "You know, today I went and watched your little sister doing conducting and then I heard you on the radio. I'm just so proud of you." You know? So, that kind of like affirms.

When I was graduating, even before I started this work of children, my dad stood up and said in my graduation ceremony and I think that really touched me in a very special way. He stood up and said, "When we had this child, we knew she was special." You know, I don't know whether he remembers that he said that but like I remember. He said, "When we had Henrietta [Rita], we knew she was special." So, it's just like, why did God choose me to be in this way? I can't take that for granted. I could have died. I could have made the wrong choices. Why did God choose me to become a Christian when I did? At fourteen years, I became a Christian ... and I really was a Christian, you know. I chose not to do the things that many youth did and that got them into trouble. With all my life and like the way you see me, this is the way, this is me, you know: full of life. But I chose not to do things that many young people have done and, you know, gotten HIV/AIDS. I chose to remain a virgin up to when I became married. I chose, and yet I was always so full of life. God is great. And I had those basic principles.

And of course my mom was always in my life. She used to come, guiding me all the time when I got into a relationship with my husband. He was the first boyfriend that I ever had and we dated for five years. I got to know

him when I was eighteen. And then my mom was there, all excited because I was falling in love. Other moms are like, "What?" But my mom was all excited and always guiding me, saying, "You know, yah, he's great but please, please, no sex before marriage. No, no. You come home at seven p.m." You know how sometimes you have small differences when you're with your boyfriend and you come home and you have a long face because today you were mad. She would come with her bottle of beer and sit beside my bed and say, "Hey, how come today you're not happy? Tell me about it. Tell me what happened." You know, being your friend and just being there. And even now, when like I get so whipped by the government and these different people, the first person that I go to is Mom. So, really when you look and say, "How many people in Uganda still have their moms and have their dads?" Maybe they would have been there. Maybe their moms and dads would have been there to give them guidance and encourage them at this time, but they are not there. So I don't take that for granted.

Initial Beginnings and My Motivation

When Rita first began working with street children, her mother was worried for her future and wanted her to get a "real" job—one that would earn her a living for her future. Her father, however, saw it differently.

I told my dad during that time. My dad was like, "Rita knows what she is doing, and if that's what she wants ..." He doesn't even say, "We need to support her"; he says, "I know she loves what she is doing. She's okay. She's okay." I remember him finding me in "street church." Because, when I had first started, I used to have "street church" and I had children who were with me in my Sunday school to come with me in the field [on the street].

So I used to go to the streets with my face painted, being a clown. Because you know, when God called me in this ministry, he showed me a picture of me in a dream dressed like a clown and being followed by this stream of dirty children. But now I know why God showed me that. I know that he was probably showing me that, in order to do his work, you've got to be really foolish, because how on earth would you come from the school that

176

you came from, with the people you've been associating with ... Like you know that man now who just told me that I was in the choir?* I was a star, you know, singing in the choir. To come out of there, everybody knows you. You come out and everybody says, "Hi Rita." Everybody wants to be your friend. But now, you are called to the ministry of the lowliest of the low. And you basically have to undress yourself of all of that picture that you were—a person who went to these upland schools, a person who was well known— and now you have to associate yourself with street children. Now I know. When God called me to this ministry, everything that I was ceased to become important. Because I would wake up in the morning and I would go and sit by the garbage bins with the kids. I didn't even know that I was doing that. Now I know because I can tell the story. But like it just seemed to come automatic—meeting the children on the streets and just being there and completely forgetting that there are people who are looking. I couldn't even smell. I don't know. Honestly, I don't know. I could sit there. I could sit by the wayside and you don't even notice that people are actually looking at you and saying, "Ooh, ew!" You don't even notice. Now I know because I can reflect, ten years ago, actually how I started my ministry and how I got to get a relationship with the children.

So, six years later, we went on a talk show with one of the kids that I first took off the streets and they asked her questions that surprised me as well, because I don't know if I did it and I don't know if I could do it now. They said to her, "What really made you come off the streets?" She said, "Yah, so many people used to come and tell me, 'I want to take you home and what' but I never used to go. But what made me go with Auntie Rita was because one day she came from church, from KPC,† and she told me, 'Heey, can I share some of the juice?'" (She had a polythene bag. I don't remember this but that's just her testimony. She had a polythene bag with juice and a small straw, all dirty and filthy. At least I remember that she was dirty and filthy but I don't remember asking her for juice. And then she gave me the juice to test me but I drank it. That's what she said.) And she said, "On that

* We had just been interrupted by a man who Rita did not know but who recognized her from the church choir and stopped to greet her.
† Kampala Pentecostal Church, a large church in the centre of downtown Kampala.

day, I realized this woman is different and from that day I made a decision that whatever she's going to tell me I'm going to do it." But today I don't think I would go on the streets and do that. So, that's why I'm saying that God just gave me the grace and undressed me of whatever I was. And I like being smart, as in dressing up, and I like makeup. And I wasn't different then. Yes, I used to wear my makeup. I used to be dressed up. But, for some reason, even in that way, clothed with whatever clothing that I had, I still used to go down and reach out to these children. And many of them that I have now, the kids that we have in the home, were the kids that I first met ten years ago.

My dad saw me with this clown painting, with bags ... I was going up in their house and looking for any clothes, any shoes, anything that was hanging around that they didn't want. I'd put it in the bag. Those days, that's all I knew how to do ... to get old clothes and what for those kids. And my husband managed to give me money to buy milk, small packets of milk, and cake. So those were the things I would take to "street church." And the kids liked touching my face because it was painted. But I felt so touched [moved]. With makeup, I felt safer because then I knew that there was this thing that attracted the kids to me and I was hiding behind it, the mask. That made it easier for me ... to be a doll, you know?

Because initially I tried to go and find permission to collect the children but everybody was chasing me away. From the government authorities to whatever, they were telling me, "Who are you? What do you think you are doing?" and "You know, you are not the first one to come and do this. You know, the street kids are always there." Because, growing up, I didn't notice that there were street children. I was always protected. And I know that, being part of KPC, that church is just right in the centre of Kampala and that's where most street children are. But I never used to see them. I never. It took God to basically call me to that ministry and undress me and give me his spectacles to see these children from his perspective because I would have never, ever seen them, never. Because even now my passion is so much about street children than any other children. I know there are disabled children—

they are there. I know there are orphans. But I have this strong passion for street children and I don't have any reason to because I've never been a street child. But I just have this thing that no child should live on the streets.

I love my son. I know I have my daughter as well, but my daughter is very independent. My son is so clingy and he likes his mom to hold him. So, when I see a child who is like my son on the streets crying ... Nowadays the Karimojong children, you see them dozing on the streets, begging and dozing. One, very early in the morning before eight, he's in the dump and he's begging and he's looking and crying, and you can't do anything about it. I always kind of imagine that was my son and something happens to my stomach. You know, like I feel it in there and I'm like, we need to do something, we need to do something. So sometimes actually that zeal, it kind of breaks my staff because then I will come with that kind of motivation to do something at that particular time. So I will land on someone at that time, not badly, but I will say, "Okay, how far have you gone with this?" because I know there is no time to waste about that child. If you waste time now, there's that child. There's one child that needs to go out so that another one can come in. Because those that go out find a place called home, but those that come in are the ones that need to come in, start the process, and go out.

But my passion is like, I was raised in a family and so my passion is to see that the children that are on the streets get a chance to be loved and rehabilitated and supported, and change of behaviour and whatever, and then find a home—whether back with their parents or into foster care or adopted. But I don't want them to be in an institution. I know we have a challenge with the teenagers because not so many people, all over the world not so many people will take a teenager into a foster care. But nevertheless, the programs that are there, just getting the teenagers to know God as their Heavenly Father, to know that he is the one who can be able to help them ... to become good adults. That's what we emphasize with them, you know?

A Mother's Pain: David's Story

I had asked Rita whether she had had challenges and struggles because of being a woman. Expecting her to speak of issues of gender discrimination, I was taken aback by her response.

I think those ones surpass any other challenges. The biggest challenge I think is that, as a woman, you're a mother, you know? I've never really had birth pains because I always have my children with caesarean birth. So I don't know what it is to have the birth pains. So the pains that I've experienced as a mother are the ones when you're desperate and you just don't know.

I remember feeling that pain when we lost our first baby who had been abandoned in the home. He was HIV positive. I was totally scared that he came in and he was HIV positive. I could not throw him away because he also needed love and protection. But we were in this other house that I told you about. We didn't have a nurse. We didn't have anyone. Nobody knew us. Nobody wanted to know us. And I was helpless because here was a child who was gasping for his last breath. And I was coming up there and totally helpless, not knowing what to do. He was stretched out. I think he was probably about three years old. Stretched, all stretched, gasping for breath, completely hopeless. On that day, I think I felt what they call birth pains because I was saying, what on earth do I do? I had all these other children watching, you know. It's something I can never forget.

The story of that child is also very, very strange, because this child was found in a bush by a police officer. The police officer had gone to use the bush as a toilet and then he heard the voice of a child saying, "Mama! Mama!" A strange thing that even in such circumstances, children still call out for mama. So the child was crying. The police officer found him like a pile of bones and flesh. He said that that child must have been there for at least two days. He had been eaten by ants. There were parts that were all eaten away. That part of the nose here [*indicates the centre between the nostrils*] was all kind of stinking. But, because they knew that I was the lady who picks up babies—by then that was really the beginning of the ministry—they called me. The police called me and said, "Ah, Rita, this one? I don't know

what you're going to do with him." So, I found they had kind of like splashed some water over him to make him a little bit approachable or whatever. And he was naked, seated in a corner like that, looking, because everybody was watching and saying, "Oh the nose!" The nose was in a state but, like I told you, God had undressed me of whatever that I was. So I reached out to this child and picked him up, and he clung onto me like he was telling me, "Don't let me go." We named him David. By then I hadn't yet got a home so we took him to my home. [*She laughs.*] I don't know how but we just somehow used to fit him into my home. And then we started taking care of him.

Then, when we got this children's home that I told you, we transferred him there. And especially I think because I was scared, because to learn that the child was HIV positive ... I didn't know how to treat an HIV positive child. I didn't know whether that AIDS would spread to my child. By then I had my first-born child, Violet. She was about nine months or something.

Like I told you, most of my friends, my schoolmates are now doctors and what, so I went and spoke to the doctors. They gave us free services in International Hospital. I had nobody to take care of him but now International Hospital, they have nurses. They took care of him. And that's when they told me he's HIV positive. So they treated him for a bit. He became better—enough to come back to the home. He came back to the home. And then they still linked us to Mildmay. There is a place there on Entebbe Road where they take care of HIV positive children and people. So they got him onto ARV drugs. Those days it was a long time and it was expensive. But somehow they used to take care of him. The truck would pick him up every day and take him and what. And then they brought him back. We got that service because of a friend that I had gone to school with. So it was easier; the burden was less. But when the day came ... Because usually what happens is that, when they get to their last stages, then they don't pick them up anymore. It's like, okay, it's their time now. Oh, but this day I wasn't prepared. Well, death never prepares you, does it? However much, even if your grandmother is 110 years, you're never prepared for death.

So, I was standing there totally helpless, not knowing the first thing, not knowing what to do with this child, and until he totally gasped for his last breath. And, I didn't know how to prepare the body. And of course we didn't have a burial ground. So these are things that I'm telling you, you just get to learn as you go along. You don't know what to do in such circumstances. Here, in our culture, you're not allowed to bury anyone within a rented house—you know, like anywhere near, in the compound or wherever. But in the *limbo** they never bury over the weekends. So, if someone dies over the weekend you don't bury them. Now here we were with no money whatsoever. We had a child who has passed away. It was a weekend. What were we supposed to do? We had to bury the child secretly and exhume the child on Monday, and then bury. It's a trauma. But I will never forget that first death. It's the hardest challenge that I've ever had as a woman. You know, having to do something like that.

We had that child for seven months only but I thanked God. That child would have died, would have been eaten by the dogs and not even been known that he existed. Somehow God chose, still chose us to take care of that child in the last days. We know where he's buried. We know he's got a name. We can talk about him. You get challenged but then you look at the other side. You look at the positive side. He would have been a thing that somebody found there and said, "Oh, this is a skull." But we know his name. We know where he is buried. And we can talk about his seven months, like what he used to do. We can relate to the smiles. We have photographs of what he used to look like. So that's the meaning of life, you know? You live, you're born, you are loved, you're taken care of, you're given a name, you have an identity, you die and they still know that that's what happened to you.

So, in the service of taking care of abandoned children and children at risk, you prepare yourself for things like that. You recognize the individuality of every child and you emphasize the fact that, when God created those children, people created them and knew them, you know, knew them, gave them a name. He knows that they are there. So even if it's a child that is born in

* *Limbo* is the Luganda word for cemetery.

182

your stomach or given to you, you know they are there. They are individuals. They are real. You treat them with respect because God has given them to you in that way. That's one of the challenges. That's the hardest challenge that I have ever faced in this ministry.

Hard Knocks

And then, of course, the challenge of God calling me as a young girl. Sometimes you're not taken seriously, you know. And again, I've never worked anywhere so I don't have any work experience. So, most of the time you're looking and having to learn on the job with no trainer or point of reference. I learned words that to me were new words. You know how you're in school, in Primary 4, they say "new words." They give you spelling, spelling, spelling, and then they say "new words." You say, "Okay, this is a new word and that's a new word" and it adds onto your vocabulary. Now for me, I had a lot of new words, simple words like "advocacy," "network," "budget," "proposal." All those are new. Like people used come to me and say, "What's your budget?" and I'm like, "What on earth?" Because I had my parents all my life, I didn't have to look and budget for things. Nooo. They were always there. They always had a budget for me. They always cared for me. But, this time, people are coming to say, "What's your budget?" You use a lot of sign language like, "Because if we could be like this and like this," and then someone says "networking." Ooh yah, that sounds like a new word, but you know it. And then you say, "You know, we need to speak for the children." Then someone talks about "advocacy" and you're like, "Yah! So what's 'advocacy'?" And then they'd say, "Oh, because advocacy means ..." So lots of people used to laugh at me. It was interesting because it was a challenge.

But also lots of people took me for granted. You know, lots of people have used me. They have come and stepped on me and got whatever they want and go away. You know, many times I don't even know what I want, but people come to me when they know what they want from me and they never expose themselves saying, "Oh, this is what I want." Many people have taken me for granted. I usually tell people that I'm like a glass. You can really,

totally look through and see everything there. So those who are exploiters ... And maybe that's one of the challenges of being a woman. I don't know, maybe there are some women who are closed but many of my friends know that, with Rita, what you see is what you get. You know? So those who are not my friends or who are not really interested in seeing Rita develop or grow, they will come and see what is inside there and totally, totally use it to try and harm me. And it's painful! It's painful not being able to explain yourself or being misunderstood or not being able to defend yourself because someone knows a lot about you and you don't know much about them. So they can use that to your harm. That is a big challenge for me.

My Husband: My Defender

In leadership, as a woman, a young woman, my strength is in the fact that my husband is a strong character who will defend me with his life, but he will take his time. You know what I mean? He won't jump in unless there's danger. He will look at it and say, "Okay, okay." But if someone comes and tries to exploit me or whatever, he will defend me with his life. I won't say that he's not always there, but he knows I'm independent and I'm just blessed that he's very, very careful in terms of finances. He's a very, very trustworthy person and he would think with his head. While I think with my heart, he thinks with his head. So it's a very good complement.

I'll wake up in the morning and say, "Ooh, but we need to do this," but he's like, "Yah, but did we plan for it?"; "Yah, but can't we do it next time?" And he will be strong and say no. Things like requisitions. As I told you, I've never worked anywhere but he knows the systems, procedures, and he's a signatory to the account. When you find that in a board meeting, many times board members say, "You know, is this your husband or he is your boss?" But I respect that, because I know he will never sign a cheque unless he's sure he knows what that money is for, and why. And that has helped me a lot. Because, with the transparency that I have, all those who come and are using that money as implementers, they know that they have someone to answer to. For me, I will say, "Okay, okay, that's fine. That's okay. No, that's

fine." But for him, he'll say, "Why? You need to show me why." Even with me. Many times he's sent me away and said I didn't show why. Because I will sit there and say, "But this requisition has come in and these people say they need this. They need this." He says, "Yah, but Rita it's not in the budget. It's not in the budget. It needs to be justified why they're using that." Otherwise, I think our deficit would have been treble.

Why we've had that deficit is because I keep "giving birth" to all these kids. That, he can't stop. [*She laughs.*] That he can't stop because I will find them and I will have to do something with them. But for him, with spending it's like, "Yah, but this money ..." So now that controls me. I'm like I can't have any more children, because if I do I'll have to spend more. But I didn't know that in the beginning. Because the kids are out there and they need to get off the streets so we've got to just take them off the streets. But now I think as well, and say, "Oh, before I get a new one on, William will have to know and the next question that he's going to ask is, "Can we afford that one?'" That's why for two years now our street outreach activity has been limited. Kids want to come but we have limited funds.

Last year, we said we're not taking on any more. But when I watched the Karimojong kids, I was like, no we can't, we can't not take on any more children. But what happened, we opened up a whole new program. So it's become easier for me to say, okay, this is Dwelling Places, that's the money for Dwelling Places and this is the Karimojong Program and this is separate and we'll raise funds for that program. But, now, instead of 238 children— those are the ones in Dwelling Places—but we have the 117 [*she laughs heartily*] that are in the Karimojong Program. So the justification is: this is a different program, and that is a different one. That, you are responsible for. This one here is just being birthed and the government is helping, so, you know ... [*She laughs.*] I have a big problem with "birth control." But I'm becoming professional. I am becoming professional. I told my husband this year that "You know what? This year you have a professional wife."

Now a Professional

That means that I'm now beginning to think with my head as well. The Bible says that a good name is better than silver or gold. So I don't want other people, like donors, to ask, "What is she up to?" If I've got to "give birth" to those kids, then I've got to find a way of making sure that the money or the finances or the resources are there to be able to take care of them. That is the fact. So that's why I'm saying now I'm professional. Now I can take time to count the cost and make a decision to help based on the support that I have raised or that I am able to spread out.

That's why, when you found me in the office, I was talking to Anthony. He's the coordinator for that project because he's Karimojong. My idea is to develop that, develop him and mentor him, put up a whole project, umbrella it within Dwelling Places ... that possibly within two years, let it grow on its own ... so that Dwelling Places can also grow on its own. So I was telling the kids, this is our cousin [*she laughs heartily*] ... this is our extended family. Dwelling Places is the family. The Karimojong Program is our cousin.

As I told you, the vision of Dwelling Places is so solid for children. And the Karimojong, you know that you can't disconnect the family from the children. So, many of these ones are abandoned and possibly need rehabilitation. But these ones here have families. [*She indicates two different groups of children.*] Whether they are Karimojong or not Karimojong, with time all the families will be going into the Herald's Initiative.

The Herald's Initiative

It's called the Herald's Initiative Project. You know how it's in the Bible that they say write down the vision and make it plain, that a herald will read it and run with it?* So a herald is somebody who hears what someone has said and runs on with the same message. So we are mentoring the Herald's Initiative Project, to do like we have done ... only that this time they are doing it within family settings; that we are the ones staying with the ones that need

* Habakkuk 2:2: "Then the Lord replied, 'Write down the revelation and make it plain on tablets so that a herald may run with it.'"

alternative families, foster care, what. Now that is something that I would love to see. Because these ones here already have their moms, they already have their dads, but these ones here, it's not so. It's a gap within Uganda, where alternative families are still a new theory. We have extended families, but even then, the children within extended families end up still not being really cared for. So that's where I see us going. And I see Herald's being registered as an independent organization by the end of next year. I want to see that they have started their registration process as an organization, and they kind of draw out from Dwelling Places. And we'll have the patronage, like just to see how are they are doing, how are things going, but just Dwelling Places to focus on children.

So Many Demands ... What About Me?

We talk of her upcoming travels to the UK, Canada, and the US to meet with donor organizations to fundraise. She had mentioned previously that she hoped to take some time to rest. After hearing of the intensity of her life, I expressed my hope that she indeed would have this time for herself.

I will have a week. I do have a week in between that time, when I'm really like on my own. My husband and I have invested in a holiday time-share program. When I go overseas, I always make sure I take one week for myself. I stay in a hotel and spend the time for really reflecting and praying, watching movies, doing puzzles, and relaxing.

I query whether William, her husband, will be able to join her since she will have to be gone so long.

No, I prefer that he doesn't because you know what? Then I will end up having to do some cooking and taking care of him and yet the whole purpose of this one week is for me to rest. And at this time it's really my time. It rejuvenates me completely just to have that one week. It's easier for me away from Uganda because then I know that I'm away, on my own. I can do what I want, sleep when I want, wake up when I want, and just think about what I

want. So, I think it's going to become a policy in my life, you know, just to basically catch up with myself.

There are so many things that are around me that are so loud, and actually it's become a bit of a concern in my life really ... because somehow people forget that I need things to be done for me. But they know that I do things for people, you know? But they forget. They forget. So there's a point in my life when I get a breakdown and I'm like, I enjoy what I do, but when does it stop? Like, can I have just one week to just commune with me? This is Rita. This is her, these are her thoughts, this is her time when she can be able to sit down and think and ... not about somebody else but just about Rita, you know? About Rita ... and possibly commune with my God.

In my position, many times I'm looked at as a pastor for the people. I'm looked at as the one who's got the answers. You know, even at home. You know husbands. I love my husband, don't get me wrong. He does a lot but, you know, in our culture the men, when they come home, they expect you as a wife to be, you know, basically looking out for them. Their job is to get the money home ... to feed you and take care of the family in that way. My husband does a great job. I told you that I'd never worked anywhere, but we have never failed to pay one bill. My kids are in good schools. We've had food all the time. I've never had to stretch and wait and say, "Ooh, we don't have money." You know, I worked for six years in my ministry without getting any money for me. But he was always there. I had my clothes, you know, I was looking good, but with money that was coming from his pockets.

But what I need is that ... after doing all this that you have done outside your home then you have to do all that *inside* your home for your kids, for your husband. So it doesn't stop. Then when you go outside the country, you have to speak for the children and look for money for the children. You have to speak, advocate, and look for money for the children. So when do you actually sit down and commune with yourself? Yah, so I'm just going to be pampered. I'm going to have my own space ... because if I don't, I'll grow old very fast. Right now I have that, you know ... but I have to always purpose to take a week away for myself.

Growing into Management

We came to the end of our discussion and then she started talking again about when she goes away and how the organization will run without her present. Excitedly, she explained the style of management she is growing into as her organization grows and develops.

I wasn't very confident about the people that were serving on the team. So I kind of like was saying, "Will they manage? Will they be able to do it?" But last year was good because everyone who was on the staff team was with me last year—I've watched them, I've seen them, I've seen their integrity, I trust them. So this year, I started by saying, I'm going to manage. I remember ... because I learned that from my school of experience.

Like when I finished university ... I did Social Sciences but, with Social Science, I don't think I know one thing that I learned ... because I didn't even know which direction I was headed for. But I guess now I know it was confidence because, when I say that I studied Social Sciences, it becomes easier for professional people to understand why I do what I do. They kind of bring it in a box and say, "Oh yah, you're a social worker, that's why." And anyway, when I was starting to do my work I told God that, "You know, God, if you can use my degree, you can use it." And now I know that he said, "Okay, I think I can make something out of this." But I did a good degree. I didn't get a First Class or Second but I had an Honours.* But what happened is that, after I started my work and I didn't know how to do what I needed to do, I started looking for how to get a skill to do what I'm doing and do it well, and that's when I went for a postgraduate diploma in Public Administration and Management.

So it was during that that we learned something that they call "management by objectives" and what they called "results-oriented management." So I told my staff, I do not even remember, I'm not really sure but it just makes sense to me because we'd been writing a lot about objectives, specific tasks, and what, in that professionalism. So, I told my staff, I said, "Oh

* First Class, Second Class, and Honours are categories of academic achievement within the university system, with First Class being the highest level.

this year I'm going to carry out management called 'management by objectives.'" So everyone was like, "What?" I said, "Yah, so this is what I mean. You set objectives. I'm going to manage you by those objectives that you've agreed." So, for me that's just it. I don't care that theory that comes with it, and the practice and what. But, it makes sense to me. If we're going to manage the organization by the set objectives, what I will do every month is sit down and say, "Oh, what did you set out to do?"

Now I don't know why I didn't understand that when I was studying because right now it does make sense to me, you know. Actually, if they were talking about it theoretically and saying, "Oh, it was started by a set of management, came from the US and whatever, whatever" ... but right now it makes sense to me to manage by objectives. People look at the objectives, sit down and say, "This is what we set out to do. How far have they gone?" at every stage. When I come back I will look at the records, look at the budget, look at the finances, look at the objectives, and appraise people. This makes sense to me. [*She laughs heartily.*]

And then results? Well, results-oriented management, you sit down and say, "This is the outcome. This is what I would like to be able to see by the end of July." So, if it's results-oriented, that means that orientation means that the dreaming comes true. So, that means that if it's results-oriented management, it says, "What did we agree to see at the end of the year? Okay, so what have we set out to do in order to get there? That must be the objective." So I said, well, I'm going to practice management by objectives and being results-oriented. I will be able to look at the results and the objectives and that will be management. [*She laughs heartily.*]

That's why, when you ask me, "How is the day going?" I say "By management." Because now I'm like sitting with my staff and saying, "Okay guys, what are we going to do? This is what we are going to do this year." So, because the program of Herald's has been so erratic because of the government and we've had to change it to tune to what the government had designed, I've been talking to Anthony, one of my staff, and showing him this is how we are going to do it. And I was putting there the point and saying, "By this

time we must have done this, by this day we must have done that, and then by December ... And these are the responsibilities that you are going to have in administration, these are the people that you're going to help, this is what you're going to do, and what." At the end of the day I said, "Wow, that's excellent." That's the professional ... and who made the professional? [*She laughs.*] Experience!

CHAPTER VI
Rose Miligan Lochiam

ROSE'S STORY RISES out of the eastern part of Uganda that borders Kenya and Sudan—Karamoja. In contrast to the rest of the country, this is an area of semiarid climate and vegetation, of vast savannah plains inhabited by the Karimojong—nomadic pastoralists who rely for their survival on their cattle. Traditionally, cattle are a source of food and wealth (especially to pay marital bride prices), and part of various cultural and spiritual practices. Raiding cattle therefore is an integral part of the culture, both as a means of accumulating wealth and for youth to prove their manhood. Raids occur within Karamoja, between neighbouring districts within Uganda, and across borders with other cattle-herding peoples in Kenya and southern Sudan. Such raids have long characterized this region, but their increased violence and

192

frequency are related to the increased prevalence of guns, the flow of which has over the long term been from the conflicts in northern Uganda, southern Sudan, and the Horn of Africa.[88] With the gun, raiding has become for some a way of stealing that is different from traditional raids. But even this is part of a complex web of interrelated factors affecting the insecurity of this region.

In Uganda, Karamoja remains "one of the most marginalized regions experiencing conflict and poverty."[89] This marginalization has its roots in the colonial era, when policies were made to intentionally isolate this region such that permits were required of anyone entering Karamoja, the people were described and treated as backward and uncivilized, and no efforts were made toward the region's general development.[90] The colonial administration also put in place policies to protect large areas of land as game parks and game reserves.[91] This effectively made 36 percent of the land inaccessible to the Karimojong nomadic herders and increased the pressure on and rivalry for the limited resources of water and pasture.[92]

The Karimojong are warriors, and resisted colonization. In a well-known story from 1940, Karimojong elders rejected education by ritually burying a pen. This was in order to protect their people from the cultural destruction witnessed in neighbouring ethnic groups that had gone to schools and undergone a Western-influenced education. Only in 1995 was this "curse" lifted in a corresponding ritual, "unearthing the pen," which opened the region to the promotion of education for the youth.[93] Isolation and underdevelopment were thus imposed through government policies, and also self-induced through the Karimojong's efforts to protect their culture and way of life. Both the lack of exposure and lack of education protected the culture, but also disadvantaged the Karimojong in terms of being able to engage with other Ugandans and be involved in the development of their region and nation.[94]

Compounding the underdevelopment of Karamoja is the harsh climatic environment characterized by long periods of drought. Water is a constant source of potential conflict. Food security is tenuous. At the best of

times, the Karimojong live a precarious existence in their relationship with nature. This is only exacerbated by the intensified raiding that leaves people destitute—their family members killed, property destroyed, wealth in their cattle stolen, and little hope of survival without these resources. The cycle of raiding is thus often perpetuated due to poverty and a lack of livelihood alternatives.

This reality does not detract from the fact that the raids and roadside ambushes make the region so insecure that most NGOs refuse to work there. United Nations staff working in humanitarian relief wear full flak gear. Such conditions discourage outside investment or contributions toward development, and so it becomes a vicious cycle. The region has also earned itself a negative reputation, in part because of its history of isolation and resistance to development, but also because of the increased gun violence since 1979.*

In the rest of Uganda, there is a dangerous stigmatization of Karamoja and the Karimojong people. All the neighbouring ethnic groups consider the Karimojong enemies. Young children have been socialised to regard the Karimojong as merciless warriors. The ethnic sentiments in the neighbouring districts are expressed more strongly by the older people, who blame the Karimojong for their socioeconomic hardships and poverty. The xenophobia against the Karimojong transcends the sub-region up to the national levels, where they are portrayed as a backward and aggressive people. In parliamentary debates over the conflict in Karamoja, ethnic sentiments, especially hatred, were expressed in statements like "kill those fellows," uttered without remorse.[95]

Throughout history, efforts to deal with the conflict and insecurity in Karamoja have been numerous and varied, from forceful military intervention to more voluntary disarmament programs to efforts at dialogue and

* Guns became prevalent in Karamoja after 1979, when Idi Amin was overthrown. His soldiers abandoned the army barracks in Moroto town and the Karimojong raided the guns and ammunition left there. Since then there has been an active cross-border gun trade in the region (Pazzaglia, 1982; Uganda Human Rights Commission, 2004).

peace agreements, all augmented by various community-based initiatives.* While each has had an impact, none has been able to address the multifaceted complexity of this insecurity and so bring peace to this region.

It is from within this context that Rose Miligan Lochiam tells her story.

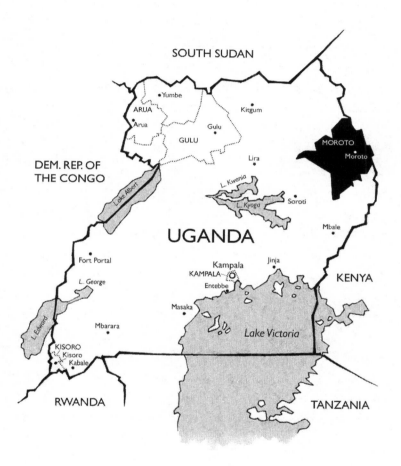

* Examples of some community-based initiatives are the Acholi Religious Leaders Peace Initiative (ARLPI), the Catholic Diocese Justice and Peace Commission, the Teso Initiative for Peace, the Karamoja Initiative for Sustainable Peace, Happy Cattle Project, Lutheran World Federation (LWF), Kotido Peace Initiative, and an organization bringing together the Pokot, Karimojong, Turkana, and Sabiny (POKATUSA) (Uganda Human Rights Commission, 2004).

Introduction

I had heard the derogatory comments from other Ugandans about the Kari-mojong being "backward" and "uncivilized" (ironically, words used by colonialists about the ancestors of those same Ugandans). I had experienced the outstretched hands of displaced Karimojong women and children begging on Kampala streets and saw their numbers increase daily. I had also heard of a prominent woman involved in peacebuilding and tried to find her, but to no avail. This is not a region to venture into without contacts so I satisfied myself by highlighting this conflict through the stories of Rita and Dwelling Places in working with those same Karimojong on the streets of Kampala.

In a serendipitous turn of events, in the midst of hearing Rita's stories, I sent my research assistant to photocopy a report I'd been loaned, *Hands Across the Border: Building Peace-Bridges Among and Between the People of Teso and Karamoja*. He came back with the phone number of Rose Lochiam, the Karimojong woman pictured on the front cover. A former classmate who just happened to be at the photocopier at the same time recognized this picture of his aunt, confirmed her involvement in peace issues, and offered her contact. I was stunned. Now I was faced with making a cold call—this in a context where introductions are so essential.

To my utter surprise, after my brief self-introduction, Rose practically began telling me her story on the phone. Her openness and readiness to talk to me I would later realize were reflective of her belief that, "This is a big problem. If it is left to us, we won't manage or succeed. We need people from outside to help us—to write, to photograph, to film. Then the different pieces can come together." She invited me to her village in Moroto District but, before I could make the trip, she made an unexpected visit to Kampala that afforded us the chance to meet.

Over drinks at a local restaurant, I listened as she gave me an overview of her life and her intentional involvement in peacebuilding in Karamoja. Rose is soft spoken and unpretentious, but with a deep, inner strength. Presently in her mid-forties, she was widowed in her early twenties when her husband was killed in front of her in an ambush on their vehicle in Karamoja.

She was left with three young children who she has raised on her own; she has not remarried. Her university-age daughter, who had accompanied her to meet me, listened silently and with interest to stories she hadn't heard before.

Rose talked about the research she conducted in Karamoja that caused fundamental shifts in communities and organizations as people realized that peace requires everyone's involvement and is not simply the purview of the army and police. I heard her assessment of the root causes of the insecurity being underdevelopment, a lack of alternatives for survival, and widespread, systemic poverty. I then heard about the vocational training institute she is starting at the community level in an effort to address these issues in her area, and of the vision she has of skills training for people with little or no formal education—all of this without a steady income or any tangible funding. Before parting, we made plans for me to accompany her on her return to her village on the weekend. There I would gather more stories and experience firsthand her life in Karamoja.

The next section begins with my reflections on the time I spent in Karamoja, in Rose's village. It is against this backdrop that Rose's stories unfolded and that my understanding of her context grew and deepened beyond the stereotypes and prejudice I had heard in the city.

Experiencing Life with Rose in Karamoja

We leave Kampala at 7:30 a.m. for the eight-hour trip to Moroto District. The seats already feel hard.

At the stops in Jinja and Iganga, I notice (by their physical features, scarification, or jewellery) that many of the youth selling snacks to passengers are Karimojong—likely some of those displaced or who have left due to the insecurity and lack of opportunity at home.

In Soroti, the bus fills, bodies crammed together, kids on laps, and the aisle packed with people standing. It's hot and sweaty. I'm thankful to be by the window. Rose and I talk of many things. She shyly snuffs tobacco, somewhat embar-

rassed. I find out later that educated people look down on this practice as backward. She tells me that she never used to use tobacco, but she suffered with sinus problems. An operation only helped for a few years, and so now she's trying tobacco as medicine. It seems to be working. She also tells me how tobacco and water are central to peace. In Karamoja, anyone can ask another, even a stranger, for some tobacco or water and they must be given. These are unspoken social rules. Tobacco, she says, opens doors for getting to know others, for making friends of strangers.

As the bus leaves Soroti, some young men on the side of the road begin shouting something at the bus in a local language. Rose tells me they are shouting "stealers of animals," stereotyping all of us on the bus because the bus is headed to Karamoja. I am taken aback by the prejudice so blatantly expressed. I wonder what Karimojong like Rose feel when they hear this and whether they feel a sense of vulnerability when outside their region.

After Soroti, people's features change as we move through Teso toward Karamoja. These people, though Iteso, look like Karimojong. They're tall, with thin, lanky legs—very different from people in Kampala. The language also changes—a very different sound, with a twisting of the tongue and a rolled r and a sound in the back of the mouth near the throat.*

The landscape is plains and swamps. I see small groups of young women knee-deep in the water with their fishing baskets. There are lines of billowing smoke as people burn the land for its regeneration. Where it has been previously burned, new grass has sprouted. It's important for the soil, I'm told. Some seeds

* Teso, in which the Iteso people live, is a region neighbouring Moroto District. The Iteso and the Karimojong, while originally from the same lineage, have become enemies known for raiding one another's cattle. They are frequently in conflict over access to water points for the Karimojong cattle during dry seasons, as well as over district boundary demarcations. To some extent, relations between these two groups were negatively influenced by the characteristic colonial strategy of setting up imbalances between ethnic groups by privileging and offering opportunities to one over the other. In this context, Karamoja lost out and was intentionally isolated and excluded from national development, while Teso was included with other areas of the northeast that, while also less developed than southern Uganda, were relatively more privileged than Karamoja. Such structural conflict continues in current relations between the two regions.

need the heat of burning in order to sprout. Even for the livestock it is necessary, as it burns off the ticks in the tall grass and so "refreshes" the cattle—of primary concern for these cattle-keepers.

At one point the wind picks up and the temperature suddenly drops. Lightning flashes, the clouds darken, and rain pelts the bus. Windows close, but leak and drip around the edges. Rose points out the window and I see how quickly the ground becomes soaked with puddles and footpaths become streams and rushing little rivers. She tells me rains in Karamoja are heavy and harsh, with lots of wind and thunder and lightning. There's much water but it falls quickly and heavily and disappears just as fast, flowing to fill the swamps of Teso. This too is a source of relationship and conflict, as Karimojong herders take cows to Teso for water in the dry season but are chased away because the water isn't theirs—though it comes from Karamoja. Rose tells me that the Karimojong talk of how they should find a way to catch and keep water in Karamoja—much to the concern of the Iteso, who know how they would suffer if this ever happened.

As we pass the border from Teso into Karamoja, she relates details of the ongoing boundary issues at the root of some of the present cross-district conflict. She explains how, during colonial times, the British had determined the regional boundary after convening a committee of local leaders from both sides. At the agreed-upon line, acacia trees were planted that are apparently still visible from the air. One such tree stands along the road and has always been the identifier of when you are officially entering Karamoja. However, in the early seventies, some local Karimojong noticed that the official boundary signpost had been moved inward toward Karamoja, but they paid it little attention. It has only been in recent years that Karimojong with more formal education have begun to question and investigate this and have found that, without any consultation or public notice, this regional boundary was changed on all the official maps of Uganda being produced by the Ministry of Lands. Their best estimates put it sometime in the early sixties, when the minister was himself an Iteso. This sur-

reptitious alteration underlies much of the current conflict between Teso and Karamoja, as those who are uninformed but formally educated now reference altered maps while the Karimojong knowledgeable of their oral history know only of the original consultations and not of any more recent changes. Rose tells me that, while an MP, she tried to educate others and bring this to the attention of the government. Since the end of her term, the issue has faded from public discussion, though it continues to have ramifications.

As we near her place, I ask how to greet and say "thank you" in Ngakari-mojong. She writes them for me so I will learn quickly. Our stop is Lorengecora, a trading centre that feels like it's in the middle of nowhere. We get out and set our bags in the red dust at the roadside. The bus pulls away and we are soon surrounded by a small group of children and some women. They obviously know Rose. This is my first chance to try out my greeting, much to their pleasure. Everyone is dusty and dirty. Everyone has some beads or some kind of necklace, and even the children wear simple arm bangles. One woman shakes my hand, then raises both our arms above our heads while saying something—clearly a big welcome.

We set off walking down the red dirt road toward Rose's house, followed by a young girl commissioned to help us carry our bags. We walk slowly but my shoulders ache from the weight of the backpack with all the bottled water I've brought, as instructed by Rose. There are no shops here. This place is flat, with a few scattered trees—mostly acacia thorn trees. Also scattered about are the huts and homesteads surrounded by kraals of close-set, upright wooden sticks. Rose shows me the mountain from which rain usually comes.

Approaching her home, Rose shows me the demarcation of her land— "That pile of stones to those two trees. And see that post? I gave a small plot to someone to build. The rest is where I dream of putting the vocational institute. Eventually I want to make a road here, so I've planted these trees"—two lines of pink frangipani trees that are still small but coming up. In the midst of what looks like a dry grassy field, there are two lines on either side of an area that will

be the future road—a wide road. To the left of that, just outside her homestead, is a pole frame of a long building she plans to thatch as a beginning for the vocational institute. This is the beginning, she tells me. When there are funds they'll build permanent structures on the larger portion of the land.

Finally, we arrive at her house and homestead. A young boy, Rose's nephew, comes out to greet us with a big smile and take our bags. He helps her out at her house, along with another smaller boy. Rose's house is long and rectangular, made of sundried red brick. It has four rooms, with doors opening to the back courtyard. At two corners of the house are large black water-tanks to catch precious rainwater from the rain gutters—an innovation I've not seen before in villages. The homestead is surrounded by a circular fence of wooden sticks like the kraals. Within the compound are three huts, all built of the same sundried bricks with mud-smeared outer walls. The huts are thatched, while the larger building is roofed with zinc sheets. In the courtyard are a small pawpaw tree, small cassava plants, an eggplant bush (almost leafless due to the chickens that feed on it), a small pile of harvested aloe vera, and several bundles of long sticks. We sit under the zinc roof overhang, on the packed-soil verandah at the back of the house. The sky is darkening. The boys are boiling water for me to bathe.

When my bathwater is ready, I go to the bath area at the back of the compound, near the fence, behind the huts. There I find a three-sided structure of zinc sheets flapping in the wind. One side is open; the others surround a cluster of rocks on which one is supposed to stand while basin bathing, thereby avoiding the mud inevitably made by the bathwater. The wind is cold on my wet body. It's a fast bath. I'm shivering by the end, and the rain is starting to pelt as I run to the shelter of the porch. Then we drink milky, gingery tea with bread while Rose tells me many stories.

Finally, as it gets dark and continues raining, Rose suggests we go into my room to sit and talk. Mine is "Door #1" of the four—they are all marked. The second is a kitchen storeroom, the third a sitting room, and the fourth her bed-

room. All the rooms are a step down from ground level. Mine has a single bed in it and some mats covering the earthen floor. There are no windows, but I feel the breeze through the slats in the rough wooden door and through the small space where the walls meet the roof. She instructs me to keep the door closed when the lantern is lit inside. I realize the seriousness as she explains how "armed thieves can see the light and be tempted," how "guns can fire from a distance." It has not happened to her, but "no need to be careless." The boys hang a heavy blanket in front of the door on the inside to make sure no light can be seen from between the slats. She tells me how local people keep their cattle at the army barracks instead of in their kraals so as to avoid attracting attacks, and that the warriors have tried raiding the nearby barrack's kraal three times—the last raid was the previous month—but unsuccessfully. I realize the very present reality of gun violence and of the possibility of the attacks. Matter-of-factly, but as if to offer some reassurance, she informs me that bullets don't go through mud walls; they go through cement breeze blocks but not through mud walls so we're actually in the safest type of structure where we are right now!

We sit in my room on the mats on the floor and talk by the kerosene lantern. I realize she is ever alert to the sounds and noises from outside, as the boys prepare supper in the next room and in the cooking hut. She won't let them cook outside lest the fire attract undue attention. She says some other people will sit outside, though not around a fire. They will drink and dance and make noise, but she says they are courageous—she won't take such risks.

The next afternoon we walk to her actual village, Kobulin, a few kilometres farther in from the main road, where there is a cluster of green. These are trees she planted years ago. There she has a second house, one more permanent and actually more urban in appearance, hidden in the middle of the bush, at the site of her family's original village. Next to her wire-fenced property is still a traditional *manyata*, a large kraal-like enclosure with several huts inside, where a few of her extended family members live—two very old aunts, and their daughters with some of their children.

In the days spent here with Rose I would have the privilege of meeting a couple of her close women friends—Eunice, her cousin's wife and a social worker staying with her temporarily while she works at the nearby Transition Centre for the resettlement of the Karimojong street people, and Anna, a childhood friend and loyal defender, a single woman, university educated, strong, fiercely tenacious, and full of wry humour. Both are leaders in their own right. From them I would hear more stories, and learn more about what it is like to be a woman in Karimojong society. They would explain to me the precarious existence in so harsh an environment and the lack of alternatives that makes raiding virtually a necessity for survival, and the moral dilemma this puts people in. They talked of the underhanded exploitation of local resources such as marble, gold, and soda ash by unknown outside interests. I would hear the indignation in their voices as they described the contributions of their people and their region to the nation but the lack of recognition and, worse still, the vilification and denigration of them and all of their tribe simply for being Karimojong. We would talk of women's leadership in their communities—of the lack of opportunities for direct leadership, of patriarchy, but of the necessity of traditional roles for surviving the harshness of pastoralist life, of women's forms of power and their indirect leadership through their abilities to influence male decisions. I heard of the very real personal risks that come with leadership and with excelling or standing out as a leader in their society—risks of personal harm and of physical and spiritual destruction due to others' jealous ambitions. As these women talked among themselves, I listened. Their presence with Rose was like a catalyst, bringing forth stories I might not have heard otherwise.

Out of these stories and discussions, I began to get a sense of the women in Karamoja, the hardships and challenges of their lives, their strength—both physical and spiritual—and their volatility; these women are as much warriors as their men. I came to see how Rose is so much a part of her society but yet also how she is truly unique. For example, Rose was one of the first Karimojong women to be formally educated. She became a teacher, in a context where education had been fiercely rejected by the elders as a de-

structive tool against their culture and people. She would later be elected as one of the first women politicians in Karamoja: at a national level as a Member of Parliament. When Rose's husband was killed, at a young age she stood against culture and the tradition of wife inheritance; in the face of intense opposition, she refused to be married to one of her husband's brothers. Perhaps most significant is Rose's approach to conflict. She does not seek revenge even in the face of unjust and malicious personal and political attacks. In an extremely volatile and violent society, Rose consciously refuses to perpetuate or contribute to further violence and conflict. She is not inclined to dichotomies of good or bad in people, but rather holds a belief that, like in nature, all are needed. Every person has a role and purpose, a contribution to the whole. In these ways Rose stands out as a leader in her community, with all the inherent risks in such a role.

Rose's Life as She Tells It

Getting Involved in Conflict Resolution

Some years ago, in 1997, when I joined the Lutheran World Federation (LWF), an organization in Moroto District, Karamoja Region, I was working in the research unit. We started a research unit because we realized we needed to research into the needs of the people so that we could get the right activities for the communities. Because in the past, the people—for example, in the ministries or in the headquarters of the NGOs—would go there and say, "I think this is what we should do for these people." But when that experiment is put, it doesn't succeed. So we started asking ourselves, "Is that the right way to continue going? Or there is need to go to the communities themselves and find out what they think is their problem? And they should rank these problems if they are many. They should rank them according to which one they feel has more weight or negative weight on them." So, in the process of that, the organization realized that there was need for a research unit. After bringing those priorities, they should be looked into seriously.

We would go to the community; then they could say, "Problem number one is insecurity. But we know you will do nothing as an NGO. So, let's assume problem number one is insecurity and it is here." We were using small stones for ranking. So they would get the biggest stone and put it there in front and say, "This is insecurity—problem number one—the biggest problem. And we know you will do nothing." Then they now start ranking other problems, one to five. So, when we went back to the research unit, we asked ourselves, "We have ranked these five. But the biggest stone still stands." And that insecurity was affecting all these others. And the program activities could get to a standstill at a certain point because of the big stone. And we started thinking, what should we do?

We knew the peacekeeping and peacemaking sides were also weak in their own way. The insecurity problem had overwhelmed the people, even the government. Like the army and police, the army has to look into the external insecurity but the police and the prison were to look into the internal insecurity and both types of insecurity were there. But left on their own they could not stop the insecurity, so there was a dilemma. Now, we started thinking about it for a while. Then one day the coordinator of the Moroto program comes up with a newspaper showing the training component for conflict management in a working situation. So he said, "You see this? This is a good news for us. I think let's look through this. It might solve the other problem which was represented by the big stone." [*She laughs.*]

So the newspaper was photocopied and circulated to various offices of the organization—because we had county offices in five village locations. Then, for us, we were at the headquarters. So the paper was circulated. It had a note attached with the information that, "Any person who is willing to go for this course, the program will sponsor for a three-months training on conflict management in the UK." But this paper circulated for two months until it was returned to the research unit. Nobody was willing. This was a big challenge. To the minds of every staff, it was death. Then, when they returned it to the research unit where they had started it circulating, it was not accompanied by any name. So I told my colleagues, "For me, I'm going to take a risk."

Then they all looked at me and laughed. They said, "What are you saying?" I said, "Yes, I'm going for this course. Let me take a risk. Everybody has feared to die, so let me die on your behalf." [*She laughs.*] They laughed and laughed. Now I said let me go to the coordinator. I picked up the paper. I found him walking in the compound. He had come out of his office. Then I said, "Sir, I would want to go for this course." He looked at me and said, "You?" I said, "Yes." He said, "Are you sure? Are you serious?" I said, "Yes, I'm serious. Because this paper has circulated for two months and it has come back without any name, so let me take a risk." Then he laughed and said, "Okay, if you're serious, we shall work on it." So he went. Within two weeks, they worked quickly and I went to the UK for that training. I trained for three months. I came back.

So, how to start? To convince the staff to get involved was not easy. [*She laughs.*] Who would work with me? Because it is common sense that I cannot work alone. It took me again one month to convince the staff. So, I could put meetings for the whole staff and start convincing them that "This issue of insecurity we all saw was the biggest problem, though we ignored it. So we must do something about it." They said, "Will they not shoot us down?" I said, "No, let us try." So, after convincing the staff for one month, I got two people. They said, "Yes, we shall work with Rose." I told them we shall start with research. We shall make a questionnaire, then we go to the communities and start asking open-ended questions, discussing with them. We started with two communities.

They were fieldworkers so they're already known in their own communities. I was the only visitor but I was also speaking with them the same language. They were already working with the communities on the other issues. When the people saw them, at least there was their trust. But, of course, since I was the friend of the ones they trusted before, their trust was extending also for me.

I told them I'll be the secretary, because, if I'm the one to ask the questions, the people can easily close down because I'm a stranger and it was a sensitive issue. So they could discuss with them that, "Ooh, we have been

working on water, on food security, on animal health and human health. But the other time, do you remember, we put a big stone on the insecurity part? Now we want to discuss with you about that one because it is an obstacle which is spoiling all these others." And then they said, "Yah, it is important to discuss." Then they could answer the questionnaire. We had a short questionnaire which we were not referring to openly; we mustered in our heads what to talk about. In the process, they get relaxed. So, all the questionnaire would be answered. Then we go back. [*She laughs.*]

After those communities, we shared our findings with the other staffs in a meeting: "This is what we have found from those communities." Then others started saying, "Eeeh, come to my community also." Now the whole program incorporated the security component. I now started the "Peace and Reconciliation" section within the organization. Within a short time, it was a serious need. It spread very fast. So, a report was written. We had now to share the report with the government officials. We went to every department. Because it came out that the peace component should not only be left to the police and the army; it should be an issue for all the people ... and all the departments, and all the NGOs, and all the visitors, and everybody who is there, even the families, and all categories of people—even the youth. Because, in the past, it was the men who were discussing. According to the customs, it was the men who were discussing the peace issues but the women and the youth were ignored. And yet, when it is time for cattle rustling, it's the male youth who are involved. But in the peacemaking, they are not there in the meetings.

These people in the government offices said, "How did you get this information? Didn't they shoot you down?" I said, "No, I am here." [*She laughs.*] So we formed a group now within the district, within the subcounty, and the thing spread like that. At a certain point, there was need to form peace groups in the communities, with the youth, the women, and the men. They could sing, they could make the marathons, they could bicycle ride.

So it has now become an issue for everybody. That's how I came to be part of that book *Hands Across the Border*. The Centre for Conflict Resolution (CECORE) people came to Moroto but they didn't know the entry point so I told them, "At least I know some people and this is what we should do." So, on the ground, I was the one who was mobilizing the people who had come for the workshop from Karamoja side. That's how I got in touch with them.

Rose would tell me later how these workshops were the beginning of peace initiatives between the Karimojong and Iteso. There had been people working for peace on both sides but they didn't know each other. This was the first time they met and came to know what each was doing. The Iteso learned of the peace groups in Karamoja and they began to start their own.

Why I Left Teaching

Before that, I was working as a teacher. I was working as a teacher in a Teacher Training Institute. I was training teachers in Moroto Teacher Training Institute. But the one thing which was puzzling me every time about the students we were teaching was that, in a group of forty, you would find one Karimojong or two. And the institute is within Karamoja. It was training people from outside the communities of Karamoja. So we could have only two teachers at the end of each training season. Then I asked myself, "What is this? What is the problem?" That is what forced me to leave teaching. So when Save the Children Norway advertised, I just deliberately decided to leave teaching ... because I felt it was not helping this community. The community was not growing as I expected. Then I decided to do the interviews. I passed. I decided to leave the classroom in order to go and work in the children's programs in the villages so that we would find why in the other classrooms [of the Teacher Training Institute] it is only the outsiders who are in, and yet the people who have the institute in their location are not there?

When I was working with Redd Barna, in the Norwegian language meaning Save the Children Norway, we went to the community to work. We were planning with the sub-county government planning unit so we would conduct meetings with the local leaders and with the people who matter there in those local locations. Then we realized what was the problem there—that primary school enrolment was low, that the children are not taken to school because those who succeed to get jobs return to their villages when they are dead. They don't come when they are alive. For example, they go and work in Mbale, Kampala, Jinja, and other towns, and they forget their families completely. Then one day, a strange vehicle arrives with a coffin with all the details ... this is so-and-so, the son of so-and-so, who was working in such-and-such institution. At times they find the family collapsed a long time ago. If the dead person is somehow elderly, the person's parents and family would have died or scattered because of hardship and neglect. But if the corpse is of a young person then they find the family in their miserable state. The villagers now explained this problem. In the planning meetings, the solution suggested was a program of ABEK (Alternative Basic Education for Karamoja) and role modeling. There is a program now which is dealing with encouraging and boosting the enrolment in the primary schools.

Then the second problem was the household work. When the children are still young, they are busy supporting their families. But when they reach a certain stage of six to ten years, when the young ones have been born who'll take over those family activities, the big one gets idle but it is too late to join a formal school. So what that program does is to encourage education within the homesteads, with a curriculum which is related with formal education. They teach them in the afternoons and evenings. In the morning they are herding, they are fetching water, they are grinding, they are doing all their domestic work. And in the class they can go with the babies and younger brothers and sisters. The class is composed of children of various ages, and parents also help the teacher to organize these children. Until they reach a certain age, when they have understood the concept of reading and writing, then they join a formal school in Primary 3 or 4. Then they continue with

their formal education. And that has helped. So now the school-going numbers have increased after that program. So that's why I left the teaching job.

Then after working with the Redd Barna organization and the ABEK program, which was run in partnership with the Ministry of Education, I joined the Lutheran World Federation (LWF), where I started to train staff on Participatory Rural Appraisal and headed the Peace and Reconciliation section.

Involvement in Politics: Member of Parliament

I moved from that to politics. I worked as a Member of Parliament for three and half years. When others worked for five years, for me I worked only for three and half years because it came as a result of the districts dividing—that was Moroto and Nakapiripirit, in 2001.* After another woman had worked in the position for one year, then we spent the second year and some months in campaigns. Then I joined the parliament from September 2002 to July 2006.

I wondered whether Rose had been involved in local politics prior to this election.

I was a teacher and even when I was in Redd Barna and in LWF, I was LC2. I was in charge of Production and Environment. And they could pick me unopposed. They were interested that I could go to LC3 level but I could not because in LC3 one has to leave the job and go there fully. For the survival for my family, I needed the job. I had a responsibility. I had children to bring up. I could not leave the job and go to that fully. So I had to climb from that, from LC2 [to become an MP].

Then I had to campaign for the Woman MP position. In spite of my being in the organization [LWF], the public felt I would be the person to be the Woman MP. At a certain point I told them I could not, I didn't have resources. They even had to get a vehicle for me for moving around. The district is wide, I cannot walk. Then the others could donate the fuel. They even gave me a driver. It was a society issue. Otherwise, I would have not be-

* When these two districts divided, there was need for an MP from Moroto District.

come the MP on my own. Because by then, I was working with an NGO and of course I had a family to bring up. I was not making any savings for campaigns. I had to keep on spending the money to keep the children at school. Then, at the same time, I could also want to have a house here in the village. So I was distributing my money within those two issues which I felt were important in my life—bringing up the family singlehandedly, then having a family residence here in the village and also keeping the children at school. Those were the main issues which were important. And now when they said I have to become the MP, so I had to share with them the challenges. But somehow they contributed and then I became the MP.

Until now, the jealous hearts want to destroy me and the development I have made for my family. What I'm telling you is about the recent campaign and what we are still going through. So it's like the campaigns have not ended. There is still something bad which is still going on. Elections were in February 2006 and now it's over one year and yet the issues still seem to be fresh. And yet it's something we should have left and seriously gotten involved in other issues. Mostly the women were supportive of me ... and some men.

There was a group of men which decided to form itself for that purpose—to oppose me and then put another woman in that position. But the other funny thing is that they are also again not satisfied with her. What is it? What do they want? They have not even given her the number of years and they are already complaining. Why? And you cannot make achievements within one year, especially on public issues. It's tough. But they are there, already complaining. So, in spite of them going for her, she's again in the awkward situation. At least for me I enjoyed somehow the five years. I didn't have even a bodyguard. I didn't see any reason of having one. I didn't have any conflict with people. I could just go to the function by myself, with a few friends maybe who have decided or people who want to travel to the other place of the function. I just give them a lift and we end up there. Then again, when I'm going away, I give again another group a lift.

Even when I was campaigning I didn't have the guards, in spite of all these people wanting to have their ambitions. Like I said, it was a strength. The bodyguard is somebody who can be bought by the other side. In my situation, they didn't have anybody to buy. So I was just moving ... but with the people of the community. When I'm going to the other side, I go with the people from there. Then when I come back, there are those who want to come to this side. I fill them in the vehicle and bring them. So those ones acted like the guards. Even they [*those who would target me*] could not now hit everybody, including their own people. Those were their own people; they were not even my own friends. They are just people I'm giving a lift. These are their own people so if they hit me, they hit their own people. Meanwhile, I was assisting them but at least also innocently they were acting as security ... but they didn't know. So I didn't have any cost on security guards. They were God given. So I just give them a lift but innocently, indirectly they were acting as a security.

Current Situation in Karamoja

In Karamoja, the peacekeeping is improving, the peacemaking is also improving, but the peacebuilding needs much work.

[*Peacekeeping she describes as the army, the police, and prisons. Peacemaking is*] ... a combination of all of them. Because it is these meetings where they talk about peace and plan how to maintain peace—a combination of the government, NGOs, the community, every other person. In peacebuilding they prevent insecurity from occurring and also get solutions to those root causes. Like now, if it is drought, what must we do to minimize that or to cope up with that drought? If it is education, what must we do? If it is famine and food insecurity, what must we do in order to correct it before it gets to the point of really being open conflict? But the problems have been recycling for many years. So now, it could be both to prevent and also to correct what has already happened. Eeh, that's how I see it.

Like now, these people who are now in the streets of Kampala. The problem happened but the root causes are unresolved. So something must be

done. Meanwhile, for the future, activities must be set to prevent a new occurrence of insecurity in the community. So the peacebuilding component is still weak. The mechanisms of how to cope up or how to correct those problems are still not strong enough. Like, most people have not gone to school so they have no jobs, no skills for income generation. Survival mechanisms like the life skills are still also lacking. This is why there is need of starting the vocational institute, which is a slow process. It needs again to bring the minds of people to see that it is something which is beneficial. So, winning the minds of people, then providing equipment for learning: these are the challenges.

Vision of a Vocational Institute

So far already I have registered, in one parish, one hundred learners. That is a big number. But where is the equipment which will keep all these hundred busy? And they have shown different interests ... so it is not only one equipment; it is various kinds of equipment. They mentioned building and concrete practice, carpentry and joinery, tailoring, cookery and catering services, agriculture and pastoralism ... because for us, we are pastoralists. Our agriculture should be connected to our livelihood. Then, when you make a permanent house, there is need for plumbing. It is not safe also to have a toilet very far so that, in the night, you fail to use it because of insecurity. We don't even have plumbers so some of them are interested in learning that. There is a cross-section of activities—those are ones that I sampled. Then there are cross-cutting issues which are necessary for all the learners—like hygiene and sanitation, primary healthcare, HIV/AIDS, peace and conflict management, environmental protection, gender. Those are cross-cutting issues which everyone needs to be aware of. We are not examining [setting exams for] those ones which are cross-cutting, but it is a knowledge everybody should know. So that is what the institute is trying to do.

And now, we have started with functional adult literacy and we are teaching them in the local language ... because they have never gone to school, the majority of them, though there are also some school dropouts.

We have started with those ones who don't know any literacy at all. Then those ones who can read and write can join the course straight away. Immediately the equipment is there, they can join. But these others have to know the numbers, have to know certain words.

Education and Mother Tongue

I had had several discussions with Ugandans about the importance of mother tongue education in assisting people to hold on to their language and culture. I had been struck by the challenges to children who start school fluent and knowledgeable in their own language and culture but are suddenly told these are useless and are forced to learn English. With education a real flashpoint among the Karimojong in terms of its destructive effects on their culture and communities, I asked Rose whether the schools incorporated any Nkakarimojong or were only taught in English.

In Primary 1 and 2, they teach in their local language and English. But you find in some schools, they underrate the local languages. The parents take them to a nursery school where they pick up English, then straight away they go to P1 and P2, where they continue with English. But that is not good enough. The mother tongue is spoken at home and in the community, affecting these learners' progress. It [the mother tongue] keeps on disappearing with the other language you have learned. But if you don't even understand things in your mother tongue, then it becomes difficult to interpret English objects and words.

Like with my own children, I took them to school and I'd not taken seriously the mother tongue, so they reached Primary 3 when they could not read clearly either my language or English—they had a problem. Then I was wondering, what could be the problem? I realized they had gone to that class without understanding the alphabet in the mother tongue. Then I had to get a special teacher to teach them in the local language. They learnt during holidays. So the next term when they went to school, they were able to read, and improved in English reading too. That's when I really felt it is important to

start from the mother tongue which they already know. But the teachers ignore the mother tongue, that they think is useless but somehow it is not. It's really a good thing to know but if you do not know, you may force the children to go through something which is hard.

I commented that many people in the cities want their children to just speak English without knowing their own language.

... which is dangerous. It's dangerous. Then one day you find yourself in the community situation, what happens? You cannot talk with other people. Then psychologically the child or an adult feels out of place. It becomes a life problem. So it is good for them to be knowing the mother tongue thoroughly ... because there is no way to avoid the village. There is something which is linking you there and if you don't know how to go about or how to communicate, which is a basic, then that is dangerous for you.

Even what you talk in English, the rural children know these things in the local languages. For example, this is the liver, this is the kidney, this is the pancreas ... in the local language. Then, if you give them the interviews or the tests using the local language, they will pass. But if you give them in English and if you have not shown and taught them that ... they fail. Usually when a teacher mentions liver it goes back into your mind: "What is this in my community? Which name do they call this?" Then you connect. When you make that connection then you can learn and not forget easily. Then you become more perfect when you make that connection. Then you understand faster.

You can even hear in the market, if you go buying things within Kampala here, you may find certain strange names but you may expect them to be in English. Now there is no English name. So the local name has to be used. So they say this is such-and-such, but it is not English. [*She laughs.*]

I commented that there are even more abstract concepts about community living that people know at a local level in their own languages but which are lost in English. Rose agreed.

Yah. Because they don't exist in typical English. They are maybe African.

I commented on the resulting struggle for parents and the Karimojong community as a whole. They want their children to be educated so that they have development in their area. At the same time, this very education causes problems for these young people when they don't get jobs or don't have skills—because the education they learn in school is not about skills.

It is not. Like for us there, we are pastoralists and we want to learn much of how to improve the pastoral life but in school they teach us a different life, a Western life, so then we get lost. At the end of the day you ask yourself, what is this? What have I learned to improve my life and my community livelihood? Nothing or very little is going to be applied. That could have been even one of the reasons why the other people were not going back to the community at the end of school—only that we don't have live examples to ask why they could not go back when they finished school. It could even be those dilemmas. You find that, of what you have learned, only a little portion can be applied somewhere.

From other people's stories, I am aware of how the education system, being so Western based, often makes young people feel bad about where they've come from, that maybe their way of living is somehow backward. Rose affirmed this.

That's what we learnt. Like when we're in the primary schools, that's what we're taught. We learnt that our village way of living was primitive and backward. But as time went on, when we were now facing the reality [*she laughs*], the need for the other bit of the world which looked primitive, you find that that is the practical thing, as it's the real environment. If you need to survive, you'd better know it.

Like now for me, I take my children deep in the village to know the reality of that kind of setting. That is home and that is a reality. That is the life they have to face when they grow. At times I bring them to the city to learn the differences and similarities. I tell them, "Pick what is good, what will be good for your survival." At least they will be able to pick something in the village, then pick something in the town, and pick something in the city. Then make those combinations to survive. Otherwise, if I don't show them

all those things they can easily get lost in future. For example, in the past, during the government takeover, people would run out of the towns and the city to the villages—but without a plan. And since they had lost contact with the villages before, survival in the village became difficult. You can find a situation which forces you to a place you have not understood in your lifetime and it becomes difficult. Those are some of the experiences we had in Uganda.

Courage to Take the Risk

Going back to her initial involvement in peace work, I wanted to know what gave Rose the courage to take the conflict resolution training when no one else would risk their life.

I think it was just a conviction. Because, for me, I believe in working out problems without fearing them. At least I believe there is a solution to every problem unless you do not work around it to get that solution. So, as I was seeing people putting a big stone there, I started thinking there could be some way out instead of just ignoring it like that; there could be something we could do to correct this. That is what gave me the courage to say, let me try to see what is at the other end ... maybe there is something which we don't have within here, which if we learn, we might apply here and it helps us. That's one of the reasons why I felt maybe there is something we have not understood or done. I thought we can also check what people in the other parts of the world do and maybe try to apply it. When I went there, I realized there are certain obvious things which we could do and we were not doing as affected people. And there are some few things we could borrow from elsewhere to add on to what we have. Otherwise, we had given up with life. Instead of even trying, we felt that was the work of the police and the army, and they have the solutions. For us, we had no solutions.

In the tradition, there are many ways of coping up with this or correcting that but the challenge is the guns which are in the hands of the villagers illegally. With the spears, even the enemies could have a chance to talk and even recognize their enemy. They could have a chance for a second thought

and even sympathize. But with the gun, it catches somebody from a distance. Even if it is a blind person, lame person, or young person, it just catches them—which was a curse in the past.* And the one who is shooting will not feel the pain. He can even disappear without reaching the dead person to have some humanitarian feeling. But I understand in the past, when they were using spears or sticks or stones, they could come to a nearby distance, then chances of sympathy, of even requesting the enemy not to kill or the cry of the other person can lower down the hatred and the anger. So the new weapon has worsened the war. Then the youth keep on experimenting. The new weapon is mainly in the hands of the youth. Many of the youth are dropouts from school, and so are caught between the two worlds.

Father's Role in My Education

Rose's parents have both passed on. When I asked how they had influenced her, she said, "... especially my father, because my father was a primary teacher."

He managed to take us to school against all the odds of society not wanting the girl child to be taken to school. My father said, "No, let me take my sons and daughters alike, for it is God who knows who could be successful." He was courageous. As a child, I could even hear some men advising him not to take the girl children to school. They said, "But why these girls? You are wasting these girls. Why are you taking them to school? They will all become prostitutes and you will just suffer.† When the other people's daughters will be married with a lot of animals and you have nothing, you would have wasted your daughters." Because the other people in the community see girls as wealth. When they marry, there is bride price. Their family gains. But for us, they thought we were going to become prostitutes and he was not

* Even in a society prone to war and fighting, traditionally there were rules of engagement in warfare that protected the women, the young, the elderly, and those with disabilities. Violation of these rules by the young warriors resulted in a curse from the elders who traditionally oversaw any raiding.

† Traditionally, there is the perception that if girls go to school, they will get "spoiled" by the boys at school—meaning they'll have sex inappropriately—because their relatives are not there to keep an eye on them. This would decrease the girls' chances for marriage and, not being worthy of being wives, they would end up as prostitutes, thereby not bringing any bride wealth to the family, but rather social disgrace and stigma.

going to gain anything. And for us, we were going to marry poor men. Good ones have the livestock. Because, with the lifestyle, we shall meet the poor boys in the school. Then everything will be messed up.

So they could talk to him and he'd say, "No. Let them be at school. I shall not be responsible for any miserable future of anyone. Let them go to school and sort out." They could sit and advise him. He said, "No, I'm taking them." We were four girls, then two boys—more girls than boys. And the girls were the first four [*she laughs*], which meant, if we were not to be taken to school, he would have kept us at home and waited for the last two children he was not even sure of if they were going to be born. So he said, "No, no, no. I'm taking them and taking all of them to school." That's how we happened to be at school. I was close with him. My mother had not gone to school. So he would be the one to check our workbooks and encourage us to continue with school and that kind of thing. Then he could tell us also his story of how he went to school.

How My Father Went to School

For him, he had not seen any live example of any successful* person in their community. At least for us he was there as our role model. Though there were only men. There were no Karimojong women to see as role models. My father could tell us his story of how he went to school.

One day they were going to the kraal. They have two places. During dry season, the young people with some men go and look for grass and water for the livestock (the kraal or *ore*). Then the old people and the young children remain in the homesteads (*ere*) where they grow some cereals in the rainy season. When it rains, the kraal people also come and join the other ones, those old ones, in the homesteads. So, my father and his father and his brother and sister were going to the kraal. My father hides on the way, behind the bushes. The other ones kept moving ahead. They thought he was going to ease himself somewhere. His elder brother said, "But he's not coming." But his father said, "Anyway, since the home was still near, he will not

* "Successful" here implies being educated.

get lost. Maybe he has decided to go back, so let's continue." They continued, without my father. After the dry season, when they came back he was in a primary school. Then, from that day on his father didn't want him in the homestead, because he had been in school; because he had left being a shepherd. So he could go the whole term, the whole holiday, and take refuge at the school. That must have been a hard life. He was young. He was young to be on his own without family support, though he was a boy who could make decisions.

Then we asked him, "How did you make that decision?" He said, sometime when they were still in the homestead, they could take their goats for grazing near the primary school. Then he could see other boys. And that primary school was the first in the whole of Karamoja so the children were coming from Teso, from Lango, and from other parts of Karamoja District. They walked all the way to school. The insecurity was not there so the children could walk all the way to that boarding school. The mixture of children impressed him. So they would ring the bell, they go for porridge with sugar. He got taken up with the sweet porridge they could give him. [*She laughs.*]

He would be standing looking at them going to the classes but he didn't know exactly what was going on in the class. So he would ask them, "What are you doing in there?" "For us we are learning here. We are at school but at least we take some meals here." He asked, "Do you go home?" "No. We come here for the whole term. We stay here, they feed us here, they maintain us. Then when it is holiday is when we go home." Then at times, the boys could give him groundnuts. So he made friends with those other boys who were in school. So every morning he would take his goats there and go back home.

Then, when it was time to go to a far distance to the kraal in the dry season, he felt he was missing the other boys and he decided to join school. "If the school can maintain me also like the other children, why should I walk all these long distances?" So he rushed there and stayed there. But his father said, "If you come to this homestead, I will kill you." He parted with his father completely. So he would come during holidays for a few days and hide in another homestead. His mother supported him. She would make

meals and take to another homestead where her son was. He eats from there and they talk and she encourages him and tells him what his father is planning. She didn't want her son to be killed so he'd better keep off. So he had that link with his mother in spite of not reaching the home. Then the missionaries supported him and understood his situation. They kept him during the holidays with a few other boys. Some other boys were facing the same challenge in their homes. It was a mission school.

How My Father Became a Teacher

After some time, the missionaries identified him as a teacher. By then, the missionaries would guide them, that's what they told me. The missionaries would come and say, "For all this time we have stayed with this student here, we think he's fit to become an administrator; he's fit to become a teacher; he's fit to become a policeman; he's fit to join agriculture." For the time they're in that school, their teachers would study what they are interested in. They guided him to become a teacher. At the end of the day, he became a teacher. The parents had nothing to do with education at all. They didn't even understand what it meant to be at school. They didn't even understand what it meant to be a teacher. So it was the other people who taught education, who understood what it was, so they guided them. They would study them and guide them. So he ended up becoming a teacher.

After becoming a teacher, that is when he reconciled with his parents. Then his father now understood why and what his child was doing: "So it was to achieve this"; it was not to avoid being a shepherd. It became a benefit to the family. He would buy some food and clothes after getting the salary and take it to his mother. Then the father would ask, "What is this?" Then she'd say, "It's the other boy who brought this. I understand he is now having a job." Until one day his father picked [gathered] courage to want to see him. After bringing these benefits, he understood and he said, "Eeh, so my son was not getting lost. At least it was for the benefit of our family." My father came and they reconciled. My grandfather died out of old age. I understand he called for my father to spend the last hours together.

221

So, from the risk he took, somehow I learned something—that it is not always that you need to know what is at the end; it could be a journey which leads you to a better destination. So it is worth starting something and trying, than drawing a negative conclusion when you have not tried. I saw the peace as something important in our society if we have to develop. But who would do the work to bring that peace if we don't involve ourselves? Then I felt I should go for the course. If there is something positive I could contribute to bring peace in Karamoja, the better. So I knew my contribution may not bring total peace but at least it would add to the contributions of others. Since it was a big problem, it is the bits and pieces which can add up to solve it. So that is how I decided to go there.

Research on Conflict in Karamoja

Aware of the risks Rose has taken in deciding to be so engaged, I couldn't help but wonder if she was afraid. She told me how they managed their fear while conducting the initial research in Karamoja.

We selected the questions which don't provoke. So we avoided those questions. We had to take the questions which, in most cases, are general. So, even if you were interviewing the culprit, if it doesn't provoke him that you're investigating him, you could ask a question but in a general form. "What do the raiders do?" but not "What do you do?", "How do they plan a raid?", "What should we do to the problems which come out from cattle raiding?" So they were like general questions but they [the people] were bringing the answers. They were not leading questions. We conversed with them but at the end of the conversation, a lot had been spoken. A lot had been spoken.

I was busy writing. And when I realized they have missed something or when I have read that the mood of that person is cool then I also asked my own questions so that the information is brought. Or, if the one they're interviewing gets emotional then I intervene to cool down and say why it is necessary to have this information. I'd say, "It is for our own good as a people. You know, we are getting finished as a people so we should not wait for

only the outsiders to come and help us. It is our responsibility to see to it that we have peace. Now our parents, our children, our friends and visitors are dying." Then the person cools down, the conversation and the interview continues. So you have to be gauging the mood of the person who is being interviewed.

And I could talk first to those ones who were going to do the interview: "Let's not provoke these people and let's be as ignorant as possible. Even if we know he stole the cows the other day or even if we know he killed somebody some day or even if he fought, we are not going to enter into those things. That is for the police and the army. We are now just for research." So that helped us and we got friendly to them and some of them could confess. It reached a point when they could confess and it reached a point where we could mediate. We could bring two fighting groups together. They blame each other, they get hot, they cry, and reconcile at the end.

It was interesting to work in the peacemaking process. We could mediate, we could negotiate, and then we could also have meetings with them, ordinary meetings. We had found out that these were the things which were to be done ... from the findings of the research which acted as our entry point. And the good thing was that I had trained on those things so we were linking the customary strength with the modern strength—all the two methods were used.

Some of My Learning

I also realized they used also to mediate traditionally. So what I learned majorly from there was I should encourage others to be in the lead role in order to own the process. Like, if there is merit, if there is an achievement which has been done there, I should not stand up and say it is my effort. I made sure I remained at the background most of the time, but kept things moving. Each one could rejoice that she or he is the one who has done. I just kept at the background. So I was not even exposed to the journalists. When it comes to the newspapers or the radio, the process gets jeopardized and the culprits

will start looking for you. And once your strength is destroyed then the whole system gets paralyzed.

They could see groups acting but they could not know where the whole thing was starting from. I could use the warrior circles and the community circles to calm down the situation ... only that it was limited to a small part of Karamoja—Moroto District. And yet the same thing must be done in both fighting communities ... like the Kenya side, because there are enemies which come from Kenya. There are enemies who come from different districts within Karamoja. Then there are also components where they go to the neighbouring districts which are outside Karamoja. So the problem is complicated, such that our activities in Moroto District were like a small dot in the ocean. But all the same, it is spreading slowly. It is slow.

We used even to fear to talk with the army and the police. But that Peace and Reconciliation Program had to make us to sit with them. And at first, we would explain the research findings because there were expectations and blame for them also. I had to share both—what people expect them to do and what the people are blaming them on. And for them, they didn't take it all so badly. They had to say, "We shall work on this one ... So this is how they think about us." But at first they were not meeting, so each side had a misunderstanding about the other one. But these days they meet. They meet and speak so that the facts can be seen, the weaknesses, the strengths, and strategies sought. So the collaboration and networking has started between the government, NGOs, and communities.

As a Mother ...

My children have been supportive. Because, when they were born, they found that I was working as a teacher. Then, when I changed the job to a social worker, all the time they had already got used to the fact that I'm somebody who is working and that that's how I support them. So they support that I work. Even now, they said I should look for a job instead of being idle, so that I can continue supporting the family and also supporting them. But the other bit is I have no time to be with them. That is only the negative

bit about being a "jobbing" mother. But the good thing, they have grown so they are able to do certain things by themselves. It was only bad when they were still young. But now at least they are able to do certain things by themselves and they can stay even on their own. But of course I still play the role of guiding them.

It was difficult when they were younger. It was difficult but of course, for them, they could not complain and they thought it was a normal thing. It's me who is feeling they must be missing something. But I made sure they were in a day school at the early stages so that they can still continue going to school and coming back home. Then when I also have time, free time, I would be with them. Then with teaching, it was good in that during holidays I have all the time for them. But after, when I changed to social work, I had to work throughout the year. Then I had only short holidays. That was when I was working with the Redd Barna—Save the Children Norway—and also with LWF, which changed later to Karamoja Agro-Pastoral Development Programme. And then when I also went into politics, active politics, then it was still the same trend.

She then reflected on the challenge for women doing peacebuilding— having to maintain a family while doing their other social work.

The men focus on the work but the women have double duty of the family and the work. And that is also another big challenge. Otherwise, if you are not gifted to balance the two, one has to "over-suffer." It has happened many a time that once the man gets more involved in the public service and he forgets the family, it affects also the family negatively. But I think it is worse for the woman.

She agrees that women certainly get blamed more because the family is seen as their first responsibility.

In the past, the children were not telling me openly that there is need to work, but at this particular moment is when they can talk—maybe because they have grown. My oldest child is now twenty-two years, then the girl, twenty, then the other one is eighteen. They are called Moses Lochiam Mudong, then Isabella Ruth Angella, then for the small boy, he's Locheng

Charles. It's difficult, because I don't have a salaried job and yet I need to maintain them at school.

What Keeps Me Going

The other one of working with the people, it is challenging all right, but it is also interesting. It is interesting to share with people their problems and burdens. At times we sit together and talk over and lament and then daydream and [*she laughs*] all sorts of things. And then you find other times, they come to share with you their problems and you try to advise or guide or something like that. There are a lot of challenges but I have lived through challenges.

The society is interesting. It appreciates. There are those who appreciate, there are those who encourage, there are those who discourage, there are those who are slow, there are those who are faster. So, amidst those human beings, you will find those who will encourage. That's how, when you feel you should leave pursuing something, others say, "No, wait. It seems it's a good thing. For us, for this reason, we think it is a good thing. Why can't we continue?" So that gives you courage and hope and strength.

Like even in the peace work, at a certain point when the peace program started picking up ... okay, so when we did not die as it was thought, a certain man came in wanting to be the one who knows it and who should be handling it, but the people kept on asking him, "Where is the woman? It's the other woman we started with and we feel we should continue with her. Where is the woman?" And that encourages. Then they come and tell you, "Don't let this man to be coming alone here. It seems his speed is not good. He pushes even when things are not ready so he might make us die in the meetings or in the process of the whole thing. So, for you, at least you've been patient with us and you could check properly and you could not take things for granted and as they are mentioned, for example. If they are mentioned, you have to analyze and you have to check properly, 'Are they serious with their words or they have only spoken but deep in their hearts they have another thing?'" So they said, "No, no, no, no. We are comfortable when you are there. We are not comfortable with this new person. But if you have to

work with him, be coming together to the community, come together." So that helps you to understand that they value and they appreciate what you are doing. Though not all of them will appreciate, but if you realize the majority are appreciating then it gives you strength. But you should not expect hundred percent appreciation. It never happens ... unless it's in another society which I've not lived in.

Then there are others who are suspicious. They get suspicious and they become extreme, so it needs again time to convince them. You will even explain to them individually so that they understand, then eventually they will become part of your group, and in some cases they will be at the forefront: "Let us do this and the other." And yet at first he was: "Hrmph, have these people not come to imprison us or to get information from us or something else?" Then you have to assure them and they have to observe over time and you have to notice them in the society. At times they even refuse at first to come for the meetings. Then you have to find a way of finding out who is important and why is he or she missing? Then you find even time for casual conversation or even go and say hello. Then eventually trust will be there and the person will be interested.

Like there were some people even in our program, the fieldworkers, they had not gone to school but they were good in mobilizing. At a certain point I realized they were being laid off. I had to stand for them. I had to go and explain in a management meeting, "We all saw that insecurity was one of the biggest impossible problems. And now, these were the people whom the villagers trusted, even if they have not gone to school, and they were good mobilizers. Now, if you remove them, it will mean the peace program will collapse. So what should we do?" Then they started now thinking, realizing it was true, and they kept them and we continued working. And they were still there when I left the program. But at first they could not see their value. They do not speak English but at least they were respected in their communities. We needed them.

Challenges as a Woman: Male Jealousy

It's more challenging being a woman. It is more challenging, like in politics. That is when I saw the biggest challenge. I was competing with men instead of women.* Men in my society are more jealous than women. They don't believe that the women can challenge them. So you will pick hatred and enemies not because you have committed any sin or any crime but because you did something which, for example, the society is appreciating. They say, "But why this woman? Why a woman, when a man is not?" They work against you. When they are asked by other people, "Why is this person bad?" they cannot explain. They cannot point out that this person did this mistake. "Ah, but she's a bad woman," they say. They can continue saying she's a bad woman but without explaining the reason. Even with resources, they get jealous. If you have a lot of livestock, as a woman, they don't feel good about you. In rare situations women can own livestock. But otherwise, the man wants to be the one who is owning that livestock. Even if it was a gift from your friend or your family, you will not be able to use it in the way you want. He will add it to his herd and say, "It is mine." So there is that bit of the male/female superiority and inferiority.

Challenges as a Woman: Confronting the Men

So up to now, a woman cannot become a County MP. They will stand with the man even if he is the weakest man. That superiority among the men is still strong in the society: "What can a woman do?" But the women are the ones who are keeping the society running. Otherwise, if the men were left on their own, they would not build the society. One day I was telling them in a meeting, "Look into the men's activities. They are the ones holding guns. They are the ones who have killed and stolen the property. They are the ones who are fighting amongst themselves and with their wives. Now, if the

* To encourage the participation of women in politics, Uganda has a certain number of designated positions for Woman MPs from each region, in addition to the other MP positions typically taken by men. In running for election as the Woman MP for Moroto District, Rose would have been competing with other women for the position. In the second election, however, she was competing against the men who were conspiring against her and backing the woman they had put up as her competition.

worlds were to be divided by a miracle into a women's world and a men's world, which world would get finished?" [*She laughs.*]

Okay, at first, when they started the meeting, they said, "Huh, we are cattle rustling because the women want the bride price and resources for maintenance, that the women quarrel a lot, that the women do this and that." I told them, "For us, we only discuss issues, which is misunderstood for quarrels. For you, you only keep quiet and pick a gun and shoot the other one. Which one is better? The one who discusses and explains so that you correct yourself or the one who just picks a stick and hits you on the head or shoots you?"

"Now, look into the issue of bride price. Who negotiates? Isn't it the men who sit there and say, 'Bring a certain number of cows, these sizes, and this and the other'? It is not the small girls who say 'I want the bride price and bring a certain number.' It is the men—the male relatives. It is still the men who bring and it is still the men who negotiate and receive. Even their mothers don't have any serious say. So how do you say it's the women? But just see from the activities, how they are done, who is there at the forefront. It's men. Who distributes amongst themselves? It's men. So the women are only to get the milk and maybe butter or ghee and, if the animal is killed, then they benefit from the meat. But do women take to the market and sell and get the money and drink off? Do they?" They said, "No."

Then they said, "Eeh, don't allow other women to talk. The other women should not talk. Now if we open up the floor to the women, you can hear what they say. [*She laughs.*] Close the chapter of women." Then they really laughed in the room and said, "But you have really analyzed ... but we think that is the truth." I said, "Yes, it's the reality. And the truth is bitter. Why blame another person when it's not the truth?" They said, "Aah, so she has spoken for all women," because they didn't give the women any chance to speak. So they were laughing. A number of the men spoke. They said, "These women are actually kind to us." Then I gave them what they had come for and they kept quiet. They said, "Ah, that is enough. Let's go to the next agenda." [*She laughs.*]

I had said, "Which world would perish? If God was to divide the world, this one for women and this one for men, which world would perish? In your thinking, which one?" And they laughed. I said, "In my thinking I think the one of the man would perish because they fool each other, they hate each other, they rob each other. So you can even see in the family quarrels that the man comes when he is drunk and he starts quarrelling. Then within a short time, after hurting the woman, he sleeps and starts snoring. Now, if it was a man he would get a stick and hit him or even get a knife and stab him. But the women are kind enough. You snore and tomorrow you again wake up. Don't you think the women are good? If you can sleep with an enemy who has been quarrelling with you? The next time he even eats the food you have made. Can't you appreciate the goodness of women?" They said, "No, no, no, no. Don't let the women speak again. We are defeated now. We have given up. We have surrendered. Let's leave this topic." And then they started analyzing things and said that, "It is true. The women are kind. They are so good. So the other society will get finished. The one of the women will continue."

We talk about how difficult it can be as a woman when you are strong and analyze such things and begin to speak out.

They [the men] get hurt. But the good thing is, it's good also to see them weak. They're pretending. At times they even come to consult. Then you get shocked and say, "Eh, so the men we used to think are superior are weak too. So they also break down." The majority of them even break down and they get support from their community.

Challenges as a Woman: Holding the Society

It is amazing what women are doing. It is really amazing. Though it is not noticed and counted. It's amazing. Like in my society, it is the women who handle it. Though you find in the men's talks they underrate women, but if you look into reality the women are the ones who are holding the society. A home without a woman cannot be a home.

Even when death comes, when the man dies, the woman can hold the children, but when it is the woman who dies, the children suffer—unless if they are big children. So the man rushes to get another woman in the pretence of saving the children, but in most cases they go wrong. The new wife fights with the children instead. Because when they bring the new wife, they throw the whole responsibility and burden to her. Then they fight. Those children are from him, not even from this woman. But they would throw the whole burden to this woman and the woman will almost collapse and she gets hostile. The men are the ones who caused that situation. Otherwise, if they remained helping, the new wife will appreciate the children. Because you have to produce the first baby, then you do the learning. But this is a situation where this young person is married and the responsibility of the many children is already there and all on her. So she gets the work piled in the process and handles these children badly.

Strong Women in Karamoja

To balance nature you need both sides of the point. That's why they are important in spite of thinking at the first sight that is a bad thing. Take time to look twice. At times it yields positive results instead of negative results.

Eeh, the society itself is rough.

I wonder whether some of the women are also like warriors.

They are there ... a majority of them. That's how they have managed to survive. Otherwise, if every woman was cool, the society would collapse. There comes a time when they even cane men. They get branches of the trees and cane men. If the men make a grave mistake in the society, the women gather themselves in a group. So the men run and hide. Even if they have guns, they will run. They will be caned and they will kill the animal* for the women, to appease them. And they also believe that you can die if you disobey or you will continue to have a bad omen if you disagree with the women ... if the women are the ones who are in the right and you are in the wrong.

* An animal sacrifice is commonly used in indigenous African cultures as a means of bringing balance to relationships that are out of balance, either with those who are living or with the ancestors.

231

So the men fear to directly provoke the women. They do their mistakes in hiding. But if they come to the open and the women notice, yah, they discipline him. They sing and sing. They are good at singing. They compose songs which expose and curse there and then, and there will be a choir from nowhere ... telling what the man has done and expressing their frustration. Then it corrects the mischief which has been done by him.

Personal and Political Challenges as a Woman

Knowing that Rose's husband had been killed nineteen years ago and that she had not remarried in spite of her society's value for and expectation of this, I was curious whether she felt any pressure in this regard.

It's there. It is enormous. It is partly what came out from the campaigns. Because I'm not married, there are men who want to marry me but I don't want. The men I let down had to express their feelings, to revenge on me by being my opposition. That was one of the reasons which resulted in my failure [in the last elections]. I realized that, "Eeh, what we discussed so many years ago or many months ago or many weeks ago has been paid in this way." I think for them they feel that was the only way to punish me. They said, "Don't elect her. She's a bad woman." So, it's not that they under-look me as a woman but they want to punish me.

It gives me more peace if they have decided like that—it's their own fault. These two things—my having a job or giving services to the community—is not what made me not to accept them. It is my human feelings. But according to them, it was difficult to punish me in any other way so the only way was to go and become my opposition. But people kept on asking them, "What is the problem between you and her?" Then they get tongue-tied. It becomes difficult to explain that scenario. Then when the local people come to me, I tell them, "It's this and the other" and then the people say, "We can now understand why they cannot explain any sound reason." I say, "It is that." Like even my former boss, that's what happened between me and him.

It was not because I was not performing [in my job] or what; it is that.* And now, in such a situation, what do you do? There is nothing you can do. The only thing is to watch and accept the situation as it is. I cannot be forced to marry them. For what? I don't want the job to be because of that. It should be out of merit, like any other person. If you qualify for the job, let the job be there. Not because you have had a sexual relationship with the person who is to fix you there [with a position], no. And that's what I advocate for. I tell the girls "never ever."

Such experiences are common for women in Uganda. I relate how so many young women I've talked to, at all levels of society, have experienced this type of "punishment" for refusing the sexual advances of their male bosses—jobs lost, salaries docked, opportunities denied, and even threats. As Rose affirms, maintaining a job for a young woman in Uganda can be at high personal cost—especially when the alternatives are so bleak.

You just see the hatred you have not created for yourself. It is the other person who is disgusted with you, because you have not let him have the advantage, the sexual advantage. And how possibly can you have sex with every man you have to work with? What is that? So I had to decide to accept to lose the job but not my dignity. So the people keep on asking the men, "What?" but they cannot explain why. But for me, I notice this reason.

They don't say I'm less than a woman because my husband is not there. Because I had my husband and family; I do what every other woman has to do, and I have to respect myself. So I have to respect other people and I have to be sober all the time. After my husband's death, if I ran around with every other man, that would have jeopardized my opportunities. They know I have avoided that but they must revenge on me because I have not let them in—I let them down. And yet, at the same time you cannot go speaking in the rallies to say things like that. You can't. Unless somebody approaches you, then you can explain, "This man is against me because I refused to sleep with him."

* It is a cultural norm to speak very indirectly and in vague terms about such male–female relationship issues. Rose here tries to be more explicit for my sake; I wasn't understanding her more indirect inferences.

Given the difficulty of not being able to publicly vindicate herself, I wonder if Rose then has to rely on her close friends to get the word out to people to correct the misperceptions.

At times I tell them, but at times I don't tell them because of the way they might handle it. Some people get even angry and might kill the men, and yet I don't want them to be killed. So I have to be careful in what I say. Like if I say, "Go and beat," they will beat. So I have to say, "No, don't." Otherwise there would be war within the society, if I take the other side—serious war. I accept to be blamed than seeing people fighting. It's a tough position to be in.

So you find even the village women who have not gone to school shedding tears to relieve their emotions because I'm controlling them not to act aggressively. They shed tears because they would want to go out there and fight. And because I tell them not to fight, they cry. They say that, "For us she's cool [calm]"; that "She's extra holy"; "Why doesn't she support us in this move?" But I keep on explaining to them, "God will pay. Don't." Otherwise we shall finish up the society if all of us go to the other side. That's how I feel. At least we should have some cool ones. Even if we are few, we should be there to balance nature. Because there is time, we should give them room to realize their mistakes themselves and also to repent, than to destroy them. I told you, like a majority of them are now apologetic. Of course I gave them time to realize for themselves. It needs a lot of patience. You get discouraged. It is a serious thing. But there is need to continue.

I have to accept at times even to be alone. Like now when I stay in the village, nobody's supporting me for staying here. Everybody wants me to be somewhere else—in the town, in the city. Yah, but I have decided to stay here. One reason why I have decided to stay here is, most of the time I have been out of the personal development and in the public. You can see even how this house is built [*there are cracks in the cement walls due to a lack of proper drainage*] because I was not there to supervise and to correct some things when it was still the right time. Then this moment helps me at least to be closer to my family. So I feel good about it, but other people cannot un-

234

derstand. They feel I have just hidden off and they are going to lose me [as a leader], that kind of thing, but that is not the case. It's not my plan. I will continue being with them but at the same time I need also to have some time for the family.

Early Influences

I joined public work when I was fifteen years old. That is a long time. Even to do my personal roles, I have had to struggle to do them. Otherwise I would have been lost in the public forum and forgot my family. At fifteen, I started teaching and getting involved into organizing public issues. I started as a licensed teacher.* I was not a trained teacher. But, immediately I finished O-level,† I had to find something to do. The salary was low but all the same I was happy. And that money was much for me as a teenager. I was organizing the house, my own house. Then I could also support my family. I could buy small things for my family and even my own things.

And I had aspired to become a teacher all along. There came a moment when my friends and my sister went to join a nursing training school. But for me, I decided not to go there. I just want to become a teacher. So other girls went. I remained. They tried to convince me to go with them but I told them, "No, I'm not interested in becoming a nurse. I want to become a teacher." So I had to wait. When I felt lonely after they went away, I went for licensed teaching, to occupy myself and be at least informed. Otherwise I would have remained in the village when other girls were going away, at least the girls who were close to me.

Training as a Youth, by the Women

And also, one thing which I remember when I was growing as a girl, when there are celebrations, other girls could be put to arrange reception, serving,

* A licensed teacher was someone who had not been trained at a Teachers Training College but who had completed a certain level of secondary school and been given a certificate or license to enable them to teach lower levels of primary school. In areas of Uganda where there is a shortage of trained teachers, these licensed teachers fill a real need in the schools.
† O-level, based on the British secondary school system, is the equivalent of grade 11.

but the women would prefer to be with me at the kitchen so that they send me: "Pick that, do the other thing, get the other thing." When people were wedding, I was always to be in the kitchen. Other girls would go to other sections but, from time to time, I was with the women, to be sent by them. Then I kept on asking myself in silence "Why?" but I could not refuse. They picked me from all the other girls and I'm amongst the women. So the women could converse all sorts of stories, their adult stories, and I'd just be listening. Of course, as a child or as a younger person, you're not supposed to join their conversation and what you have heard you are not supposed to go and share out. So I listened to these and learned a lot about general life through their stories, rumours, and experiences. But I had to keep to myself because it will be bad if they hear. They'd say, "It is the other girl who has betrayed us."

But every time, they'd say, "Give us the other girl." They were training me. At least I am happy that I was in their circle, the women's circle, instead of being in the girls' circle. It helps me. It makes me into what I am. Like, I was able to know certain things which, if I kept in the group of girls, I would not know. Even if they were tough things or bad things or good things I was getting from their conversation. But there are certain issues which those women would discuss. I think they ignored that I was even there. So they would discuss women's issues, women's experiences, women's rumours. Then I would be listening and analyzing: "Eh, so the world is like this!" They could discuss about relationships, about grudges, about jealousy, about politics, about the children's education, about anything they would want to discuss. Then I would just be listening to them. This was not only within my village. Even at community and district celebrations that would happen. They would look down and say, "Which youth can we involve in this thing?" Then they would invite us. All the women would travel to that venue. So these could be strange women to me, not my mothers, nor my aunts. But I don't know how they could select us.

Since I was exposed to the women and adults, it helped. They trained me to be patient. Like they can over-send me, and I had to do it. Or you sac-

rifice. You know, when you are with other youth, that good feeling you get and that kind of thing? But that had to be sacrificed for all that time I had to be with them. Then there is the other bit of the function which everybody is curious to see but you are held behind there preparing food with the women, so you don't get to be in the celebration itself. So that needs patience in itself ... because you would be curious to go and see. Like, when people were wedding, it became difficult for me to know what was happening in the church, that kind of thing, until when I went to other districts. I even grew now into an adult when I didn't know ... until I had to go to other districts to see. When I now went to other districts I had to learn very fast what it is. Then there comes the moment when you become the main character again in front and yet, most of the time, you were behind. That's challenging. It is challenging. That taught me a lesson that, when you come to the front, you must learn seriously because it could be the only chance. That could be the only chance, so you must learn.

Being Behind the Scenes and Out in Front—It's a Balance

Since Rose had grown up spending so much time behind the scenes, I wondered how she had learned to be so effective in giving the impromptu speeches she gives that so move people.

Of course, in the celebrations I would be there [in the background]— especially at those [events] which need the cooking and the women are involved. But there were other celebrations whereby I was not part of the behind scene so I could learn from that ... or where there was no behind scene—maybe it was the hotel which was arranging. Though you accept to be in the behind scene most of the time, there is need to also know the front scene. So it is a challenge. When you're given an opportunity to be at the front scene, you don't take it for granted because it is not the obvious. You must pick almost all the important things you see there because you know again one day you will be behind the scenes. So it helped me to be sharp. I think I'm disadvantaged, but I have to balance. When the other people are

taking it lightly when they are in front, that it's the obvious, for me it is not. I had to pick it [learn the skill], knowing one day I may be at the front and if I don't have the skill, what happens?

So, let me say, as much as most of the time the women want me to be with them behind there as the society wants, what about if one day I have to be at the front, like if I would be the one to handle the main part? But as I grew up, of course I had to do my own things now. I qualified as a teacher. So there now again came a moment for me to be the main person. So at least I had the advantage of being at the back, then connected now at the front. Then eventually everything corrected itself. So by the time I was making these speeches, I had already had the experience of both the front and the back. So I didn't stay permanently at the behind. It was at the early stages, when I was growing into a youth, is when I was most of the time there.

Visioning the Future

We talked of Rose's visions for the future, what I referred to as "big visions."

[*She laughs.*] Of course, naturally those are things I call small things. I don't see them as big things. I want to make a vocational school. And everybody's wondering how I will make it. But I tell them I have the clue and believe that I will make it, don't worry—even if it's a slow process.

Story of My Gate

Illustrating her ability to hold a vision, Rose told the story of the gate to her home property.

I think roughly it was in 1991 when I got the metal bars from an Italian friend. We got the pipes from the borehole. Of course they were of no use because they could not work in the borehole. They just pulled them out and put new ones. I asked him to give me the pipes. He said, "For what?" I said, "I want to make a gate." He said, "Where is the compound?" I replied, "There is no compound but I just want to make the gate." This was just in the village. So I made the gate and he brought it to the other land where I now

want to put the vocational training school [along the main gravel road going to Moroto]. It stood there for many years. And there was no building, no compound demarcated. The gate was just standing. People thought, immediately the gate has been put up, the next thing is the fence, but there was nothing. So the gate stood as a gate for very many, many years. I just put the poles which were making the gate to stand, then a few dotted poles, without any fence between them. Then my friend would go to Europe and when he comes back, the gate is still standing alone. He'd say, "The gate is still alone?" I said, "Yah." He'd say, "Eeh, why don't you put something?" I said, "I don't have money but I have the dream." Then he laughs. So when I now got money I decided to shift the gate here [to my other village home, off the main road] and made this house and made a fence. So recently when he came, I told him the gate is now here. He said, "This is amazing." Then he entered into the house. He said, "It's a good house." Then, when he was now going away, he said, "At last the famous gate has got a compound and a building." Then we laughed. And of course the first location where the gate was is on the main road. For everybody, it was a point of discussion. "What is this gate for? It has lasted here for many years and there is nothing. Why did she put it there? Why can't she put a fence?" Nobody could answer. These were passengers who were just traveling. Then another person let me know later that, "People were talking about the gate." They talked about the gate standing alone without any compound and a house. They were curious ... until it became obvious. No more discussion about the gate. It was something which was to stand there forever, without explanation. Some of them could come and ask me. I would tell them, "I'm planning to put the fence." So they'd say, "Okay." But when it took a long time, ah-ah, they started doubting if the building would be there.

But I think it is good, if you have a chance of getting something, you'd better get it. Don't say, "Because the other pieces are not there, there is no need of this one." Like those long-lasting things, there is no need of leaving them. You get them and then you continue adding the pieces until eventually it will be something real. You may look funny in the very beginning but,

as time goes on, the reality will come. I don't mind about what people say. I just continue having hope and believing in my dreams. I said, "Even if I don't build, my children will build or, if my children will not build, my grandchildren will build." Since it is not something which will rot, at least another generation will find and make the best use of it. They [the local community members] say, "No, we shall build. Don't talk about the other generation."

Investment Property

As another example of her ability to vision, Rose talked about the plot she has bought in Moroto town with plans for a multistoried commercial building.

Now the commercial plot I bought in town. I bought the plot. It lasted for a longer time, until the municipal council started writing me a letter and some other people also started getting interested in it since it's in a strategic place. Those ones were now giving pressure because I had not put up any structure for a long time. So the land stayed. In spite of not having a clear future, a clear way of getting the money for building, I believed one day I will build.

Then, when I got the opportunity, I have raised the wall up to the ring beam level. And I'm dreaming that it will become a storied building. At first I was thinking maybe two storeys but I decided to put a very strong and deep foundation which can give chance to these children to add up to four storeys. If each one gets a chance of getting some resources, they can build using light materials to put at least one storey. I believe I have started the ground one, up to the ring beam level. I still dream I will finish that one, one day. Then one child again will put the second one, then another one the third one, and the fourth one. I think that will be enough. That will be enough. Then I will rent for income. So that's one of the ways I would want to generate income for the family. Because there will come a time when I will not be able to have a salaried job.

Peace and Interconnectedness

If the society is not at peace there is no way the individual can pretend that he or she is having peace. And that's why, even when a problem affects somebody you don't know or if it's happening in another part of the world, you will find that as a human being you will also feel some pain or some fear or some concern that something wrong is happening in the world. Because you know, even if it is not affecting you directly, there is a way it will affect you indirectly and the world will not be a good place to live in.

We related this to the Karimojong fleeing the insecurity to go to the streets of Kampala and the fact that, while most Ugandans prefer to ignore the situation in Karamoja, they are affected by those begging on the streets.

There is a way it has affected them negatively. *Then they are forced to give some attention to it.* And it has become more expensive for them. So, even if it is not death which is facing them but poverty because the resources are going to something which was unplanned.

She means that even if people in Kampala are not faced with the threat of death like those in Karamoja, they are still being impacted by the Karimojong conflicts because they end up having to give money and resources to support the Karimojong who have fled to the city streets. In this way, they are facing "poverty" because their personal and government resources are being used to address the effects of a crisis in another region.

Anti-Corruption Strategy—Informed Communities

One of the things which I feel is necessary in the anti-corruption exercise is for the communities to be empowered so that they would be able to know what has been planned and brought for them and if it is done or implemented in the correct way and if the outcome is really within the community and is having positive impacts on the lives of the people. So if the resources, for example from the central government to local government, disappear in between, the communities should not be ignorant about what is happening. Otherwise the corrupt people will not be able to be monitored, advised, and

guided if the community is ignorant of the whole thing. So they take advantage of the communities' ignorance. So there is need to build the strength of the community economically, socially, and politically so that they will be able to participate fully in implementing successful projects.

Coming from this perspective, Rose's strategy was to form groups in the community.

Especially in doing that, the groups should be formed and strengthened—the youth groups, the men groups, the women groups, the mixed groups for both men and woman—both modern and traditional or customary ... so long as they have some activities of their interest which bring them together, some reasonable activities which bring them together so that there is a value for life, for improvement. So, as a strong voice they can be heard, unlike when it is individuals talking and unlike if it's an individual who understands and knows what is going wrong and what should be done. But if the majority of the people within the community are enlightened, are aware, then they act as a group, it helps to give pressure. The voice will be stronger and the people who must have been doing the mistakes will correct themselves quickly so that they cannot be outcast in the community. So they will be careful in the way they do the work which has been meant for the public.

Once the community is aware, they will alert them of the mistakes and they will guide them. They will even inform them and advise them that that is wrong. At times here even the people can threaten to have mob justice on somebody or they can even sue. So the more people who are involved in monitoring the public affairs, the better. The groups which I formed were village peace groups, village banks, and village income-generating groups which are dotted throughout Moroto District.

Peace Groups

Why I said the peace groups should be there is because, during the research I realized that there were gaps. Like the youth were not involved, then the women also. Like, in the customary peace process, the men were the ones who could attend meetings; they could go out of the homesteads and meet

somewhere under a tree and discuss the issues of peacemaking and the information would not be shared equally in the community. So, that was a gap. If you are present in a meeting, at least you will have access to all information. When somebody is reporting to you, you just get a summary and yet this is something which affects your life seriously.

Then on the modern peace process, it was the men still who had access to the information, like for example, the leaders, male elders, plus maybe the men in the villages who would go. The women would still remain in the homesteads and continue with other work. And yet the decisions which are made affect them directly. So there was a gap. And we felt, if the pressure groups of all the sexes and age groups could be involved it would be okay. When these men were going, they would select themselves. Then there was lack for the pressure groups and involvement of almost all the willing souls in the village ... and the people who will be affected.

To encourage all the willing souls, the interest groups were formed. Because, when you go to a peace group, it is you who decides whether to be in a peace group or not; nobody is forcing you to go there. So all the willing souls were able to join the peace group, unlike in a peace meeting where they select and invite certain categories only—for example the politicians, then the kraal leaders or the home leaders. So they would select themselves. But with the pressure group, anybody who has a will and talent joins.

So I set up those peace pressure groups. Then the other thing was, what activity could they handle? So we observed that, for example, singing—people here like music; it draws people's attention; it moves the souls of the people. So that would be something good for education in the peace process. Then, apart from the music, drama could also be part of it. Then speeches also, the meetings would be part of the process. Then also the peace rallies; some people are talented in running, for example, and it is done mainly by the young who at times go cattle rustling or at times they go for thuggery or at times they cause theft across and within the villages. They would cause all kinds of crimes. And yet some of them are gifted in running. So, those who are interested in, for example, marathon could be motivated to be doing that.

Then, during that, they would get the message of peace. Then there was also bicycle rally. Of course, for us, we don't have the vehicles. So at least the bicycles could be afforded by both those young people who have not gone to school and those ones who have. Or it was even possible for them to borrow from other people, especially for practice. At the end of the day the peace information is included [is provided by] any person who is willing to speak and say something which will build peace and development of the community.

Another benefit is that then that thing [event] also could bring the youth together from various places, because we as a people were not visiting places outside Karamoja. You find most people know their village mates. They have nothing in common with the villagers in the next village. But when such marathons or bicycle rallies are put, it draws a cross-section of people in a wider area to come together and participate. Like others would come to watch, others could be involved in the activity directly. So it draws a cross-section of various people. So that's why we felt it was important to have groups. Then also, there are certain new ideas which are learnt, even if you are from the same village or across the villages or across Karamoja. But if you come together with many other people, you will be able to have a chance to learn what you didn't have as one individual. So, that was why it was important to have the groups.

When the groups started they were throughout Moroto District but they have spread across Karamoja. Then it has also spread to the neighbouring country—into Kenya. So when the people from Kenya come, they come at times for traditional dances, for bicycle rallies, and for the marathon. At times it happens here in Karamoja, at times it happens in Kenya. So this process helps people to appreciate each other. Because like, in the past, people could know that another group is existing somewhere, though maybe when they come to steal animals—on a negative side mainly. So that was what was linking the people commonly. But now there are other good things which are also connecting them. So they appreciate each other; they make friends. Then the value for each other is cultivated instead of knowing that

by history and revenge they are our enemies. The child is born and is told "they are our enemies," and he doesn't have chance to discover their importance and their good. So when they come in these peace groups, they are able to appreciate positively and to make friends.

These peace groups came out of my work in 1998 and they are continuing and they are increasing. Okay, the research was done but then when I became the MP I had now to also add physical resources. Like at times, I could buy for them the t-shirts, I buy for them the *lessos*.* The earrings you saw, for example, some of them went to those income-generating groups and the peace groups.

In these peace groups, another advantage is a cross-section of people come together instead of all the time being with a particular age-set. The age doesn't matter. It is your ability and your interest which matters. In those groups you find people are mixed up. In the process, the young appreciate the old, the old appreciate the young. Then at least they learn from each other. Then there will be a chance to influence especially those young ones who are cattle rustling and stealing. Then they also act as a tool of breaking redundancy. In the past, most of the time people could sit under the trees and just gamble and gamble and tell all sorts of stories and rumours but now they spare some of their free time to go and sing and dance and prepare for the marathons and meetings.

The communities themselves organize these events. They are free to decide when and which activity to have in their own local location. But the ones across districts or countries [Kenya and Uganda] are facilitated by the NGOs and the government. The government and the NGOs are involved because the villagers cannot move such long distances on their own; there is a big cost. So what is good now is that every NGO in Karamoja has decided to be put a small budget for the peace work. In the past, they were only involved in issues of drought, of agriculture, of health, of what, but at least now every NGO is conscious that the peace component is important. Because without peace, the staff and the communities will get affected. It crosses everything. So even locally, you find that the LCs work together with the government

* *Lesso*s are fabric used by women to wrap around like a skirt.

departments, the NGOs, and the communities. So everybody sees now that it is something which is needed by all the people. They are now taking it as part and parcel of the job.

Peacekeeping, Peacemaking, Peacebuilding

For the peace to exist, there are three sections. There is peacekeeping, peacemaking, and peacebuilding. So currently we have the army in most locations in the region. The police and prison wardens are few. These are helping in the peacekeeping. Meanwhile, the NGOs and other institutions and the government institutions are helping in the peacemaking, like this one maintaining the peace meetings and peace groups. But what I see still as a weak point is on the peacebuilding. For example, the individuals are not economically empowered so that they can be able to run the peace issues on their own and solve the root causes of insecurity. The families are not able to provide for their members so the thieves are many. Because now, if there is no food or there are no clothes or resources are too few to maintain the family members, you find that some of those members start looking for bad ways of surviving. So that component of solving basic needs has to be strengthened.

Peacekeeping and peacemaking are moving on fairly well but peacebuilding is not yet strong and that's why I thought a vocational training institute would be something of help. If people are trained with skills of getting enough resources at least to run the family and to solve their basic human needs, it would be okay. Because a majority of the people have not gone to school, for example. They don't have jobs for earning their salaries. If they could know other skills for getting money and other resources which can help them to solve their basic needs, it would be better.

CHAPTER VII

Expanding the Definition of Peacebuilding

AS I GATHERED the women's stories I kept asking myself, is what these women do peacebuilding? As defined by whom or by what standards? If it is peacebuilding, what are their roles? What do their lives contribute to our understandings of peacebuilding? Based on the contributions of the women and their stories to peacebuilding and development, I propose a redefinition of the relationship between these two fields of practice and study.

Peacebuilding and Development or Development Peacebuilding?

Sustainable development requires conditions of peace and, by inference, peace implies holistic and sustainable development in which basic needs are met and human rights protected in contexts free of the threat of violence and injustice.[96] Development is implicit in a culture of peace.[97]

However, while the feminist peacebuilding literature speaks strongly to the inclusion of meeting basic human needs in definitions of peacebuilding and the central role of women in this regard, it does not profile many examples. Cases largely present women's initiatives in response to the effects of war and violence—and these primarily the initiatives of women's groups. Understandably, this may be due in part to the need to use more dramatic examples to make women's roles in peacebuilding more prominent and visible, and therefore more widely recognized and acknowledged. This approach, however, leaves a significant gap.

Examples of women's involvement in the provision of basic needs do abound in literature about development.[98] However, these are not generally viewed from a peacebuilding perspective and therefore are not valued, supported, or promoted as making any significant contribution to conditions of

peace in communities. Development literature could benefit from a peace-building lens to make more obvious the connections between peace and development. Similarly, the peacebuilding literature should profile as peacebuilding the extraordinary yet ordinary efforts of women engaged in meeting basic needs at the community level—and this by way of specific examples.

In order to more deeply connect peacebuilding and development, both in theory and practice, I propose the term "development peacebuilding." Front and centre in this integration of terms is the recognition that development initiatives, whether locally inspired or imported, have impacts that either contribute to or undermine the cultivation of cultures of peace. International development projects, so often critiqued for inadequately addressing the needs of people, do not generally make these connections to peacebuilding. And, at the community level where many women's daily work is meeting the basic needs of their families, their contributions to peacebuilding are rendered invisible by a lens that focuses on self-defined peacemakers or peace projects, mostly in contexts of violent conflict, and fails to see the deeper connections between women's work and peace, and between poverty and conflict.

This book is unique in its profiling of ordinary, community-based women who are not self-defined peacebuilders but whose various life activities can be said to contribute to building cultures of peace. In this regard, the stories of these women's lives reflect a lived peacebuilding; a peacebuilding that emerges out of the experiences and realities of the women's lives, often in response to their struggle for survival—both individually and for their families and communities. For this reason they do not fit into predominant definitions of peacebuilding in the literature that focus primarily on efforts and intentions of Western interventionists.

The forms of the women's peacebuilding emerge from and are therefore defined by their local contexts. Where food cultivation is the norm for women throughout Uganda, Tina's focus on this is significant because she does it in a context of war and dislocation, where settlement could not be assumed, where land was lost and required a legal battle to be regained, and

where jobs and resources were in short supply. Similarly, Juliana's environmental preservation of land takes place in a part of the country where land scarcity and population density are extremely high, where men are severely disenfranchised and women even more so. Her preservation of language is of importance because she is part of a minority linguistic and cultural group in Uganda. Mama Joyce was a social worker, like many others in Uganda, but it is what she did with those skills that stands out: She became an LC5 politician and was able to relate to all parts of her community—rebels, government soldiers, and civilians—in mediating a volatile situation during the LRA war. Rose's decision to acquire conflict-resolution training only becomes extraordinary in a context like Karamoja, where such involvement could have meant her own death and the orphaning of her children. And, while Rita's compulsion to sit amid garbage heaps building relationships with street children is probably an anomaly in any society, it is made that much more so by the fact that she is from an upper-middle-class family, is well educated, and is a married woman in a context where such behaviour would reflect badly on her and her family's social status, not to mention jeopardize her health. These examples of a few of the women's initiatives make clear that it is the nature of their response within their particular context that turns what is ordinary into the extraordinary and thus makes it more visible as peacebuilding.

These women's peacebuilding efforts are reflective of their lives as women within their society, at times working from within socially and culturally defined roles; at others challenging and even defying these same roles. They are influenced by the values, knowledge, and skills acquired through their Western education. They are also reflective of the values embodied in their indigenous African worldview—interconnectedness, relationships, cooperation, and social balance. Of significance is the fact that values necessary for building cultures of peace are intrinsic to the African context; they are in no need of being imported from the West. In a similar vein, the concept of development in its origins and in its most sustainable form speaks to true development coming from within, rather than being imposed from outside.

It is from this perspective that the women's stories speak of real community development and peacebuilding. It is with this awareness that we must learn to recognize and value those peacebuilding efforts so embedded in the soils of ordinary life that they appear invisible at first sight, but which, after deeper analysis and understanding, reveal themselves to be the very foundation upon which all higher-level peacebuilding initiatives are built and which provide the nurturance and sustenance that builds and sustains communities. Indeed, the everyday work of many women at the community level creates the building blocks of peace in families and indeed whole societies. It is through meeting basic needs and strengthening the capacity of individuals and communities that peace and development become sustainable. The stories of these extraordinary, ordinary women in Uganda demonstrate this bottom-up peacebuilding.

Recognizing Peacebuilders

Peacebuilding at the grassroots is most obvious in the various organized groups whose mandate is peace-related and whose programs and activities are direct and intentional responses to conflict. In Uganda, there are such groups in almost every region of the country, many of which are initiatives of local women, often linked to more institutionalized peacebuilding. These attract what I would call self-defined peacebuilders. They are the obvious starting point for anyone doing peacebuilding research at the community level. These are not, however, where I started; nor are they where I ended up. These are not where I found the women for this book.

The women whose stories I gathered are not self-defined peacebuilders. Apart from Rose, who from her training is conversant in conflict resolution concepts, none of the others spoke in terms of peace and conflict when we first met. All of these women recognize their efforts to be about development—personal, family, and community development. This is their motivating concern. So it is I who have put the lens of peacebuilding on their stories in order to make visible what is present but not often apparent—that within communities there are ordinary people who are involved in building a cul-

ture of peace even if, and perhaps especially if, they do not self-define as peacebuilders. It is these people who, through their personal and community-based efforts at development, lead the way in building a culture of peace and provide the foundation on which to build networks and groups, as well as organized action at other levels of society.

The question for the larger, international, peacebuilding community is how best to support such people in their peacebuilding. The natural impulse is to assume "support" means money, but it is too facile to think that it is only about money. A starting point is to take heed of Lederach's assertion that

> [T]he two greatest tragedies that negatively affect peacebuilding ... [are] (1) the inability to recognize and see what exists in a place that could have potential or is already building the web infrastructure of constructive change; and (2) stepping quickly toward action to provide short-term answers to predetermined problems driven by a sense of urgency. In both cases the in situ web of change—people, processes, and relational spaces—are overlooked, ignored, and diminished, or, worse, replaced or destroyed.[99]

I would propose, then, that the first step is to *recognize* peacebuilding resources in the ordinary and mundane places at the community level. This requires developing and utilizing a peacebuilding lens through which to view all aspects of life and activities, continually asking how people's lives and activities reflect peacebuilding values—values of interconnectedness, relationships, cooperation, social and spiritual balance, respecting life, and limiting violence.[100] Next it is to *affirm* and *validate* these forms of peacebuilding both to those involved, for whom it may seem ordinary, as well as more broadly through profiling such examples by presenting and writing about them. By recognizing and validating what such people do as peacebuilding, it enables them to see that what they do has meaning beyond the mundane everydayness of survival. It also legitimizes their contributions within the formal peacebuilding discourse and within the international community.

Another step is to participate in *networking* with such individuals, thereby expanding their and your network. Where appropriate, it is important to facilitate opportunities for people—and particularly women—to meet and network with others, both at the grassroots level as well as with those at higher levels of influence, and to do so across regions and borders. As is made evident through this research, it is the power of connection and influence through relationships that is the greatest resource for those at the grassroots, especially for women.

At this point it is important to provide a note of caution about not idealizing the identity and role of a "peacebuilder." As I worked with the women, I realized that the term "peacebuilder" is not static, in that no person is always a peacebuilder. Being a peacebuilder is a dynamic, daily living out of certain values. It is about moment-by-moment choices about the attitudes and actions one takes which inevitably reflect underlying values. The evaluative question is whether these are peacebuilding values. I do believe that being a peacebuilder is not the purview of certain types of individuals, though there are those who make specific commitments to such philosophies and spend much of their time and energy in such work. Peacebuilding potential lies within everyone.

This perspective is, I believe, enormously empowering, as it takes peacebuilding from the realm of the few who are activists and theoreticians and places it in the midst of the masses. Peacebuilding becomes the resource and responsibility of every individual in every community. It is about personal and collective choices about how to respond to life's struggles and relational challenges. Ultimately, it becomes the expression of values, beliefs, and attitudes in behaviours and actions that are life affirming, promoting personal and local development, and enhancing relational interconnectedness.

EPILOGUE
Completing the Quilt

TO COME TO THE END of this writing is to come to the end of a journey. Going to Uganda was a decision to continue my own personal journey of healing and integration in conjunction with the research. It was to grapple with the themes of my own life story—my identity(ies), sense of place, spirituality, and my own process of decolonization. It was also to share in the lives of others and, by being in relation with them, to experience and come to deeper understandings of myself and of issues for women in building peace, particularly within this African context. Now, two years later, I am not who I was; nor, of course, who I will be. I am. I am full of stories and of a renewed sense of myself and of life.

Across my bed now lies a patchwork quilt—as much a product of this time and space and process as the book itself. Four such quilts have now been completed by our small Kampala women's group. My quilt, with its many pieces variously patterned—in hues of purple, black, and white—from different skeins of fabric, and imperfectly sewn together by women of both Uganda and Canada, is symbolic both of the research process and of my life. It represents for me the numerous people whose lives and stories are now pieced into my own and it speaks to the richly textured cultural diversity that is so much a part of who I am. Through both these processes—the quilting and the research—previously disparate pieces of my own life and identity have come together in new ways.

So, as I leave Uganda, I carry with me these stories and my quilt. I am blanketed by the many stories told to me. I bask in the beauty of both of these creative works—the drawing together of so many pieces into a whole. I muse at the imperfections—mine and others—that appear in the stitching and that have been part of our lives together. I am grateful for the memories

embodied in each page, each square, and in each person I have come to know. I am grateful for who I am and who I have become as a result of this time spent together.

And so this journey ends, but in a sense it doesn't; another path now opens and I am drawn onward and inward, to delve deeper into what of Spirit motivates and informs women in their peacebuilding.

NOTES

1. Ball & Halevy, 1996; Boutros-Ghali, 1992, 1995; Jeong, 2000, 2002a
2. Jeong, 2002b; Lederach & Jenner, 2002; Reynolds & Paffenholz, 2001
3. Burton, 1990; Galtung, 1996; Lederach, 1995, 1997, 2003; Maise, 2003; Mazurana & McKay, 1999; Moshe, 2001; Reardon, 1993; Schirch, 2004; Strickland & Duvvury, 2003
4. Moshe, 2001; Paffenholz et al., 2005; UNESCO, 2002
5. Mazurana & McKay, 1999; McKay, 2002; McKay & de la Rey, 2001; Strickland & Duvvury, 2003
6. Strickland & Duvvury, 2003, p. 7
7. Boulding, 2000, 2002; Reardon, 1993
8. Boulding, 2000; Dipio, 2004; Reardon, 1993; Vincent, 2003
9. Boulding, 2000; Reardon, 1993
10. Mazurana & McKay, 1999; Porter, 2003; Sorensen, 1998
11. Baksh et al., 2005; Reardon, 1993; Rehn & Johnson Sirleaf, 2002b
12. York, 1998, p. 23
13. Strickland & Duvvury, 2003; Yusufu, 2000
14. Pankhurst, 2004
15. Pankhurst, 2004
16. Ramsey Marshall, 2000
17. Afshar, 2004; Heyzner, 2003; Rehn & Johnson Sirleaf, 2002b
18. Etchart & Baksh, 2005; Handrahan, 2004; Pankhurst, 2004
19. Etchart & Baksh, 2005; Rehn & Johnson Sirleaf, 2002b
20. Sideris, 2002; Meintjes, Pillay, & Turshen, 2001
21. Bop, 2001; Rehn & Johnson Sirleaf, 2002b
22. Rehn & Johnson Sirleaf, 2002a, p. 9
23. El-Bushra, 2004; Handrahan, 2004
24. Mazurana & McKay, 2004
25. Anderlini, 2003; Onubogu & Etchart, 2005
26. Handrahan, 2004
27. Reardon, 1993; Rehn & Johnson Sirleaf, 2002b
28. Isis-WICCE, 2005c; Rehn & Johnson Sirleaf, 2002b
29. Isis-WICCE, 2005, December-b; Mazurana & McKay, 1999
30. G. Herman, personal communication, November 12, 2007
31. Hussain, 2004; *Sunday Mail*, 2003
32. Afshar, 2004; Marshall, 2005
33. International Fellowship of Reconciliation and International Peace Bureau, 1997 in Mazurana & McKay, 1999

34. Isis-WICCE, 2005, December-b; Marshall, 2005; Mazurana & McKay, 1999; Porter, 2003; Strickland & Duvvury, 2003
35. Anderlini, 2003, p. 20
36. De la Rey & McKay, 2006; Mazurana & McKay, 1999
37. Mazurana & McKay, 1999
38. De la Rey & McKay, 2006
39. Leggett, 2001; UNDP, 2011
40. Nzita & Niwampa, 1993
41. Nzita & Niwampa, 1993
42. Leggett, 2001
43. Barnes & Lucima, 2002; Leggett, 2001; *Uganda 30 Years: 1962–1992*, 1992
44. Leggett, 2001
45. Leggett, 2001; UNDP, 2007a
46. UNDP, 2007b
47. UNDP, 2013a; UNDP 2013b
48. UNDP, 2011
49. UNDP, 2007b
50. Kyomuhendo & Keniston McIntosh, 2006
51. Tripp, 2000
52. Mulumba, 2002; Tripp, 2002
53. Tripp, 2002
54. Tripp 2001, p. 1
55. Tripp, 2002, p. 6
56. Dipio, 2004
57. Tripp, 2002
58. Isis-WICCE, 2004; Tamale, 1999
59. Tripp, 2002
60. Tripp, 2002, p. 9
61. International Crisis Group, 2006.
62. Tripp, 2002
63. Ankrah, 1987 in Tripp, 2000
64. International Crisis Group, 2006, p. 12
65. International Crisis Group, 2006; Mulumba, 2002
66. Mulumba, 2002
67. Isis-WICCE, 1998, 1999, 2002, 2005a, 2006
68. UWONET, 2005
69. UWONET, 2005
70. International Crisis Group, 2006; Mulumba, 2002; Tamale, 1999
71. UNIFEM News, 2007
72. International Crisis Group, 2006; Isis-WICCE, 2005, December-a, 2005, December-b

73. Isis-WICCE, 2005, December-b, p. 14
74. International Crisis Group, 2006, p. 15
75. Human Rights Watch, 2005, September
76. Worldview Strategies, 2006, April
77. Human Rights Watch, 2005, September
78. Otunnu, 2002
79. Allen, 2006; Leggett, 2001
80. Allen, 2006; Leopold, 2005
81. Otunnu, 2002
82. Leopold, 2005
83. *The Defunct UNRF II and the Uganda Government Peace Agreement*, 2004
84. Okech, 2005
85. Ssewaya, 2003
86. Fitzpatrick et al., 2003, p. 463
87. Briggs, 2003, p. 127
88. Leggett, 2001; Pazzaglia, 1982; Uganda Human Rights Commission, 2004
89. Uganda Human Rights Commission, 2004, p. 38
90. Leggett, 2001; Pazzaglia, 1982; Uganda Human Rights Commission, 2004
91. Leggett, 2001; Uganda Human Rights Commission, 2004
92. Uganda Human Rights Commission, 2004
93. Leggett, 2001
94. Uganda Human Rights Commission, 2004
95. Uganda Human Rights Commission, 2004, p. 96
96. Reardon, 1993; Yusufu, 2000
97. UNESCO, 2002
98. Boulding, 1980; Mosse, 1993; Visvanthan et al., 1996
99. Lederach, 2005, pp. 105–106.
100. Schirch, 2004; UNESCO, 2002

REFERENCES

African Commission on Human and People's Rights. (2003). Protocol to the African charter on human and people's rights on the rights of women in Africa. Retrieved March 14, 2008, from http://www.achpr.org/english/_info/women_en.html

African Union. (2007). List of countries which have signed, ratified/acceded to the African Union convention on protocol to the African charter on human and people's rights on the rights of women in Africa. Retrieved March 14, 2008, from http://www.achpr.org/english/ratifications/ratification_women%20protocol.pdf

African Union Heads of State and Government. (2004, July). Solemn declaration on gender equality in Africa. Retrieved March 30, 2008, from http://www.chr.up.ac.za/centre_projects/gender/docs/AfricaSolemnDec04.pdf

Afshar, H. (2004). Women and wars: Some trajectories towards a feminist peace. In H. Afshar & D. Eade (Eds.), *Development, women, war: Feminist perspectives* (pp. 43–59). Oxford, UK: Oxfam GB.

Akatsa-Bukachi, M. (2006). The role of women in advancement of society. In S. A. H. Abidi (Ed.), *Peace in Uganda: The role of the civil society* (pp. 103–117). Kampala: Always Be Tolerant Organization (ABETO).

Allen, T. (2006). *Trial justice: The International Criminal Court and the Lord's Resistance Army*. London: Zed Books.

Anderlini, S. N. (2003). The untapped resource: Women in peace negotiations. In ACCORD *Conflict trends, Issue 3: Women, peace and security*, 18–22.

Anderson, K., & Jack, D. C. (1991). Learning to listen: Interview techniques and analyses. In S. B. Gluck & D. Patai (Eds.), *Women's words: The feminist practice of oral history* (pp. 11–26). New York: Routledge.

Appropedia. (2008). Majority world. Retrieved May 30, 2008, from http://www.appropedia.org/Majority_world

Atkinson, R. (1998). *The life story interview* (Vol. 44). Thousand Oaks, CA: Sage Publications.

Atkinson, R. (2001). The life story interview. In J. F. Gubrium & J. A. Holstein (Eds.), *Handbook of interview research: Context and method* (pp. 121–140). Thousand Oaks, CA: Sage Publications.

Ayindo, B., Doe, S. G., & Jenner, J. (2001). *When you are the peacebuilder: Stories and reflections on peacebuilding from Africa.* Harrisonburg, VA: Eastern Mennonite University.

Baksh, R., Etchart, L., Onubogu, E., & Johnson, T. (2005). *Gender mainstreaming in conflict transformation: Building sustainable peace.* London: Commonwealth Secretariat.

Ball, N., & Halevy, T. (1996). *Making peace work: The role of the international development community.* Washington, D.C.: Overseas Development Council.

Barnes, C., & Lucima, O. (2002). Introduction. In O. Lucima (Ed.), *Accord—Issue 11—Protracted conflict, elusive peace: Initiatives to end the violence in northern Uganda.* London: Conciliation Resources in collaboration with Kacoke Madit.

Berg, B. L. (2001). *Qualitative research methods for the social sciences* (4th ed.). Boston: Allyn and Bacon.

Bop, C. (2001). Women in conflicts, their gains and their losses. In S. Meintjes, A. Pillay, & M. Turshen (Eds.), *The aftermath: Women in post-war transformation* (pp. 19–34). London: Zed Books Ltd.

Boulding, E. (1980). *Women: The fifth world.* New York: Foreign Policy Association.

Boulding, E. (2000). *Cultures of peace: The hidden side of history.* Syracuse, NY: Syracuse University Press.

Boulding, E. (2002). Peace Culture. In M. Afkhami (Ed.), *Toward a compassionate society* (pp. 8–15). Bethesda, MD: Women's Learning Partnership.

Boutros-Ghali, B. (1992). An agenda for peace: Preventive diplomacy, peacemaking and peacekeeping (No. A/47/277-S/24111). Retrieved May 3, 2008, from www.un.org/Docs/SG/agpeace.html

Boutros-Ghali, B. (1995). Supplement to an agenda for peace: Position paper of the secretary-general on the occasion of the fiftieth anniversary of the United Nations (No. A/50/60-S/1995/1). Retrieved May 3, 2008, from www.un.org/Docs/SG/agsupp.html

Briggs, P. (2003). *Uganda: The Bradt travel guide* (4th ed.). Chalfont St. Peter, UK: Bradt Travel Guides Ltd.

Bruner, J. (2002). *Making stories: Law, literature, life*. New York: Douglas & McIntyre Ltd.

Burton, J. (1990). *Conflict resolution and prevention*. New York: St. Martin's Press.

Centre for Conflict Resolution (CCR). (2005). *Building an African Union for the 21st century: Relations with regional economic communities (RECs), NEPAD, and civil society*. Cape Town, South Africa: The Centre for Conflict Resolution.

Centre for Conflict Resolution (CCR), & UNIFEM. (2005). *Women and peacebuilding in Africa*. Cape Town, South Africa: The Centre for Conflict Resolution.

Chanfrault-Duchet, M-F. (1991). Narrative Structures, Social Models, and Symbolic Representation in the Life Story. In S. B. Gluck & D. Patai (Eds.), *Women's words: The feminist practice of oral history* (pp. 77–92). New York: Routledge.

Christie, D. J., Wagner, R. V., & Winter, D. D. (2001). Introduction to Peace Psychology. In D. J. Christie, R. V. Wagner & D. DuNann Winter (Eds.), *Peace, conflict, and violence: Peace psychology for the 21st century* (pp. 1–13). Upper Saddle River, NJ: Prentice Hall.

Creswell, J. W. (1994). *Research design: Qualitative and quantitative approaches*. Thousand Oaks, CA: Sage.

David, C.-P. (2002). Does Peacebuilding Build Peace? In H.-W. Jeong (Ed.), *Approaches to peacebuilding* (pp. 18–58). New York: Palgrave Macmillan.

de la Rey, C., & McKay, S. (2006). Peacebuilding as a Gendered Process. *Journal of Social Issues, 62*(1), 141–153.

The defunct UNRF II and the Uganda government peace agreement of 24th December 2002—1st anniversary celebrations. (2004, January 22). Kampala: Global Press 2000 Ltd.

Diamond, L., & McDonald, J. (1996). *Multi-track diplomacy: A systems approach to peace*. West Hartford, CT: Kumarian Press.

Dipio, D. (2004). An African woman: Prototype of peace and nonviolence. In N. R. K. Deusdedit & M. Levis (Eds.), *Towards a culture of peace and non violent*

action in Uganda (Vol. 2, pp. 83–96). Kampala: Konrad-Adenauer-Stiftung (KAS).

Dirasse, L. (1999). *The gender dimension of making peace in Africa.* Paper presented at the Commonwealth Human Rights Initiative Conference on Pan-Commonwealth Advocacy for Human Rights, Good Governance and Peace in Africa. Retrieved from www.unifem-easternafrica.org/peacepaper.htm

El-Bushra, J. (2004). Fused in combat: Gender relations and armed conflict. In H. Afshar & D. Eade (Eds.), *Development, women, and war: Feminist perspectives* (pp. 152–171). Oxford, UK: Oxfam GB.

Elliot, J. (2005). *Using narrative in social research: Qualitative and quantitative approaches.* London: Sage Publications.

Etchart, L., & Baksh, R. (2005). Applying a gender lens to armed conflict, violence, and conflict transformation. In R. Baksh, L. Etchart, E. Onubogu & T. Johnson (Eds.), *Gender mainstreaming in conflict transformation: Building sustainable peace* (pp. 14–33). London: Commonwealth Secretariat.

Fitzpatrick, M., Ray, N., & Parkinson, T. (2003). *Lonely planet: East Africa* (6th ed.). Footscray, Australia: Lonely Planet Publications Pty Ltd.

Ford, C. W. (1999). *The hero with an African face: Mythic wisdom of traditional Africa.* New York, NY: Bantam Books.

Foster, R. M. (1987). *The cultural constraints to participation: Value conflicts and the NGOs in sub-Saharan Africa.* University of Guelph, Guelph, Ontario.

Galtung, J. (1996). *Peace by peaceful means: Peace and conflict, development and civilization.* London, UK: Sage Publications Ltd.

Gawaya, R., & Mukasa, R. S. (2005). The African Women's Protocol: A New Dimension for Women's Rights in Africa. *Gender and Development, 13*(3), 42–50.

Gergen, K. J., & Gergen, M. (2004). *Social construction: Entering the dialogue.* Chagrin Falls, Ohio: Taos Institute Publications.

Gergen, M. (1992). Life Stories: Pieces of a Dream. In G. Rosenwald & R. Ochburg (Eds.), *Storied lives* (pp. 127–144). New Haven, CT: Yale University Press.

Gluck, S. B. (1991). Advocacy Oral History: Palestinian Women in Resistance. In S. B. Gluck & D. Patai (Eds.), *Women's words: The feminist practice of oral history* (pp. 205–220). New York: Routledge.

Gluck, S. B., & Patai, D. (Eds.). (1991). *Women's words: The feminist practice of oral history*. New York: Routledge.

Grenoble, L. A., & Whaley, L. J. (2006). *Saving languages: An introduction to language revitalization*. Cambridge: Cambridge University Press.

Hale, S. (1991). Feminist Method, Process, and Self-Criticism: Interviewing Sudanese Women. In S. B. Gluck & D. Patai (Eds.), *Women's words: The feminist practice of oral history* (pp. 121–136). New York: Routledge.

Handrahan, L. (2004). Conflict, Gender, Ethnicity and Post-Conflict Reconstruction. *Security Dialogue, 35*(4), 429–445.

Harding, S. G. (1987). *Feminism and methodology: Social science issues*. Bloomington, IN: Indiana University Press.

Hatch, J. A., & Wisniewski, R. (1995). Life History and Narrative: Questions, Issues, and Exemplary Works. In J. A. Hatch & R. Wisniewski (Eds.), *Life history and narrative* (pp. 113–135). London, UK: Falmer Press.

Haugerudbraaten, H. (1998). Peacebuilding: Six Dimensions and Two Concepts. *African Security Review, 7*(6), 17–26.

Heyzner, N. (2003, March). Foreword. *Conflict Trends: Women, Peace and Security*, 3–4.

Human Rights Watch. (2005, September). Background. Retrieved March 24, 2008, from www.hrw.org/reports/2005/uganda0905/4.htm

Hunt, S., & Ogunsanya, K. (2003, March). Women Waging Peace. *Conflict Trends: Women, Peace and Security*, 44–46.

Hussain, S. Z. (2004, July 19). Women rage against "rape" in northeast India. Retrieved March 16, 2008, from http://southasia.oneworld.net/article/view/90168/1/

Huyse, L., & Salter, M. (Eds.). (2008). *Traditional justice and reconciliation after violent conflict: Learning from African experiences* Stockholm, Sweden: International Institute for Democracy and Electoral Assistance (IDEA).

IndexMundi. (2008). Uganda Exports—commodities. Retrieved May 20, 2008, from http://www.indexmundi.com/uganda/exports_commodities.html

International Crisis Group. (2006). *Beyond victimhood: Women's peacebuilding in Sudan, Congo and Uganda*. Brussels: International Crisis Group (Crisis Group).

Isis-WICCE. (1998, June). *Documenting women's experiences of armed conflict situations in Uganda 1980–1986: Luweero District*. Kampala: Isis-WICCE.

Isis-WICCE. (1999, June). *The short-term intervention of the psychological and gynaecological consequences of armed conflict in Luweero District (Uganda)*. Kampala: Isis-WICCE.

Isis-WICCE. (2002, August). *Medical interventional study of war affected Teso region, Uganda—Part two*. Kampala: Isis-WICCE.

Isis-WICCE. (2004, December). *Standing up against gender violence: Quality for equality: Celebrating activism*. Kampala: Isis-WICCE.

Isis-WICCE. (2005a). *Documenting the violations of women's human rights during armed conflict: A tool for advocacy and sustainable peace*. Kampala: Isis-WICCE.

Isis-WICCE. (2005b). *Nurturers of Peace, Sustainers of Africa: Selected Women's Peace Initiatives*. Kampala: Isis-WICCE.

Isis-WICCE. (2005c). *Women building peace and good neighbourliness in the Great Lakes region: Proceedings of the Isis-WICCE Regional Institute 2005*. Kampala: Isis-WICCE.

Isis-WICCE. (2005, December-a). *Standing up for peace*. Kampala: Isis-WICCE.

Isis-WICCE. (2005, December-b). *Women on the move: Engendering peace building in Uganda*. Kampala: Isis-WICCE.

Isis-WICCE. (2006, May). *Medical interventional study of war affected Kitgum District, Uganda*. Kampala: Isis-WICCE.

Jeong, H.-W. (2000). *Peace and conflict studies: An introduction*. Burlington, VA: Ashgate Publishing Company.

Jeong, H.-W. (2002a). Peacebuilding: Conceptual and Policy Issues. In H.-W. Jeong (Ed.), *Approaches to peacebuilding* (pp. 3–17). New York, NY: Palgrave Macmillan.

Jeong, H.-W. (Ed.). (2002b). *Approaches to peacebuilding*. New York, NY: Palgrave Macmillan.

Justice and Reconciliation Project (JRP). (2007a). *'The cooling of hearts': Community truth-telling in Acholiland*: Liu Institute for Global Issues, Gulu District NGO Forum.

Justice and Reconciliation Project (JRP). (2007b). *The Justice and Reconciliation Project: Field notes—'Abomination': Local belief systems and international justice*: Liu Institute for Global Issues, Gulu District NGO Forum.

Kitzinger, C. (2004). Feminist Approaches. In O. Seale (Ed.), *Qualitative research practice* (pp. 125–140). Thousand Oaks, CA: Sage Publications.

Koen, K. (2006). Claiming Space: Reconfiguring Women's Roles in Post-Conflict Situations. *Institute for Security Studies Paper 121*. Retrieved from http://dspace.cigilibrary.org/jspui/bitstream/123456789/31134/1/PAPER121.pdf?1

Kvale, S. (1996). *Interviews: An introduction to qualitative research in interviewing*. Thousand Oaks, CA: Sage Publications.

Kyomuhendo, G. B., & McIntosh, M. K. (2006). *Women, work, and domestic virtue in Uganda 1900–2003*. Kampala: Fountain Publishers.

Lederach, J. P. (1995). *Preparing for peace: Conflict transformation across cultures*. Syracuse, NY: Syracuse University Press.

Lederach, J. P. (1997). *Building peace: Sustainable reconciliation in divided societies*. Washington, D.C.: U.S. Institute of Peace.

Lederach, J. P. (2003). *The little book of conflict transformation*. Intercourse, PA: Good Books.

Lederach, J. P. (2005). *The moral imagination: The art and soul of building peace*. New York: Oxford University Press, Inc.

Lederach, J. P., & Jenner, J. M. (Eds.). (2002). *Into the eye of the storm: A handbook of international peacebuilding*. San Francisco, CA: Jossey-Bass.

Leggett, I. (2001). *Uganda: An Oxfam country profile*. Kampala, Uganda: Fountain Publishers.

Leopold, M. (2005). *Inside West Nile*. Oxford, UK: James Currey.

Lieblich, A., Tuval-Mashiach, R., & Zilber, T. (1998). *Narrative research: Reading, analysis, and interpretation*. Thousand Oaks, CA: Sage Publications.

Liu Institute for Global Issues, Gulu District NGO Forum, & Ker Kwaro Acholi. (2005). *Roco Wat I Acholi: Restoring relations in Acholi-land: Traditional approaches to reintegration and justice*. Kampala: Liu Institute for Global Issues, Gulu District NGO Forum

Machel, G. (1996). Impact of Armed Conflict on Children. Retrieved March 20, 2008, from http://www.unicef.org/graca/a51-306_en.pdf

Magesa, L. (1997). *African religion: The moral traditions of abundant life*. Nairobi, Kenya: Paulines Press Africa.

Maiese, M. (2003). What It Means to Build a Lasting Peace. In G. Burgess and H. Burgess (Eds) *Beyond intractability*. Boulder, CO: University of Colorado, Conflict Resolution Consortium. Retrieved from www.beyondintractability.org/m/peacebuilding.jsp

Malan, J. (1997). *Conflict resolution wisdom from Africa*. Durban: ACCORD.

Marshall, M. G. (2005). *Conflict trends in Africa, 1946–2004: A macro-comparative perspective*. Arlington, VA: Center for Systemic Peace, George Mason University.

Mattera, D. (1988). The Spirit of Ubuntu. *Peace Africa, 2*(4).

Mazurana, D. E., & McKay, S. R. (1999). *Women and peacebuilding*. Montreal, Canada: International Centre for Human Rights and Democratic Development.

Mazurana, D., & McKay, M. (2004). *Where are the girls? Girls fighting forces in Northern Uganda, Sierra Leone and Mozambique: Their lives during and after war*. Montreal: Rights and Democracy.

Mbiti, J. S. (1991). *Introduction to African religion* (2nd ed.). Oxford: Heinemann Educational Publishers.

McCandless, E., & Abu-Nimer, M. (2004). Building Socially Accountably Peace and Development in Africa. *Journal of Peacebuilding and Development, 2*(1), 1–5.

McKay, S. (1998). The Psychology of Societal Reconstruction and Peace: A Gendered Perspective. In L. A. Lorentzen & J. Turpin (Eds.), *The women and war reader* (pp. 348–362). New York: New York University Press.

McKay, S. (2002). Gender in Post-Conflict Reconstruction. In H.-W. Jeong (Ed.), *Approaches to peacebuilding* (pp. 123–144). New York: Palgrave Macmillan.

McKay, S., & de la Rey, C. (2001). Women's Meanings of Peacebuilding in Post-Apartheid South Africa. *Peace and Conflict: Journal of Peace Psychology, 7*, 227–242.

Meintjes, S., Pillay, A., & Turshen, M. (2001). *The aftermath: Women in post-war transformation*. London, UK: Zed Books.

Mies, M. (1991). Women's Research or Feminist Research? The Debate Surrounding Feminist Science and Methodology. In M. M. Fonow & J. A. Cook (Eds.), *Beyond methodology: Feminist scholarship as lived research* (pp. 60–84). Bloomington, IN: Indiana University Press.

Mies, M. (1999). Towards a Methodology for Feminist Research. In A. Bryman & R. G. Burgess (Eds.), *Qualitative research* (pp. 67–85). Thousand Oaks, CA: Sage Publications.

Mishler, E. G. (1995). Models of Narrative Analysis: A Typology. *Journal of Narrative and Life History, 5,* 87–123.

Moshe, M. (2001). Peace Building: A Conceptual Framework. *International Journal of Social Work, 10,* 14–26.

Mosse, J. C. (1993). *Half the world, half a chance: An introduction to gender and development.* Oxford: Oxfam Publishing.

Mulumba, D. (2002). The women's movement and conflict resolution in Uganda. In A. M. Tripp & J. C. Kwesiga (Eds.), *The women's movement in Uganda: History, challenges, and prospects* (pp. 106–117). Kampala: Fountain Publishers.

Murithi, T. (2006). African approaches to building peace and social solidarity. *African Journal on Conflict Resolution, 6*(2), 9–36.

Mwenda, A. (2006, July 12). *Foreign aid and the weakening of democratic accountability in Uganda.* Washington, D.C.: CATO Institute.

Nakaya, S. (2004). Women and Gender Equality in Peacebuilding: Somalia and Mozambique. In T. F. Keating & W. A. Knight (Eds.), *Building sustainable peace* (pp. 143–166). Edmonton, AB: University of Alberta Press.

Nhema, A. G. (Ed.). (2004). *The quest for peace in Africa: Transformations, democracy and public policy.* Addis Ababa: OSSREA.

Nkempia, M. N. (1999). *African vitalogy.* Nairobi: Pauline Publications Africa.

Nkurunziza, D. R. K. (1989). *Bantu philosophy of life in the light of the Christian message: A basis for an African vitalistic theology.* Frankfurt am Main, Germany: Peter Lang.

Nzita, R., & Niwampa, M. (1993). *Peoples and cultures of Uganda.* Kampala, Uganda: Fountain Publishers.

O'Donnell, B., & Sevcik, K. (2006). *Angels in Africa: Profiles of seven extraordinary women.* New York: Vendome Press.

Okech, A. (2005). *Uganda case study of literacy in Education For All 2005: A review of policies, strategies and practices. Paper commissioned for the EFA Global Monitoring Report 2006, Literacy for Life.* Geneva, Switzerland: UNESCO.

Olesen, V. (2000). Feminisms and Qualitative Research at and into the Millenium In N. K. Denzin & Y. S. Lincoln (Eds.), *Handbook of qualitative research* (2nd ed., pp. 215–255). Thousand Oaks, CA: Sage Publications.

Onubogu, E., & Etchart, L. (2005). Achieving Gender Equality and Equity in Peace Processes. In *Gender mainstreaming in conflict transformation: Building sustainable peace* (pp. 34–55). London: Commonwealth Secretariat.

Otunnu, O. (2002). The Conflict in Northern Uganda: Causes and Dynamics. In O. Lucima (Ed.), *Accord—Issue 11—Protracted conflict, elusive peace: Initiatives to end the violence in northern Uganda.* London: Conciliation Resources in collaboration with Kacoke Madit.

Owen, H. (2004). *The practice of peace.* Circle Pines, MN: Human Systems Dynamics Institute.

Paffenholz, T., Abu-Nimer, M., & McCandless, E. (2005). Peacebuilding and Development: Integrated Approaches to Evaluation. *Journal of Peacebuilding and Development, 2*(2), 1–5.

Pankhurst, Donna (2004). The "Sex War" and Other Wars: Toward a Feminist Approach to Peace Building. In H. Afshar & D. Eade (Eds.), *Development, Women, and War: Feminist Perspectives* (pp. 8–42). Oxford: Oxfam GB.

Pazzaglia, A. (1982). *The Karimojong: Some aspects.* Bologna, Italy: E.M.I.

Personal Narratives Group (Ed.). (1989). *Interpreting women's lives: Feminist theory and personal narratives.* Bloomington, IN: Indiana University Press.

Polkinghorne, D. E. (1995). Narrative Configuration in Qualitative Analysis. In J. A. Hatch & R. Wisniewski (Eds.), *Life history and narrative* (pp. 5–23). London: Falmer Press.

Porter, E. (2003). Women, Political Decision-Making, and Peace-Building. *Global Change, Peace & Security, 15*(3), 245–262.

Ramsey Marshall, D. (2000). *Women in war: Grassroots peacebuilding.* Washington, D.C.: United States Institute of Peace.

Rapley, T. (2004). Interviews. In O. Seale (Ed.), *Qualitative research practice* (pp. 15–33). Thousand Oaks, CA: Sage Publications.

Reardon, B. A. (1993). *Women and peace: Feminist visions of global security.* Albany, NY: State University of New York Press.

Refugee Law Project (RLP). (2005). *Peace first, justice later: Traditional justice in northern Uganda.* Kampala: Refugee Law Project.

Rehn, E., & Johnson Sirleaf, E. (2002a). Executive summary: Women, war, peace: the independent experts' assessment, progress of the world's women 2002— Vol. 1. Retrieved from http://www.unifem.org/resources/item_detail.php?ProductID=17

Rehn, E., & Johnson Sirleaf, E. (2002b). Women, war and peace: The independent experts' assessment on the impact of armed conflict on women and women's role in peace-building. Retrieved from http://www.unifem.org/resources/item_detail.php?ProductID=17

Reinharz, S., & Chase, S. E. (2001). Interviewing Women. In J. F. Gubrium & J. A. Holstein (Eds.), *Handbook of interview research: Context and method*. Thousand Oaks, CA: Sage Publications.

Reynolds, L., & Paffenholz, T. (Eds.). (2001). *Peacebuilding: A field guide*. Boulder, CO: Lynne Rienner Publishers.

Riessman, C. K. (2001). Analysis of Personal Narratives. In J. F. Gubrium & J. A. Holstein (Eds.), *Handbook of interview research: Context and method* (pp. 695–710). Thousand Oaks, CA: Sage Publications.

Riessman, C K. (2002). Narrative Analysis. In A. M. Huberman & M. B. Miles (Eds.), *The qualitative researcher's companion* (pp. 217–270). Thousand Oaks, CA: Sage Publications.

Rosaldo, R. (1998). Subjectivity in Social Analysis. In S. Seidman (Ed.), *The postmodern turn: New perspectives on social theory* (pp. 171–183). Cambridge: Cambridge University Press.

Salazar, C. (1991). A Third World Woman's Text: Between the Politics of Criticism and Cultural Politics. In S. B. Gluck & D. Patai (Eds.), *Women's words: The feminist practice of oral history* (pp. 93–106). New York: Routledge.

Sara, S. (2007). *Gogo Mama: A journey into the lives of twelve African women*. Sydney, NSW: Pan Macmillan Australia.

Schirch, L. (2004). *The little book of strategic peacebuilding: A vision and framework for peace with justice*. Intercourse, PA: Good Books.

Schwandt, T. A. (2000). Three Epistemological Stances for Qualitative Inquiry: Interpretivism, Hermeneutics, and Social Constructionism. In N. K. Denzin & Y. S. Lincoln (Eds.), *Handbook of qualitative research* (2nd ed., pp. 189–213). Thousand Oaks, CA: Sage Publications.

Schwandt, T. A. (2001). *Dictionary of qualitative inquiry* (2nd ed.).

Sideris, T. (2002). Rape in War and Peace: Social Context, Gender, Power and Identity. In S. Meintjes, A. Pillay & M. Turshen (Eds.), *The aftermath: Women in post-war transformation* (pp. 142–148). London: Zed Books.

Some, M. P. (1994). *Of water and the spirit: Magic, ritual and initiation in the life of an African shaman.* New York: Penguin Books.

Some, M. P. (1999). *The healing wisdom of Africa.* New York, NY: Jeremy P. Tarcher/Putnam.

Sorensen, B. (1998). Women and Post-Conflict Reconstruction: Issues and Sources, *The War-Torn Societies Occasional Paper No. 3.* Geneva: United Nations Research Institute for Social Development (UNRISD) and Programme for Strategic and International Security Studies (PSIS).

Ssewaya, A. (2003). *Dynamics of chronic poverty in remote rural Uganda.* Paper presented at Staying Poor: Chronic Poverty and Development Policy from http://www.chronicpoverty.org/pdfs/2003conferencepapers/Ssewaya.pdf

Stavlota, U., Nannyonjo, J., Pettersson, J., & Johansson, L. (2006). *Uganda: Aid and trade.* Case study for the *OECD Policy Dialogue on Aid for Trade: From policy to practice. 6–7 November,* Doha, Qatar: Organization for Economic Co-operation and Development (OECD); Gulf Organization for Industrial Consulting (GOIC).

Strickland, R., & Duvvury, N. (2003). *Gender equity and peacebuilding: From rhetoric to reality: Finding the way.* Washington, D.C.: International Institute for Research on Women.

Sutherland, J. (2005). *Worldview strategies: Transforming conflict from the inside out.* Vancouver, BC: Worldview Strategies.

Tamale, S. (1999). *When hens begin to crow: Gender and parliamentary politics in Uganda.* Kampala: Fountain Publishers.

Tandon, Y. (2000). Root Causes of Peacelessness and Approaches to Peace in Africa. *Peace and Change, 25*(2), 166–187.

The Sunday Mail. (2003, February 9). 750 Women Go Nude in Protest. Retrieved March 16, 2008, from http://www.commondreams.org/headlines03/0208-06.htm

Tillmann-Healy, L. M. (2006). Friendship as Method. In S. N. Hess-Bider & P. Leavy (Eds.), *Emergent Methods in Social Research* (pp. 273–294). Thousand Oaks, CA: Sage Publications.

Tripp, A. M. (2000). *Women and politics in Uganda*. Kampala: Fountain Publishers.

Tripp, A. M. (2002). Introduction: A New Generation of Women's Mobilization in Uganda. In A. M. Tripp & J. C. Kwesiga (Eds.), *The women's movement in Uganda: History, challenges, and prospects* (pp. 1–22). Kampala: Fountain Publishers.

Tutu, D. (1999). *No future without forgiveness*. New York: Doubleday.

U.S. Department of State. (2007). Uganda. Retrieved January 28, 2008, from www.state.gov/cms_images/uganda_map_2007-worldfactbook.jpg

Uganda 30 years: 1962–1992. (1992). Kampala, Uganda: Fountain Publishers.

Uganda districts information handbook: Expanded edition 2005–2006. (2005). Kampala, Uganda: Fountain Publishers.

Uganda Export Promotion Board (UEPB). (2008). Uganda's Exports. Retrieved May 30, 2008 from http://www.ugandaexportsonline.com/exports.htm

Uganda Human Rights Commission. (2004). *Karamoja: Searching for peace and human rights, special report*. Kampala, Uganda: Uganda Human Rights Commission.

UNDAW. (1995). Fourth World Conference on Women—Platform for Action. Retrieved March 14, 2005, 2008, from http://www.un.org/womenwatch/daw/beijing/platform/index.html

UNDP. (2007a). About Uganda. Retrieved December 4, 2007, from www.undp.or.ug/aboutug.php

UNDP. (2007b). *Human development report 2007/2008. Fighting climate change: Human solidarity in a divided world*. New York: United Nations Development Programme.

UNDP. (2011). International Human Development Indicators. Retrieved September 20, 2013, from http://hdrstats.undp.org/en/countries/profiles/UGA.html

UNDP. (2013a). *Human development report summary: The rise of the South: Human progress in a diverse world*. New York: United Nations Development Programme. Retrieved September 20, 2013, from http://hdr.undp.org/en/media/HDR2013_EN_Summary.pdf

UNDP. (2013b). *Human development report summary: The rise of the South: Human progress in a diverse world—Explanatory note on HDR composite indices: Uganda*. New York: United Nations Development Programme. Retrieved

September 20, 2013, from http://hdrstats.undp.org/images/explanations/ UGA.pdf

UNESCO. (1999a). Zanzibar declaration: Women of Africa for a culture of peace. Retrieved March 20, 2008, from http://www.unesco.org/cpp/uk/ declarations/zanzibar.htm

UNESCO. (1999b). Zanzibar women's conference on a culture of peace and non violence. Retrieved March 20, 2008, from http://www.unesco.org/cpp/uk/ news/zanzibar.htm

UNESCO. (2002). *UNESCO—Mainstreaming the culture of peace.* Paris, France: United Nations Educational, Scientific and Cultural Organization (UNESCO).

UNIFEM. (2005). Supplement on Beijing +10. *Currents: UNIFEM Electronic Newsletter,* Retrieved March 12, 2008, from www.unifem.org/news_events/ currents/currents200501_suppl1.html

UNIFEM News. (2007, May 7). From Peace torch to peace treaty: Ugandan women promote an inclusive, sustainable peace. Retrieved July 18, 2007, from http://www.unifem.org/news_events/story_detail.php?StoryID=593

United Nations. (1985, July). Report of the World Conference to Review and Appraise the Achievements of the United Nations Decade for Women: Equality, development and peace. Retrieved March 14, 2008, from http:// www.un.org/womenwatch/confer/nfls/Nairobi1985report.txt

United Nations. (1998, January). Resolution Adopted by the General Assembly— 52/13—Culture of peace (A/RES/52/13). Retrieved March 14, 2008, from http://www3.unesco.org/iycp/uk/uk_sum_decade.htm

United Nations. (2000). United Nations Security Council Resolution 1325 on Women, Peace and Security. Retrieved from www.peacewomen.org/un/ sc/1325.html

UWONET. (2005). Uganda women's network: Gender transformation and development. Retrieved September 18, 2007, from http://www.uwonet.org/

Vincent, L. (2003, March). Current Discourse on the Role of Women in Conflict Prevention and Conflict Transformation: A Critique. *Conflict Trends: Women, Peace and Security,* 5–10.

Visvanthan, N., Duggan, L., Nisonoff, L., & Wiegersma, N. (Eds.). (1996). *The women, gender, and development reader.* London, UK: Zed Books Ltd.

Wa Thiong'o, N. (1986). *Decolonising the mind: The politics of language in African literature.* Nairobi: East African Educational Publishers Ltd.

Wangoola, P. (2006). The Indigenous Child: The Afrikan Philosophical and Spiritual Basis of Honouring Children. In R. Cavoukian & S. Olfman (Eds.), *Child honouring: How to turn this world around.* Westport, CT: Praeger Publishers.

Wangoola, P. (2007). Afrikans Cannot Modernize While Using the English Language ... They Can Only Enslave Themselves and Die Out. Mpambo Afrikan Multiversity, Uganda.

Wikimedia Commons. (2007). Uganda. Retrieved June 2, 2008, from commons.wikimedia.org/wiki/Image:Un-uganda.png

Worldview Strategies. (2006, April). The current situation in northern Uganda from Acholi perspectives by Bishop Ochola II, retired Anglican bishop in residence. Retrieved May 20, 2006, from http://www.worldviewstrategies.com/index.php?option=com_content&task=view&id=67&Itemid=5#biogs

Yin, R. K. (2003). *Case study research: Design and methods.* Thousand Oaks, CA: Sage Publications.

York, J. (1998). The Truth about Women and Peace. In L. A. Lorentzen & J. Turpin (Eds.), *The women and war reader* (pp. 19–25). New York: New York University Press.

Yusufu, A. (2000). Women and a Culture of Peace. *International Journal of Humanities and Peace, 16*(1), 19–22.

ABOUT THE AUTHOR

Jennifer Ball, PhD, MCIP, RPP, was born in Zambia and has spent over fifteen years living and working in East and Southern Africa. She holds a PhD in Rural Studies with a focus on Sustainable Rural Communities from the University of Guelph in Ontario, Canada. She has conducted research on women's community-based peacebuilding, intercultural communication in professional planning, conflict management, storytelling, and rural land use planning. She is the coauthor of *Doing Democracy with Circles: Engaging Communities in Public Planning*.

Jennifer is an international facilitator and Circle trainer, with experience in North America, Australia, and East and Southern Africa. She is an accredited land use and community development planner. Currently, she is an Adjunct Professor in the School of Environmental Design and Rural Development at the University of Guelph, and also works as a private consultant.

Made in the USA
Charleston, SC
06 October 2015